ANCIENTS AND MODERNS

General Editor: Phiroze Vasunia, Reader in Classics, University of Reading

How can antiquity illuminate critical issues in the modern world? How does the ancient world help us address contemporary problems and issues? In what ways do modern insights and theories shed new light on the interpretation of ancient texts, monuments, artefacts and cultures? The central aim of this exciting new series is to show how antiquity is relevant to life today. The series also points towards the ways in which the modern and ancient worlds are mutually connected and interrelated. Lively, engaging, and historically informed, *Ancients and Moderns* examines key ideas and practices in context. It shows how societies and cultures have been shaped by ideas and debates that recur. With a strong appeal to students and teachers in a variety of disciplines, including classics and ancient history, each book is written for non-specialists in a clear and accessible manner.

MICHAEL SQUIRE is Junior Research Fellow in Classics and Art History at Christ's College in Cambridge, and Alexander von Humboldt-Stipendiat at Ludwig-Maximilians-Universität, Munich and Humboldt-Universität zu Berlin. His other books include *Panorama of the Classical World* (with Nigel Spivey: second edition, 2008), *Image and Text in Graeco-Roman Antiquity* (2009) and *The Iliad in a Nutshell: Visualizing Epic on the Iliac Tablets* (2011); he has also co-edited *The Art of Art History in Graeco-Roman Antiquity* (2010).

ANCIENTS AND MODERNS SERIES

THE ART OF THE BODY: ANTIQUITY AND ITS LEGACY • MICHAEL SQUIRE

DEATH: ANTIQUITY AND ITS LEGACY • MARIO ERASMO

DRAMA: ANTIQUITY AND ITS LEGACY • DAVID ROSENBLOOM

GENDER: ANTIQUITY AND ITS LEGACY • BROOKE HOLMES

LUCK, FATE AND FORTUNE: ANTIQUITY AND ITS LEGACY • ESTHER EIDINOW

MAGIC AND DEMONS: ANTIQUITY AND ITS LEGACY • TO BE ANNOUNCED

MEDICINE: ANTIQUITY AND ITS LEGACY • CAROLINE PETIT

PHILOSOPHY: ANTIQUITY AND ITS LEGACY • EMILY WILSON

POLITICS: ANTIQUITY AND ITS LEGACY • KOSTAS VLASSOPOULOS

RACE: ANTIQUITY AND ITS LEGACY • DENISE MCCOSKEY

RELIGION: ANTIQUITY AND ITS LEGACY • JÖRG RÜPKE

SEX: ANTIQUITY AND ITS LEGACY • DANIEL ORRELLS

SLAVERY: ANTIQUITY AND ITS LEGACY • PAGE DUBOIS

SPORT: ANTIQUITY AND ITS LEGACY • TO BE ANNOUNCED

WAR: ANTIQUITY AND ITS LEGACY • TO BE ANNOUNCED

ANCIENTS AND MODERNS

THE ART OF THE BODY
ANTIQVITY AND ITS LEGACY

MICHAEL SQUIRE

OXFORD
UNIVERSITY PRESS

Frontispiece (p.v): Rip Cronk, *Venice Reconstituted*, 1989: a liquitex, acrylic and air-brush mural in front of the Venice Beach Hotel, Venice Beach, Los Angeles; for discussion, see pp.27–28.

OXFORD
UNIVERSITY PRESS

Oxford University Press, Inc., publishes works that further Oxford University's objective of excellence in research, scholarship, and education.

Oxford New York Auckland Cape Town Dar es Salaam Hong Kong Karachi Kuala Lumpur
Madrid Melbourne Mexico City Nairobi New Delhi Shanghai Taipei Toronto

With offices in
Argentina Austria Brazil Chile Czech Republic France Greece Guatemala Hungary Italy
Japan Poland Portugal Singapore South Korea Switzerland Thailand Turkey
Ukraine Vietnam

First published by I.B.Tauris & Co. Ltd. in the United Kingdom

Published by Oxford University Press, Inc.
198 Madison Avenue, New York, New York 10016

www.oup.com

Oxford is a registered trademark of Oxford University Press

Library of Congress Cataloging-in-Publication-Data

Squire, Michael,
The art of the body / Michael Squire.
p. cm. -- (Ancients and moderns)
ISBN 978-0-19-538080-4 (hardback) -- ISBN 978-0-19-538081-1 (paperback)
1. Human beings in art--Psychological aspects. 2. Art, Classical 3. Art and society.
4. Civilization, Modern--Classical influences. I. Title. II. Series
N7625.5.S69 2011
704.9'42--dc22 2011006710

ISBN (HB): 978-0-19-538080-4
ISBN (PB): 978-0-19-538081-1

Typeset in Garamond Pro by Ellipsis Digital Limited, Glasgow
Printed and bound in Great Britain by CPI Antony Rowe, Chippenham

To MMS

For all the Oldstead lunches,
stripy socks,
Betty's cakes,
and everything else besides

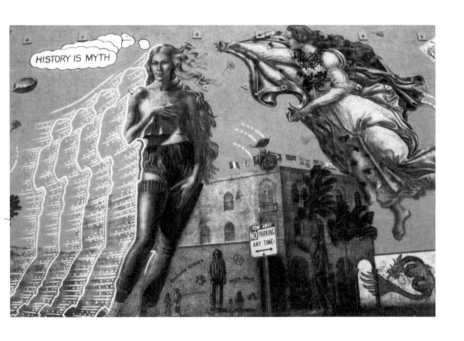

CONTENTS

FOREWORD (*by Phiroze Vasunia*) ix

PREFACE xi

CHAPTER I: EMBODYING THE CLASSICAL 1

 'Ancients and moderns' 4

 The thinking behind the body 7

 Body Fascism 16

 A passé past? 24

 The body of the book 27

CHAPTER II: FIGURING WHAT COMES NATURALLY? WRITING THE 'ART HISTORY' OF THE BODY 32

 A 'Greek Revolution' 33

 The *Story of Art* and the history of art history 46

 The burden of the Renaissance 53

 Seeing double 62

CHAPTER III: THE ANCIENT 'FEMALE NUDE' (AND OTHER MODERN FICTIONS) 69

 V-ness 71

 Crying, talking, sleeping, walking – *living* dolls 79

 Looking at Aphrodite 88

 Aphrodite looks back 96

 Fatal attraction 102

 Slapping with slippers 109

CHAPTER IV: STRIPPING DOWN AND UNDRESSING UP 115

 Indecent exposure 117

 Compromising traditions 125

 The emperor's new clothes 133

 Inheriting inherited bodies 141

 The body in pieces 147

CHAPTER V: ON GODS MADE MEN MADE IMAGES 154

 Imaging and imagining the gods 157

 God Incarnate 167

 Wholly holey holy Lord – or God of power and might? 174

 Figuring [out] the empty body 181

 Icons and idols 186

 Beyond the body? 195

FURTHER READING 202

PICTURE CREDITS 229

INDEX 233

FOREWORD

Ancients and Moderns comes to fruition at a propitious moment: 'reception studies' is flourishing, and the scholarship that has arisen around it is lively, rigorous, and historically informed; it makes us rethink our own understanding of the relationship between past and present. *Ancients and Moderns* aims to communicate to students and general readers the depth, energy, and excitement of the best work in the field. It seeks to engage, provoke, and stimulate, and to show how, for large parts of the world, Graeco-Roman antiquity continues to be relevant to debates in culture, politics, and society.

The series does not merely accept notions such as 'reception' or 'tradition' without question; rather, it treats these concepts as contested categories and calls into question the illusion of an unmediated approach to the ancient world. We have encouraged our authors to take intellectual risks in the development of their ideas. By challenging the assumption of a direct line of continuity between antiquity and modernity, these books explore how discussions in such areas as gender, politics, race, sex, and slavery occur within particular contexts and histories; they demonstrate that no culture is monolithic, that claims to ownership of the past are never pure, and that East and West are often connected together in ways that continue to surprise and disturb many. Thus, *Ancients and Moderns* is intended to stir up debates about and within reception studies and to complicate some of the standard narratives about the 'legacy' of Greece and Rome.

All the books in *Ancients and Moderns* illustrate that *how* we think about the past bears a necessary relation to *who* we are in the present. At the same time, the series also seeks to persuade scholars of antiquity that their own pursuit is inextricably connected to what many generations have thought, said, and done about the ancient world.

Phiroze Vasunia

PREFACE

This is a book about the ancient Greek and Roman art of the body and its enduring western legacy. It is not a history of ancient art. Nor is it a chronicle of its modern reception. Anybody who has bought this book seeking a synopsis of Greek and Roman writings about the body (or for that matter, ancient medicine) should likewise keep hold of their receipt. There are plenty of linear histories of Greek and Roman visual culture; following Michel Foucault's pioneering work, there are also numerous cultural histories of the body, especially in relation to theories of gender and sexuality. But there are surprisingly few books on Graeco-Roman visual representations of the body; still fewer concerned with subsequent western responses to them; and none (that I know of) that relate these issues to broader questions about modernity's relationship with antiquity, or indeed antiquity's relationship with modernity.

The present volume sets out to fill this gap. It pays testimony to three long-standing convictions. First, that the ancient art of the body is to be found everywhere we look: like it or not – and there have been many reasons for *not* liking it – antiquity has supplied the mould for all subsequent attempts to figure and figure out the human body. Second, the book argues that the afterlife of ancient images necessarily complicates our understanding of what they 'originally' meant: each 'modern' re-appropriation of 'ancient' models muddles the assumed distinction between antiquity and modernity in the first place. Third and finally, my objective has been to demonstrate, through a series of diachronic case studies, how ancient and

xi

modern *corpora* of images shed light each on the other. When viewed comparatively, ancient and modern images of the body prove at once familiar and strange: there follows a process of *mutual* illumination.

These overriding issues could be explored in relation to all manner of different subjects: witness the other volumes in this *Ancients and Moderns* series. When dealing with material rather than textual 'sources', however, there can be no shying away from such questions of method. As ancient thinkers knew only too well, there is no seeing without theory (*theōria* in ancient Greek): our view of the world is never objective, but always filtered through cultural values, assumptions and ideologies. And yet the simultaneous power and problem of pictures lies in their lulling us into thinking – indeed, *viewing* – otherwise. It's an overwhelming urge: do we not see as others saw?

Images therefore negotiate 'ancients and moderns' quite differently from texts. The difference is played out with our every act of viewing and reading. We freely acknowledge that to understand past literatures, or even a contemporary foreign culture, we have first to master the language: dictionaries, grammars and handbooks are required – and a great deal of hard graft; we either have to learn the 'otherness' of the language, or else make do with an approximate translation, letting someone else do the hard work for us. Not so with images. The hordes of tourists filling the British Museum demonstrate as much: save for an optional audio-guide or label, no interpretative intercession seems necessary. Standing before us, objects appear as portals that fast-forward past into present: their 'Tardis' or 'Stargate' effect means that images collapse 'antiquity' into 'modernity' in a way that words do not. Think again of those pilgrims to the British Museum, or for that matter the National Gallery: who heads to the *library* to read an ancient Greek papyrus of Homer unless s/he has first grappled with the linguistic (and papyrological) conventions?

The immediacy of pictures is illusory, of course. Conventions are at work behind visual and verbal representations alike. It's just that the formulae of imagery are different from the vocabulary, grammar and syntax which structure texts. When it comes to Greek and Roman images, though, it's

especially hard to reconstruct what these formulae are. This is partly because of ancient art's all-pervasive influence, as we shall see. But it also has to do with what that imagery actually looks like. Because Graeco-Roman art bestowed us with our western concepts of 'naturalistic' representation – a statue of the human body is found to look like an actual body itself – ancient images resemble not only our modern images, but also the 'real' world around us. This makes it all the more difficult to determine what is 'ancient' in what we moderns see, or indeed in how we see it. The history of Graeco-Roman art is bound up with our western visual psychology *tout court*.

Thankfully, the present book does not set out to solve all these issues. Instead, it aims to show why antiquity must be implicated within our modern-day diagnosis. Two hundred years or so ago, when 'art history' first grew out of aesthetics and philosophy, before hatching into an academic discipline of its own, this fact was widely acknowledged: almost *every* discussion of aesthetics, replication and vision drew upon ancient writings and examples (not least in Germany, where this book was written – consider the likes of Winckelmann, Lessing, Herder, Goethe and Hegel). The same can be said for the turn of the nineteenth and twentieth centuries, when art historians were still trained as much in the ancient as in the modern (especially, once again, in the German and Viennese tradition of Riegl, Wölfflin, Cassirer, Saxl, Warburg, Panofsky, et al.). After fleeing the Nazis, and re-establishing itself in London in 1933, the 'Warburg Institute' could still define its academic remit in terms of a 'Classical tradition' – and of the *Nachleben* ('afterlife') of Graeco-Roman images in particular.

In 2010 we have ended up in the reverse situation. Today, most departments of art history and visual culture are entirely divorced from faculties of Classics and Classical Archaeology. A whole series of institutional barriers police the boundaries: university curricula, departments, and not least appointment committees. As we shall see, this current situation stems in no small part from the aesthetic backlashes of the twentieth century, with its various calls to look forward, not back (pp.24–6). It's a delicious irony: had Graeco-Roman art *not* been so historically influential, it might well

have a greater academic presence within departments of art history today.

Some have been only too glad to see the 'ancient' and 'modern' go their separate ways. Uninterested in bigger art historical questions, indeed rather embarrassed by them, Classical archaeologists have sometimes preferred to pore over their relics in splendid antiquarian isolation. Why should we want to force Graeco-Roman art 'into anthropological moulds and structures' or 'subject it to the service of ideologies bred by modern concerns with race, gender and psychology'? Others have abandoned the visual and aesthetic altogether. 'All art is material culture . . .', as one trenchant 'material culturalist' insists: 'Classical art history therefore is archaeology or it is nothing.'

Fully fledged 'art historians' can prove no less partisan. I discovered this the hard way as a naïve graduate student at a prestigious North American university. Upon enrolling on an introduction to art historical theory, I was told that my Classical training rendered me *non*-eligible to participate. Within that department, at least, the ancient was judged irrelevant for the modern, and the modern irrelevant for the ancient: the cut-off date was AD 500 – this within a course on art historical method!

Such (lack of) thinking provides the axe to this book's proverbial grind. If nothing else, I want to demonstrate why – *especially* in art historical circles – we have to think about the ancient and modern alongside each other. As I explain below (pp.28–31), the book therefore proceeds thematically, not chronologically. Despite the forward march of time, their 'Stargate effect' makes images in some sense *ahistorical* entities: the material creations of the past are always experienced through the lens of the present.

A few brief notes of thanks. The following five chapters stem from five rather different 'supervisions', devised in conjunction with an undergraduate course on 'The Classical body: The archaeology and legacy of an ideal' at the Faculty of Classics, Cambridge. Nigel Spivey, who directed that course between 2003 and 2006, and who has long inspired in less listable ways, deserves special mention; so too do those students whose lively debates inform every page (I think especially of Sarah Appleton, Jon Crookes, Imogen Goodier, Danielle Meinrath, Zanna Wing-Davey and Nadia

Witkowski). I've subsequently amassed at least three other notable debts besides. First, I've been very lucky to write this book in Munich during a generous fellowship from the Alexander von Humboldt-Stiftung: there's nothing like working in the Neoclassical surrounds of a Nazi 'Verwaltungsbau' to get one rethinking antiquity's modern legacy; my particular thanks to Rolf Schneider, the most generous of hosts, and to the Alexander von Humboldt-Stiftung, which provided an additional subvention to cover the substantial photographic costs. Second, I'm grateful to Jaś Elsner, John Henderson, Robin Osborne and Verity Platt, who (along with two anonymous referees) read and commented on an earlier draft of the book, improving it in numerous ways. Last but not least, I'm greatly indebted to the editorial team who patiently guided this book from proposal to press, especially Phiroze Vasunia (series editor), Amy Wright (project manager at Ellipsis Books) and Ian Brooke (copy editor).

The Usual Suspects deserve acknowledgement too – in particular my parents Janet and James, and not least Christopher Whitton. I have dedicated the book, though, to my wonderful granny Margaret, and with much love and thanks. I hope she'll forgive the naughty pictures . . .*

Munich
April 2010

Sadly – and most unexpectedly – the dedicatee passed away within just a few weeks of this book's final appearance. She is missed. Terribly.

EMBODYING THE CLASSICAL

Looming over the stairwell of Apsley House in London stands a gleaming, white, marble statue [**fig. 1**]. We might know nothing about the statue's maker, provenance or subject. Yet most modern western viewers feel very much at home with the visual idiom. Imagine an identification line-up, where the task was to pair different images with different cultural labels ('Indian', 'Aztec', 'Egyptian', etc.): few would have any difficulty labelling our statue 'European' or 'western' in stylistic mode. It's not just the marble medium that strikes us as familiar. There's something about what the statue actually *looks* like.

Perhaps the most recognisable aspect is the statue's nudity: the defined torso, delicately placed fig-leaf, and cloak over the left arm. Despite our western hang-ups about appearing naked in the flesh, a statue like this is granted an artistic licence of its own: 'art' is allowed to break usual social conventions, even if the fig-leaf simultaneously recalls them. The exposed muscular physique is recognisable in a different way too. We see our subject to have what we deem a 'good' rather than 'bad' sort of body: this is a masculine physique to which all western men (are assumed to) aspire.

Although the Apsley House figure wouldn't have to be naked for us to recognise its 'western-ness', the lack of clothing accentuates a second feature besides: the recognisable pose. The statue stands with his right leg forward and his left leg back. One foot is firmly on the ground, carrying the body's weight, while the other is flexed and mobile. This simultaneous tension and relaxation of the legs throws the upper body into a whirling diagonal dance:

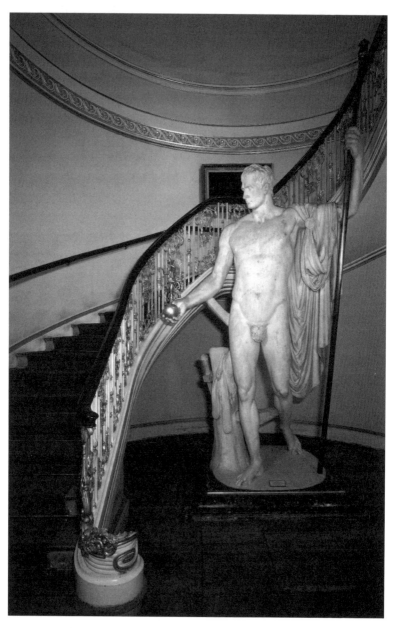

Fig. 1: Antonio Canova, *Napoleon as Mars the Peacemaker*, 1802–6. The balancing of the limbs underscores the symmetry of the whole, with one arm raised to hold a lance, the other lowered and outstretched. Removed in 1816 to Apsley House (home to the Duke of Wellington), the statue had a quite different legacy from the one Canova – or Napoleon – imagined: see pp.117–20.

the shoulders and hips each point in opposite directions, so that the subject's left shoulder stands higher than his right, and his right hip appears higher than his left. In the wake of the Italian Renaissance, western viewers have come to call this *contrapposto* or 'counterpoise'. Our eye is made to rove over the body in a series of criss-crossing directions: the weight courses to and fro from top to bottom, twisting sinuously across the neck, channelling down the S-curve of the torso, passing inward through the weight-bearing leg, and then finally crossing outward through the ankle (which aligns perfectly under the chin). All this endows the statue with a unique sort of dynamic animation: there's movement even as the marble subject stands still.

The nudity and pose consequently point to the statue's most familiar aspect of all: its imitation of a real-life figure. Despite the superheroic size, standing at some 3.45 metres (11½ feet), the image seems to take on the appearance of an actual living and breathing being. We even bestow the nonchalant statue with a subjectivity of its own. Re-read the paragraph above, for instance, and note its talk not of 'the left leg' or 'right hip', but rather '*his* right leg' and '*his* left hip': reversing our own orientation as viewers, we privilege the imagined standpoint of the statue. The image comes *alive*: it partakes in the dramas of our gaze.

So embedded in our collective western consciousness are these various visual conventions that they are all too easily taken for granted. But where do they come from, what do they mean, and how have they exerted such influence on the western cultural imaginary? This book addresses these questions by tracing the western art of the body back to its Graeco-Roman roots: many of our deepest-lying assumptions about figurative representation, it argues, lie latent in our ancient inheritance. There follows a process of two-way enlightenment. Just as ancient art illuminates the modern, so too can the modern illuminate the ancient: we discover some critical continuities between the ancient world and our own – as well as some all-important cultural rifts.

'Ancients and moderns'

In line with this edited series of books, let me begin with a seemingly straightforward question: is **fig. 1** 'ancient', or is it 'modern'?

Those who recognise the tell-tale face may find this a facetious question. The 'facts' of this image allow little room for ambiguity: the statue was sculpted at the beginning of the nineteenth century; it represents Napoleon Bonaparte – the self-declared 'First Consul' (and subsequent Emperor) of the post-revolutionary French Republic. As for the statue's artist, there is a clue in the translucent lustre of the polished surface: it's the work of Antonio Canova, the leading Italian sculptor of the age. At Napoleon's personal request, Canova visited Paris in 1802, completing the statue back in Rome in 1806. Historically speaking, then, this is a 'modern' image. Better perhaps, it's more 'modern' than it is 'ancient', sculpted some two centuries ago rather than some two millennia.

But we only need consider the title to see that things are somewhat more complicated: *Napoleon as Mars the Peacemaker*. The title asks viewers to imagine the latter-day French leader in ancient guise, likening him to the Roman god of war, while also hailing him as the harbinger of peace. This Graeco-Roman allusion helps us to make sense of several other visual references too. Like Pheidias' famous gold and ivory statue of Zeus at Olympia, crafted in the mid-fifth century BC [**fig. 61**], Napoleon is shown holding a golden personification of Nike ('Victory'): just as Zeus was known as the supreme 'father of gods and men', Napoleon is presented as the larger-than-life ruler of all – the whole world in the palm of his hand.

Even if viewers do not know the title, or catch the visual allusions, the Graeco-Roman debt is nonetheless clear. There is something recognisably 'ancient' in *how* the statue appears as much as in *what* it represents. Indeed, each of the three characteristics described above has its origins in the arts of Greece and Rome: the statue's nudity, its pose and the 'naturalistic' appearance.

The statue's state of undress can *only* be understood in the light of ancient precedent. Much to Napoleon's displeasure – as we shall see in the

fourth chapter (pp.117–20) – his masculine power and prestige are quite literally embodied in this 'sculpted' physique. The fig-leaf stops short of full exposure, of course. And yet even this little feature nods to Graeco-Roman tradition, or rather its later cultural mediation. In fact, no Greek or Roman statue originally had its genitals covered in this way. By the late eighteenth-century, however, the fig-leaf had become synonymous with the 'ancient': inspect by and large any gallery of antiquities in the early 1800s, and almost all the statues would have been modestly fig-leafed, following a practice implemented by the Vatican in the late sixteenth century.

It's not just the rhetoric of nudity that makes this 'modern' body look 'ancient'. The *contrapposto* pose also derives from antiquity. The ultimate model seems to have been a statue crafted by an Argive sculptor named Polyclitus in the middle of the fifth century BC. We cannot be sure whom Polyclitus intended to represent (we rely solely on later versions like **fig. 2**); indeed, the particular subject does not seem to have worried later Roman commentators, who simply referred to it as a generalising 'Spear-Bearer', or *Doryphoros.* For all the uncertainties surrounding its origins, however, Polyclitus' sculpture supplied the canonical schema for all subsequent images of the western male body. The turn of the head, the twist of the torso, the tilt of the hips: Canova's Napoleon is modelled after a prototype that was itself modelled over two millennia earlier.

Most fundamentally of all, perhaps, Canova's statue of Napoleon is 'ancient' in its representational mode. Whatever Napoleon actually looked like, he is attributed with (what we deem) a *believable* sort of body. As we shall see in the following chapter, the legacy of naturalism is perhaps the most enduring legacy bequeathed to us from Greece and Rome. Indeed, it's no exaggeration to say that the whole history of western art responds to this Graeco-Roman quest for visual verisimilitude – from the rationalisation of linear painted perspective in the fifteenth century, to the development of modern-day media like photography and film (high-definition TV, blu-ray DVDs and three-dimensional cinema very much included).

To return to our opening question, then, it's clear that Canova's statue is at once modern *and* ancient. By the same logic, an image like Polyclitus'

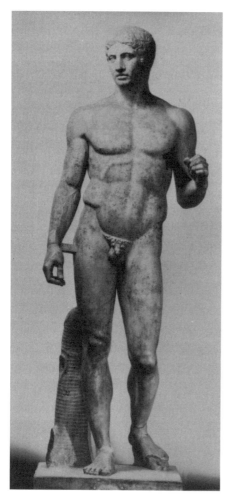

Fig. 2: Roman marble copy of Polyclitus' fifth-century bronze *Doryphoros*. This particular version of Polyclitus' statue seems to have been set up in the Samnite Palaestra at Pompeii in the first century AD; it measures 2.12 metres (7 feet). Contemporary Romans waxed lyrical: 'of all mankind, Polyclitus alone is deemed to have created art itself – and to have done by means of a single work of art' (Pliny the Elder, *Natural History*, 34.55).

Doryphoros (or rather our subsequent Roman copy of it) appears at least as modern as it does ancient. Despite their relative modernity or antiquity, both images tap into artistic conventions that are simultaneously rooted in the past *and* in the present.

To some extent, this tension of tense belies all images from the past. As the late Michael Camille put it, pictures are 'actual apparitions' of history, 'blurring the line between the past and the present . . . where the gazes of both can meet'. But the all-enduring legacy of the Graeco-Roman body makes

6

it especially difficult to disentangle the present from the past, and indeed the past from the present. When it comes to the western art of the body, our 'ancient' and 'modern' labels are stripped of their strict chronological force.

This phenomenon is acknowledged in the way in which we describe ancient Greek and Roman images. Since the eighteenth century, English-speakers have labelled them 'Classical'. Among 'Classicists' – i.e. those who study the 'Classical' world of Greece and Rome – the term refers to the collective cultures of Graeco-Roman antiquity; in the narrowest sense, it describes a particular cultural window between the early fifth and later fourth centuries (traditionally deemed the most 'Classical' of all: cf. pp.52–3). But this is hardly a neutral delineation. In the visual arts, as in other spheres, the 'Classical' defines a supposed standard that transcends the vicissitudes of chronology: the *Classical* betokens the *classic*, and vice versa.

If the word 'Classical' is used to describe Polyclitus' *Doryphoros*, 'Neoclassical' is the term traditionally used of an image like Canova's statue of Napoleon. As a Neoclassical work, Canova's sculpture is characterised as something new on the one hand, and yet deliberately fashioned after Graeco-Roman models on the other. The term certainly captures Canova's knowing and purposeful evocation of established 'Classical' forms – and hence his relation to a wider European cultural movement in the mid-eighteenth and early nineteenth centuries. One of the things I hope to demonstrate during the course of this book, though, is that *all* western images are 'neoclassical' in an associated sense. As we shall see, the whole history of western art has been forged out of an ongoing series of engage-ments with the ancient Greek and Roman.

The thinking behind the body

So why, then, has this book chosen to focus on the image of the body specifically? Unlike so much modern art from the late nineteenth century onwards, the images bequeathed to us by antiquity are unabashedly embodied. Gods, concepts, even abstract ideas: antiquity rendered all of these figurable in personified human form.

From the very beginnings of Greek monumental sculpture, outward physical form incorporated an assumed inner intellectual ideal. *Kalokagathia* was one compound way of expressing the formula, whereby being physically handsome (*kalos*) was inseparable from being ethically upstanding (*agathos*). In the minds of later Roman writers, it was Polyclitus – that sculptor from Argos – who was judged to have epitomised the quality. Understanding the body as a perfect equation of abstract proportions – a sort of musical harmony turned flesh (or at least bronze) – Polyclitus was said to have shown how each body-part was commensurable with every other. An accompanying written treatise called the *Canon* ('rule') appears to have explained the system of mathematical ratios (*symmetria*) involved: *panta pros panta*, literally 'everything in relation to everything', was how one later commentator sized up the founding principle (Galen, *On the Doctrines of Hippocrates and Plato*, 5.448); 'perfection is the step-by-step [*para mikron*] product of many numbers' (Philo Mechanicus, *Syntaxis*, 4.1).

It was a contemporary of Polyclitus named Protagoras who declared that 'man is the measure of all things [*pantōn chrēmatōn metron*]'. But we can see how, at least from the fifth century BC, the art of the body came to embody the sentiment. Just as Polyclitus used each part of the body to

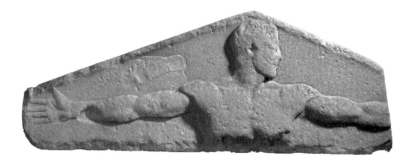

Fig. 3: Marble metrological relief, probably from Lycia (in modern-day Turkey), third quarter of the fifth century BC. The parts of the body provide different units of measurement: the fingers, the clenched fist (beneath the right wrist), the foot (over the right arm), the cubit length (from elbow to fingertip) and the fathom (i.e. both outstretched arms together). Such 'anthropometric' systems of measurement make man the literal measure of all things – and remain very much with us today.

measure each and every other, corporeal units could provide an external yardstick of quantification [**fig. 3**]. The thinking remains very much with us. Despite various attempts to modernise through metrics – not least in post-revolutionary France – the body confers some of our standard twenty-first-century units of measure. If ancient 'cubits', 'handbreadths' and 'spans' ring rather obscure, antiquity still provides us with our 'feet', 'yards' and 'fathoms'.

Polyclitus' *Canon* is lost, and we know of his bronze statuary only through later copies, most of them made in marble [e.g. **fig. 2**]. For all the later Roman hagiography, we cannot even be sure where the *Doryphoros* was set up. Nor should we think that subsequent Greek artists universally accepted Polyclitus' particular fifth-century vision: fourth-century sculptors like Praxiteles, Scopas and Lysippus offered their own distinctive refinements, experimenting with both male and female bodies alike [e.g. **figs. 9, 34**].

But Polyclitus' legacy lies in the *idea* of the ideal. Two points are particularly important: first, the Polclitan body was understood to manifest abstract, numerical calculations; second, this materialised ideal of immaterial beauty was thought to hold universally. Like the *Doryphoros* itself, Polyclitus held one foot on the ground while suspending the other in meditative contemplation. Perfected through sculptural *technē*, couldn't the human body incarnate an *absolute* standard of beauty, equilibrium and truth?

At no time was the idea of this ideal more influential than in the Italian Renaissance. Unlike so many terms of academic convenience ('Classical', 'Mediaeval', 'early modern', etc.), sixteenth-century writers coined the label 'Rinascimento' themselves, using it to describe their supposed 'rebirth' of antiquity during this time. It's no coincidence that the first testified usage is by Giorgio Vasari, and in the context of the visual arts: architecture, sculpture, painting – these had all been resurrected, Vasari explains, through modernity's self-conscious revival of ancient models. Vasari constructs a whole narrative of artistic development around the assumption (cf. pp.50–1): while artists like Sandro Botticelli had looked to ancient exemplars [**fig. 4**], subsequent masters like Michelangelo built upon their progressive (or rather *re*gressive) ancient-cum-modern achievements.

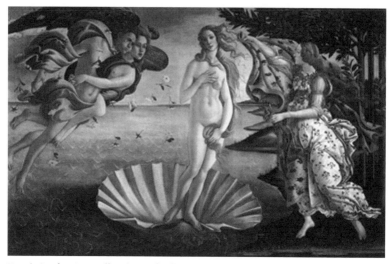

Fig. 4: Sandro Botticelli, *The Birth of Venus*, c. 1486. Botticelli looked to both ancient images and texts to give 'rebirth' to the image of Aphrodite born from the sea: on the one hand, the picture derives from ancient descriptions of Apelles' painting of *Aphrodite Anadyomene* (long since lost); on the other, Botticelli's Venus is modelled after ancient adaptations of the Knidian Aphrodite [**fig. 34**].

For us in the twenty-first century, Michelangelo's colossal statue of David provides the most iconic image of this 'rebirth' [**fig. 5**]. Although the pose reverses the stance of Polyclitus' *Doryphoros* [**fig. 2**], the distribution of weight is precisely analogous. Observe, for example, how one foot is firmly on the ground, while the other leg is extended; note too how the hips angle in the opposite direction from the shoulders, completing the studied *contrapposto* effect. Comparing images like this with the standard iconographic repertoire of the Roman Catholic Church, we can understand how Classical art provided a sort of artistic, cultural and social *carte blanche*. The body of Christ, the shamed nakedness of Eve, the draped reticence of the Virgin Mary: these weren't the *only* paradigms for figuring Man and Woman; indeed, even these bodies could be understood in renewed Graeco-Roman terms.

Renaissance artists had increasing access to ancient monuments: newly excavated statues allowed them to excavate ancient thinking about the body. But artists were also reliant on Latin (and later Greek) texts. One of

the most celebrated – at least during the fifteenth century – was a Latin treatise *On Architecture*. Vitruvius' manual, composed at the end of the first century BC, is half-handbook and half-digest (the author surely made a better engineer than he did literary stylist). Along the way, Vitruvius provided Renaissance thinkers with tantalising glimpses of an 'ancient' aesthetic system. As Vitruvius declares at the beginning of his third book, moreover, this visual ideology was derived from a certain conceptualisation of the human body (3.1.1–2):

> The composition of temples depends upon symmetry, and architects ought diligently to understand why... Without symmetry and proportion no temple can have a regulated composition: it must have a precise order, just like the limbs of the human figure. For nature has

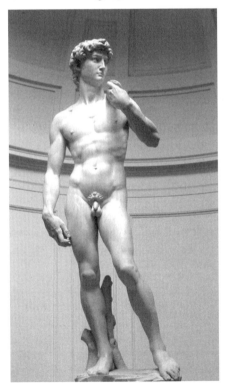

Fig. 5: Michelangelo's *David*, 1501–4. The sling held in David's left hand (and draped around the back) transforms pagan models into a Judaeo-Christian hero. But Judaeo-Christian tradition made Goliath the giant, not David, who stands here at 5.17 metres (17 feet).

so designed the human body that the face is a tenth part of the overall height (from the chin to the top of the forehead and the roots of the hair); the distance from the palm of the hand to the tip of the middle finger measures the same, whereas that from the head (from the chin to the crown) is an eighth part of the whole, that from the top of the neck (including the bottom of the breast) to the roots of the hair is a sixth, and that from the middle of the breast to the crown is a fourth. As for the height of the face, the distance from the bottom of the chin to the bottom of the nostrils is one third of this total; the nose from the bottom of the nostrils to the line between the eyebrows is the same; from that line to the roots of the hair, the forehead also comprises a third part of the whole. The length of the foot is one sixth the height of the body, the forearm is one quarter, and a quarter too is the breadth of the breast. The other limbs also have their own proportionate measurements [*proportiones*]: it was by using these that ancient painters and famous sculptors attained such great and boundless renown.

Architectural temples, writes Vitruvius, must be no less perfectly proportioned than human bodies, and both comprise a harmonious set of symmetrical *proportiones*. To drive home the sentiment, Vitruvius adds a final significant detail: the human figure is the perfect paradigm of proportion, he writes, because it can be fitted within the two most perfect geometrical forms, the circle and the square (3.1.3):

Like the members of the body, the members of temples ought to have dimensions in their individual parts that correspond with the general sum of their total magnitude. Now, in the human body, the central point is naturally the navel: if a man be placed flat on his back, with hands and feet extended and the centre of a circle placed over his navel, the fingers and toes of his two hands and feet will touch the circumference of the circle that encompasses him. Just as the human body yields a circular schema, so too will a square outline be produced

within it. For if we measure the distance from the soles of the feet to the top of the head, and apply that measure to the outstretched arms, the breadth will be equal to the height, as in the case of plane surfaces which are perfectly square . . .

For Vitruvius, man is quite literally the measure of all things – and first and foremost of himself.

Vitruvius' analysis inspired numerous theoreticians in fifteenth-century Florence. The most famous commentary would be by Leonardo da Vinci, c. 1487 [**fig. 6**]. All of the ratios described by Vitruvius find their parallel

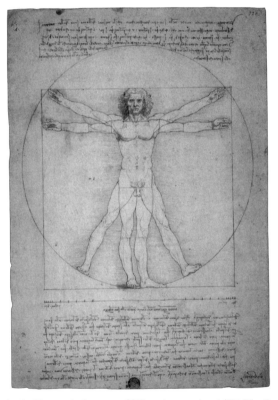

Fig. 6: Leonardo da Vinci, ink drawing of 'Vitruvian man', c. 1487. The Renaissance embodied: Vitruvius' image of bodily symmetry is made to incorporate fifteenth-century concepts of divine *disegno*; the ultimate figuration of 'Vitruvian man', however, would be found in the body of Christ [**fig. 69**].

in Leonardo's drawing, topped and tailed with a series of written notes: just as Vitruvius hypothesises, Leonardo reveals a male figure in two superimposed positions, the one set within a square (legs together and arms in cross formation), the other circumscribed within a circle (legs apart and arms raised to the level of the head). But questions nevertheless remained. Should the lower part of the circle be contained within the square (as Leonardo has

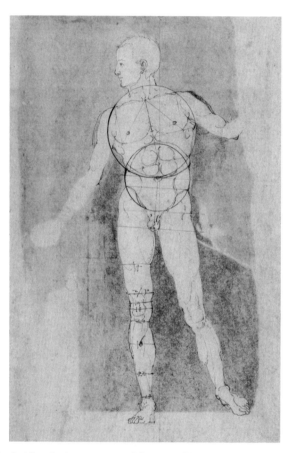

Fig. 7 (cf. **pl. 1**): Albrecht Dürer, measured drawing of the human body, 1504. Hailing from Nuremberg in German Bavaria, Albrecht Dürer helped bring the arts of the Italian Renaissance north of the Alps. Dürer spent his life attempting to master systems of bodily proportion (epitomised in his 1528 *Four Books on Human Proportion*). As this preliminary study of an 'Adam' figure demonstrates, moreover, he ultimately looked to ancient models.

it)? Or should the whole square be contained within the circle (as in the woodcut image by Cesare Cesarino, accompanying his Italian translation of 1521)? Indeed, was there any basis for Leonardo's opening apart of the legs so as to make them fit within the circle (his 'Vitruvian Man' only works by making the height of the circular figure a fourteenth shorter than the square)? Like countless other Renaissance thinkers before and since – Giovanni Giocondo, Francesco di Giorgio, and Cesare Cesarino among them – Leonardo must have realised the problems. And yet the difficulty of resurrecting ancient standards made the quest all the more beguiling.

For Leonardo the lure of ancient bodily *symmetria* lay in its promise of uniting the abstract with the material. Here was a microcosm of cosmic order, one that fused mathematical geometry with organic form. It was not just a question of our bodies, or even of how to represent them. This concrete configuration seemed to hold the secret for all other kinds of visual expression: recall, for example, how Vitruvius mentions the comparison in the larger context of *architectural* design. The quest to lay the ancient ideal bare became an all-encompassing obsession [**fig. 7**]. By revealing the *disegno* of the human form, couldn't Renaissance artists reveal the intellectual principles of God's own creation? Indeed, mightn't artists learn to play God themselves?

This idea of a bodily ideal, and its embodiment though Classical sculpture, has very much endured. When 'aesthetics' was first coined as a self-standing branch of philosophical enquiry in the eighteenth century, Graeco-Roman sculptures continued to play a major role, offering the ultimate exempla of the 'beautiful' and 'sublime'. Some, like William Hogarth, even attempted to formulate a single overarching principle. In the opening plate of his *Analysis of Beauty*, published in 1753, Hogarth shows the canonical greats of Classical sculpture assembled in an imaginary open-air courtyard [**fig. 8**]. To the upper left we see the back of the 'Farnese Heracles' [cf. **fig. 9**], and beside it the Laocoön, Vatican Antinous, Belvedere torso, Medici Venus [**fig. 29**], and Apollo Belvedere [cf. **fig. 41**]. For Hogarth, the *Beau Ideal* is a supposed ancient Classical ideal: it follows that a statue like the Apollo Belvedere can 'serve . . . to exemplify every principle that hath been hitherto advanced'.

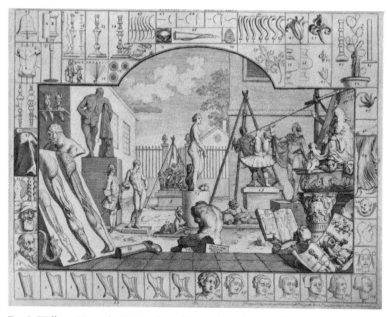

Fig. 8: William Hogarth, *The Analysis of Beauty* (London, 1753), Plate 1. The disparate objects framing the central composition show how the ancient 'line of grace' is incorporated in modern (and wholly more mundane) places – cacti, candlesticks, and corsets among them. There's an additional joke for the in-the-know dilettante: each of the Classical statues has been reversed, so that this 'Farnese Heracles' holds his left hand behind his back (rather than his right: contrast **fig. 9**). As always with Hogarth, tongue-in-cheek satire frames serious analysis, and vice versa.

Body Fascism

As Hogarth's print so nicely demonstrates, eighteenth-century aesthetics was premised on the study of ancient systems of proportion. Nineteenth-century theoreticians like Adolf Zeising continued to turn to statues like the Venus de' Medici [**fig. 29**] in their attempts to demonstrate a numerical 'golden ratio'. But then came the question: could real human bodies *themselves* attain this paragon of perfection?

This issue has directed not only our western art of the body, but also our internalised images of ourselves. Perhaps most importantly, it has given rise to twenty-first-century notions of 'working out' our bodies. The idea of physically incorporating the Classical has a substantial history: portraitists

had long depicted historical subjects after established Graeco-Roman poses, for example, and Lady Emma Hamilton was notorious for beguiling her guests with 'performances' of Classical schemata in Georgian England. But it was in the late nineteenth century – following the invention of photography – that the quest to embody the Classical came to a head.

Take the 'father' of modern body-building, Eugen Sandow. Hailing from Prussia, and born in 1867, Sandow started out as little more than a circus act. But he quickly recognised something about his doting public: fans were less interested in the objects lifted than in the body that lifted them. Savvy to the last, Sandow duly changed his routine, including new 'performances'

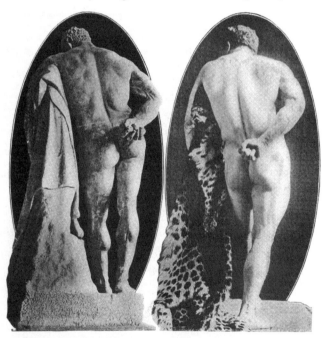

The original Farnese Hercules, to whom the Author has been compared. The accompanying photo shows—

The Author in a similar pose. Many say that the Author's proportions are the more symmetrical of the two.

Fig. 9: Eugen Sandow (right) imitating the 'Farnese Heracles' (left), as reproduced in Sandow's *Life is Movement: The Physical Reconstruction and Regeneration of the People* (London, 1920), p.500. Modern muscle measures up to hallowed antiquity – a celebrated Roman version of Lysippus' fourth-century BC statue, in fact a colossal 3.15 metres (almost 10½ feet) high. 'Many say that the Author's proportions are the more symmetrical of the two', boasts the original caption. Would that the present author could say the same . . .

of muscle display: he began to pose for photographs, using these to sell his own brand of manuals, dumbbells and pulleys. Therein lay the commercial wheeze. For in striking his modern-day poses, Sandow took on the appearance of various Greek and Roman works – the 'Dying Gaul' and 'Farnese Heracles' among them [**fig. 9**]. In addition to donning the compulsory (and flatteringly large) fig-leaf, Sandow was even known to 'white up' before wowing his audiences: he dusted his body with talcum powder so as better to imitate the pallor of ancient marble.

Sandow's resort to the 'Grecian ideal' helped to dissipate Victorian anxieties about the (homo)eroticism involved. If it was 'improving' to look upon ancient statues of the naked male body, wasn't it somehow okay to look upon naked male bodies in the flesh? Such associations also dignified Sandow's modern 'physical culture' movement with an air of highbrow legitimacy: it was part of a larger project of British imperial regeneration – 'you cannot maintain an A1 Empire with a C3 population', as British Prime Minister David Lloyd-George declared in 1917.

This all made Sandow's ideology of body-building – what Sandow labelled 'man in the making' – markedly different from our exercise regimes today. Sandow marketed himself as an artist: he was a 'Gym Beau', not a gym bimbo. It therefore made sense that, when it came to the 'Great Competition' of British muscle-men in 1901, Sandow's search to find England's most Classical-looking man should be hosted in London's prestigious Albert Hall. Yes, this may have been a sort of Victorian version of the *X Factor* or *Britain's Got Talent*. But it had decidedly highbrow aspirations: alongside Sandow on the adjudicating bench were two of London's most celebrated aesthetes – the sculptor Sir Charles Lawes, and the writer Sir Arthur Conan Doyle (of 'Sherlock Holmes' fame).

It's perhaps significant that Sandow was born and bred in Prussia. Although the late nineteenth-century obsession with resurrecting the Classical was a pan-European phenomenon – witness the first modern Olympic Games, held in Athens in 1896 – nowhere was it more keenly felt than in Germany. Ever since Johann Joachim Winckelmann [**fig. 23**] had hymned the 'noble simplicity and quiet grandeur' of Greek statuary in the 1750s and 1760s, German writers

like Goethe, Herder, and Schelling saw Greek art as embodying a romantic ideal of their own.

Following the unification of Germany in 1871, this quest to equate the German with the Greek took on a new nationalist urgency. Just as Richard Wagner claimed that his operas presented the ultimate in Greek theatre (in spite of their North European subjects), Friedrich Nietzsche heralded the rise of an Aryan *Übermensch* out of the revitalised Hellenic tradition. *Man will zurück*, writes Nietzsche – 'we want to go *back*': 'back through the Church Fathers to the Greeks, from the north to the south, from the formulaic to pure form [*aus den Formeln zu den Formen*]!' The Reformation must be undone; the legacy of that 'unholy' Martin Luther had to be reversed. Germany has joined anew its bond with the Greeks – 'the hitherto highest form of man known to us'. It began with concepts, or *Begriffe*. But it will end in embodied flesh:

> Today we are again getting close to all those fundamental modes of interpreting the world which the Greek Spirit devised. Day by day, we're becoming more Greek. At first, as is to be expected, in our concepts and estimations – like Hellenising ghosts [*gräcisirende Gespenster*], so to speak. But one day – or so we hope – we will also become more Greek in our *bodies*.

To be truly German, according to Nietzsche, meant being truly Greek – in spirit (*Geist*) *and* in body (*Leib*). 'Herein lies my hope for the German character – and it has long remained my hope before now.'

This unmistakably fetishistic desire to resurrect the Greek body is not just a matter of modern cultural history. It's also implicated within the cataclysmic political upheavals of the twentieth century. Whatever Nietzsche would have made of National Socialism (the odd-bod philosopher died in 1900), his ideology of a Greek-looking Germany inspired a whole host of nationalist ideologues.

Foremost among them was a failed – and somewhat weedy – Austrian artist named Adolf Hitler [**fig. 10**]. True to Nietzsche's vision, Hitler planned

for Germany to re-embody the Classical ideals of the Greek. This aspiration directed programmes like the Hitler Youth, designed to make virile, dynamic, and bellicose subjects of Germany's young boys. It also directed Nazi propaganda. Sculptors like Arno Breker, Karl Albiker, and Josef Thorak [**fig. 12**] were called upon to personify nationalist concepts through colossal *Übermensch* statues ('Party', 'Army', 'Comradeship', etc.); at the same time, art historians (most famously Paul Schultze-Naumburg) espoused the 'Aryan' purity of Classical art. 'Never was humanity in its appearance and its feeling closer to Classical antiquity than today', as Hitler put it in 1937: 'competitive sports and combat games are hardening millions of youthful bodies, and they show them rising up in a form and condition that have not been seen, perhaps not been thought of, in possibly a thousand years'.

According to the aesthetic-cum-political ideology of the Third Reich, all bodies could be categorised according to Classical and non-Classical types. 'If the creative spirit of the Periclean age is manifest in the Parthenon', as Hitler raved in his *Mein Kampf* ('my struggle'), 'the Bolshevik era is embodied in its cubist grimace.' Jews, Communists, homosexuals: it was only to be expected that their bodies – no less than their figurative art –

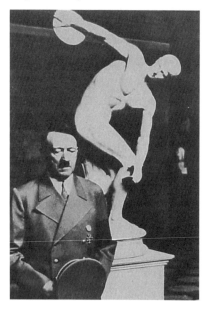

Fig. 10: Adolf Hitler, standing before the 'Lancellotti *Discobolos*', 1936. A moment of silent reflection before this most hallowed of Classical relics [**fig. 24**]: in 1938, Hitler persuaded Mussolini to sell the statue to Germany for 3 million lire; it remained in Munich until 1948 when it was 'repatriated'.

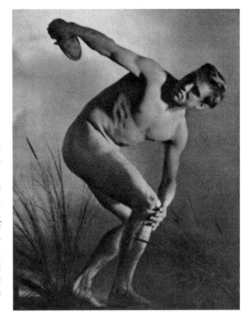

Fig. 11: Cinematic still from the opening of Leni Riefenstahl's *Olympia: Fest der Völker*, 1938. The magic of motion pictures turns the Classical *Discobolos* [**fig. 24**] into living flesh – and then cuts to the opening ceremony of the 1936 Olympic Games. Many Nazi Olympic inventions remain part of our Olympics today – not least the bearing of the Olympic flame from ancient Greece to the modern host-country.

should look so lumbering, puny, lanky, scrawny, gaunt, scraggy, and gangly. For those who saw them, the millions of emaciated cadavers crammed into ghettoes and concentration camps can only have reinforced the rhetoric: wasn't *this* why Nazi Germany needed its programme of bodily eugenics?

The Nazi fixation with the Classical body made Berlin's hosting of the Olympics in 1936 a particularly poignant coup. With the Olympics coming home, Germany could finally show off its hardened bodies to the world – and duly did so by winning 33 gold, 26 silver, and 30 bronze medals (far more than any other country). This was not just a sporting victory. Because the Olympics included competitions for the arts, and continued to do so until 1948, Germany had a chance to prove its creative vision: Germany was awarded first prize for Emil Sutor's 'Hurdlers' in the category of sculptural relief, and second prize for Arno Breker's free-standing 'Decathlon Athlete' (that gold went to Italy, or so the story goes, in an official effort to boost the medal-count of the host country's ally). Little by little, the rumours seemed to be coming true: Berlin really was the 'Athens of the Spree'.

21

The Hellenic triumphs of the Berlin Olympics were also captured in film. Presided over by Goebbels' Ministry of Propaganda, Leni Riefenstahl released her 1938 *Olympia* in two separate parts, celebrating both the 'festival of nations' and the 'festival of beauty'. Most memorable is the opening of the first film. Among the shadowy landscapes of ancient Greece we catch odd glimpses of romantic ruins and relics – columns, fragmented temples, loving glances of the Athenian Acropolis; we then move to some languishing shots in a museum – the Barberini Faun, an Alexander the Great, the Aphrodite of Knidos. This culminates in a view of Myron's *Discobolos*, a Roman marble copy of a celebrated Greek 'disk-thrower', made in the middle of the fifth century [**fig. 24**]. At first it seems like any of the other statues; the camera revolves around the sculpture – slowly, tenderly, cautiously, charting the exquisite three-dimensional turn. Then something magical happens. Even as we look at it, Myron's *Discobolos* melts into Aryan flesh and blood [**fig. 11**]. The mist clears, the gloom dissipates, and we breathe in – the *frische Luft* of modern-day Germany! Riefenstahl knew how to pull her audience's heart-strings: Nietzsche's dream had turned into reality.

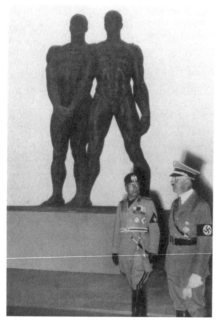

Fig. 12: Photograph of Hitler and Mussolini standing before Josef Thorak's *Kameradschaft* ('Camaraderie') in Munich's *Haus der Deutschen Kunst*, 1938. Thorak's muscle-men won him the affectionate title of 'Professor Thorax'. But this photograph also shows up the awkwardness of Nazi neoclassicism. With these two comrades standing shoulder-to-shoulder, and hand-in-hand (or should that be hand-in-groin?), 'mein Kampf' easily turns into 'mein camp': no wonder that the Führer and il Duce look so wary – just what might their own 'camaraderie' entail?

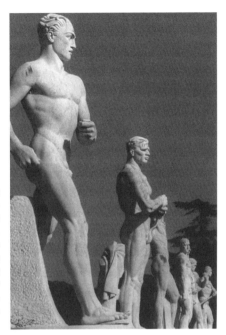

Fig. 13 (cf. **pl. 2**): Some of the Carraran marble sculpture surrounding the Stadio dei Marmi in Rome's Foro Italico, inaugurated in 1932. Each of these 60 pouting statues was associated with a particular province and sport. By no means everyone approved: fig-leaves were quickly appended to many of the statues in an attempt to appease the Roman Catholic Church.

Mussolini had lent this particular copy of the *Discobolos* to Berlin for the Olympics; he was subsequently 'persuaded' to sell it, despite the many protests in Italy. Although Fascist Italy defined its citizen body slightly differently from Nazi Germany – aspiring to the military might of Imperial Rome, not the Romantic relish of Aryan Hellenism – it placed no less emphasis on shaping up to Classical standards [**fig. 12**]. A state-sponsored programme of sports and athletics followed (the Opera Nazionale Balilla). 'Everyone agrees', wrote Lando Ferretti in his 1928 *Libro dello Sport*, 'that the Fascist education of youth into masculinity is one of the most urgent and fundamental aims of the Regime'.

As in Nazi Germany, Italian artists and architects materialised the fantasy. Take the Stadio dei Marmi in Rome's northwest Monte Mario region, designed by Enrico del Debbio in 1927 [**fig. 13**]: 60 marble statues adorn the perimeter of the sports field, framing the real-life athletes within. By running around the pitch – and wearing as little as possible – the Italian hunks could emulate the Classical chunks towering over them. *Viva Roma – e viva Italia!*

23

A passé past?

The ideologues of the 1930s and '40s have thankfully been displaced. But the Classical ideal remains very much with us. Whether we like it or not, Nietzsche's fantasy of becoming 'Greeks in our bodies' remains our fantasy today. This is why chiselled Classical torsos sell copies of 'manazines' and designer underwear, or why western politicians are so keen to strip down and show off their sporting credentials (Vladimir Putin bare-chested astride a horse, Nicolas Sarkozy in his lycras, David Cameron in his running shorts, etc.). It's also one reason why 'Venus' suggests itself as a name for a women's razor – indeed, why western women feel the need to shave in the first place (cf. p.86). Whether we worry about looking too fat or too thin, strive to slim down or bulk up, resolve to exercise more or eat less, our *modern* thinking has been conditioned by the *ancient*. We are married to antiquity – for better *and* for worse.

Precisely because of its enduring cultural grip, the Classical legacy has also been subject to artistic remonstration, especially in the late nineteenth and twentieth centuries. 'The beauties of the Parthenon, Venuses, nymphs, Narcissuses, are so many lies', spoke Pablo Picasso; 'art is not the canon of beauty, but what the instinct and brain can conceive beyond any canon: when we love a woman we don't start measuring her limbs.' One of the key moments came in 1909, when Filippo Tommaso Marinetti proclaimed a new 'age of Futurism' in the French newspaper, *Le Figaro*: 'a racing car is more beautiful than the Victory of Samothrace', and museums are 'cemeteries . . . absurd abattoirs of painters and sculptors ferociously slaughtering each other': 'we want to free this land from the smelly gangrene of professors, archaeologists, ciceroni and antiquarians'.

Movements like 'Surrealism', 'Fauvism', 'Expressionism', 'Dadaism', and 'Cubism' followed suit. From the perspective of the early twentieth century, being avant-garde meant emphatically *not* being ancient – or for that matter, 'Neoclassical', 'pre-Raphaelite', or 'Gothic'. The brave new world of modernism had little time for the old: the past had become *passé*.

Although modernism has a substantial prehistory in the nineteenth century, it was the end of World War Two that marked the most significant

watershed. Beckmann, Chagall, Dix, Grosz, Klee, Kirchner, Munch: these were among the numerous artists whom Hitler had condemned for their 'deformed cripples and cretins, women who look simply loathsome, men who resemble beasts, and children who, were they alive, would have to be regarded as cursed by God'. But everything changed with the Allied victory. If Marinetti had long been espousing that the Parthenon and its sculptures were 'the prison of futile wisdom' (as he did in his *Manifesto to the Young People of Greece* in 1930), the ugly truths of the Third Reich added new urgency to such modernist calls for a new beginning. The German Holocaust, and no less the American atomic bomb, had discredited traditional talk of aesthetic absolutes. Art had either to be very different, or else abandoned

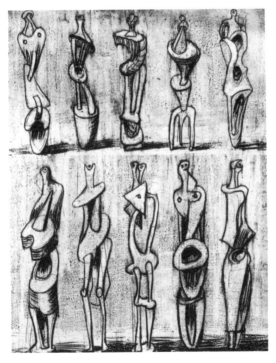

Fig. 14: Henry Moore, sketch in pastel and watercolour, c. 1950. For British sculptor Henry Moore (1898–1986), the art of the body had to recover its lost magisterial mystery: viewers must linger over the suggestive visual surface. The resulting images might *look* very different from the others in this chapter. But the quest to find a universal aesthetic standard in some sense aligns with the ideals of Renaissance Classicism.

altogether: 'after Auschwitz', wrote Theodor Adorno, 'all culture, including its urgent critique, is rubbish'.

The Classical body found itself at the centre of this postwar modernist project. As the British sculptor Henry Moore put it, Graeco-Roman modes, mediated through the Renaissance, had to be abandoned so as 'to start again from the beginnings of primitive art'. With the universalising dream of 'Vitruvian man' having seemingly turned totalitarian, artists were compelled to look elsewhere, above all to non-western artistic traditions: the guiding principle of western naturalism – sculpted bodies looking like real bodies – was knowingly and deliberately overhauled [**fig. 14**]. If humanity was to recover its lost innocence, renegade regressionism was required: 'it took me four years to paint like Raphael', goes the aphorism attributed to Pablo Picasso, 'but a lifetime to paint like a child'.

In some ways, this was a case of head over heart. Ironically, the very renunciation of the Classical legacy testifies to its continuing cultural importance: wilful rejection is still an acknowledgement of influence. At the same time, we should be wary of judging this a rejection of the Classical *tout court*: while Polyclitus and his fifth-century forms were out ('frigid', 'sterile', 'uncreative', according to Henry Moore), the 'great elemental simplicity' of third-millennium BC Greek Cycladic figurines (or for that matter sixth-century Greek kouroi [e.g. **fig. 17**]) was very much in. Something similar can be said for the Italian-Swiss sculptor Alberto Giacometti. With Classical forms tainted by Mussolini, Giacometti enthused over second-century Etruscan figurines from Northern Italy as an alternative aesthetic model: interest must lie not in the human form of the Classical tradition, as Giacometti put it, but rather in the 'shadow that it cast'.

If modernist artists tried to eradicate the Classical body – or at least strip it down to its bare essentials – their late twentieth-century 'postmodern' counterparts have attempted something different. Modernism might have put paid to the complacent imitation of the Greek and Roman. But there can be no denying the enduring grip of the ancient body over our western cultural psyche. Who goes to the gym to turn themselves into a Henry Moore?

Rather than attempt to undo the past, postmodernism has owned up to its enduring presence. The result, in the words of Italian critic Umberto Eco, is a playful mode of homage-cum-reassessment: 'the postmodern reply to the modern consists of recognising that the past, since it cannot be destroyed, because its destruction leads to silence, must be revisited: but with irony, not innocently'. Artists flirt with ancient models, all the while emphasising their fracture and facture: we end up with a sort of collage and pastiche.

The image of *Venice Reconstituted* reproduced on the frontispiece of this book nicely demonstrates the point. A series of pasts are merged into this single mural, overlooking Venice Beach near Santa Monica. We see the prototypical western 'female nude' made by the Greek sculptor Praxiteles [cf. **fig. 34**], filtered through the 'Medici' type of *Venus Pudica* [**fig. 29**], and presented after the manner of Botticelli's painting [**fig. 4**]. The resulting image is a reconstitution of Venus, as much as of Venice: through a series of overlapping transformations, the ancient goddess is converted into a modern-day Angelina – a roller-blading, bikini-bathing, beach-babe. In case we were to take this all too seriously, the speech bubble strikes a chord of cautious campery: isn't history just myth?

The body of the book

The *Venice Reconstituted* mural figures a thesis at the heart of this book: that the ancient art of the body remains with us – whether as ideal, antitype, or point of departure. Even in antiquity itself, we find artists looking back to past sculptural models, using them to make their viewers both laugh and think [e.g. **fig. 39**]. By the same logic, Salvador Dalí could transform the second-century Venus de Milo [**fig. 32**] into a surrealist, mink-pom-pom fantasy, inviting viewers to take the joke seriously [**fig. 15**]. Some seventy years later, Marc Quinn used the same ancient model to reaffirm and challenge our ideals of beauty [**fig. 16**]: erected on Trafalgar Square's fourth plinth between 2005 and 2007, Quinn's *Alison Lapper Pregnant* looks to the Venus de Milo in an effort to champion a wholly *non*-canonical image

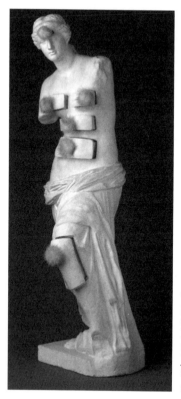

Fig. 15: Salvador Dalí, *Venus with Drawers*, 1936. Dalí turns a reduced-scale reproduction of the Venus de Milo [**fig. 32**] into surrealist paradox. Is the statue empty, or is it full? Does it embody a timeless secret, or a cast-away cliché? How does the body's 'chest' of drawers relate to the psychoanalytical drawer in the head? Just as the statue's surface is both hard and soft, its content is at once hollow and solid: it both *is* and *isn't* a joke . . .

of beauty (or indeed disability). Classical models have *always* served an array of aesthetic, social and political ends. And they can still be found even in the most unlikely-looking of places.

The present volume is very much written in the aftermath of this (post)-postmodern temperament. Like Rip Cronk's *Venice Reconstituted*, it responds to the challenges of retrospection. If we are to say anything meaningful about the ancient art of the body, or indeed the modern, the book argues, we have to face up to the multifaceted bonds that bind the two together.

It's for this reason that the following four chapters proceed thematically rather than chronologically. Most 'art histories' tell linear, sequential stories: they re-inscribe the variable of time, hoping thereby to re-historicise images. In doing so, they follow the lead of Johann Joachim Winckelmann

[**fig. 23**], whose 1764 *History of the Art of Antiquity* established a paradigm for ancient and modern art histories alike, giving 'art history' its name. By analysing the knotty ways in which ancient and modern images of the body are necessarily tied up each with the other, this book is rather different. Some will detect a residual Classicist historicism: the chapters do maintain a sort of chronological logic, moving from early Greek kouroi in the second chapter to the late antique materials of chapter five. But I've simultaneously sought to collapse history: antiquity and modernity are explored not as separate entities, but as poles that collude and collide. Not just 'ancients and moderns', then, but each *through*, *alongside* and *in relation to* the other.

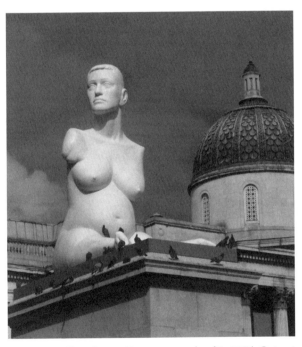

Fig. 16: Marc Quinn, *Alison Lapper Pregnant*, completed in 2004. Quinn is a 'Young British Artist' (YBA) celebrated for his innovative body images – his *Sphinx* and *Siren* statues of Kate Moss, for example, as well as his self-portrait from frozen blood. This 13-tonne statue of fellow-artist Alison Lapper, sculpted from gleaming Carraran marble, proves no exception: Lapper was born without arms and with shortened legs; here, though, that physical disability transforms her into a Classical goddess. The result is not just a Venus de Milo [**fig. 32**], but a Venus of modern-day London.

The following chapter returns to the history of art history. In particular, it explores how our conventional narratives of art's development are invested in the legacy of Greek naturalism – and nowhere more so than in our stories about the 'Greek Revolution' of the sixth to fifth centuries BC. As we shall see, the ancient fantasy of represented bodies looking like real bodies has directed not only what western art looks like, but also the histories that we have come to write about it.

If the second chapter concentrates on male bodies, the third turns to so-called 'female nudes'. On the one hand, it argues, our canonical western image of the female body, subject to the penetrating stare of men, is derived from ancient artistic convention – above all, Praxiteles' fourth-century BC statue of the Knidian Aphrodite [**fig. 34**]. On the other hand, the secular assumptions that modern viewers bring to such images mean that we look at them rather differently from our Greek and Roman counterparts. By re-examining the modern 'male gaze' through the lens of the ancient – and using the ancient to expose the modern – the chapter uncovers some essential similarities and differences between these 'ways of seeing' at large.

Like the words 'ancients' and 'antiquity', 'Graeco-Roman' is a term used throughout this book. To my mind, this is a question of intellectual honesty: so much of what we know about 'Greek' sculpture derives from 'Roman' texts and artefacts; by the same token, 'Roman' images of the body are inexorably bound up with the 'Greek'. The 'Greek' and 'Roman' therefore go together. Still, they are not the same. Chapter four tackles this issue in relation to the political portrait. Comparing ancient Roman appropriations of the Greek body with those of more modern political leaders, the chapter charts the essential difficulties of working within the Classical inheritance. In doing so, it lays bare what's particular about Roman figurations of the body, as compared to the modern, and indeed the earlier Greek.

Our fifth and final chapter hones in on images of the gods. The relationship between image and deity is a recurrent theme throughout this book – in relation to the 'Greek Revolution', for example, the appearance of the first 'female nude', or indeed the hallowed connotations of the unclothed portrait. In this final chapter, though, I turn to think about the

Christian inheritance of the pagan past specifically. As we shall see, the 'idolatrous' bodies of the Graeco-Roman gods provided both a paradigm and a problem for Judaeo-Christian theologians: the various attempts to square the Classical with the Christian, I argue, have directed the entire course of western art ever since.

The following chapters are necessarily selective. There are conspicuous absences in both material and subjects. By choosing to concentrate not just on sculpture, but on free-standing sculpture in particular, I've downplayed a number of other representative forms – painting, relief sculpture, and grave and honorific monuments among them. I've also had to cut short huge thematic topics: desire and homoeroticism; images of 'Others' and 'Orientals'; attitudes towards the suffering body; hybrid bodies and the idea of the monstrous; figurations of the dead. Sometimes this has been deliberate: there are other books in this *Ancients and Moderns* series that deal with certain subjects in much greater detail (e.g. Daniel Orrells on sexuality, Brooke Holmes on gender, Paul Christesen on sport, Caroline Petit on medicine, Denise McCoskey on race – to name but a few). Mostly, though, these decisions have to do with the pressures of space and illustration. Needless to say, there is much more to be said.

The structure of this book is decidedly idiosyncratic (some will say idiotic). But my foremost aim has been to guide readers through the questions, not to deliver all the answers, which I for one don't have. The result articulates both a method and a position. For if we only strip down our familiarity with, and investment in the 'Classical nude', this material can illuminate numerous aspects of ancient thought and practice; true to the best traditions of cultural history, moreover, it sheds light on the peculiarities of our own modern mindsets.

CHAPTER II

FIGURING WHAT COMES NATURALLY? WRITING THE 'ART HISTORY' OF THE BODY

We began the last chapter with a recognisably 'western' image [**fig. 1**]. One of the things that made this sculpted body so recognisable, it was said, was what we called its 'naturalistic' appearance. What's more, we related this modern representational mode to ancient traditions of figuring the human body (pp.1–7).

But Graeco-Roman images didn't always look like this. The features which modern western viewers recognise and admire in ancient art emerged only gradually. Earlier Greek images of the body, whether in the sculpted round [**fig. 17**], or on painted pottery [**fig. 22**], appear very different from the sorts of images that we normally associate with the 'Classical' or 'Graeco-Roman'. How, then, should this stylistic shift be explained: where, when and why did it become an objective to make images that seem believable and lifelike?

These are the questions which the present chapter sets out to explore. I should say from the outset that my aim isn't simply to 'answer' them. Because this is a book about both ancients *and* moderns, I'm as much concerned with the legacy of (what we call) naturalism as with its Graeco-Roman development. My objective in this chapter is therefore historiographical rather than simply historical: to pose some larger questions about *how* we moderns have conventionally figured the history of ancient art. The point is important because it's all too easy to overlook: that the stories we tell

about ancient images are ideologically invested in our modernity; by extension, that the stories we tell about modern figurative art are themselves forged out of our histories of the ancient.

A 'Greek Revolution'

All manner of 'textbook' case studies might be introduced here. I've chosen to concentrate on arguably the most familiar: Ernst Gombrich's *Story of Art*, first published in 1950. Whether Gombrich's blockbuster is the best single-volume introduction to western image-making is open to debate. But this volume – with its self-confessed rationale of imposing 'some intelligible order into the wealth of names, periods and styles' – has certainly proved the most popular. Little could Gombrich have known in 1950 just how popular it would become. Sixty years (and some seven million copies) later, the *Story of Art* appears in its sixteenth English edition, available in some thirty or so translations.

Gombrich's combined interest in ancient and modern psychology makes for a particularly appropriate case study in this chapter. Why is it, he asked, that western artists set out to craft images that mirror the real world around us? For Gombrich, this phenomenon could only be explained in Graeco-Roman terms. A variety of phrases were devised to describe the phenomenon: the 'Greek Miracle', 'Pygmalion's Power', the 'Great Awakening'; the Greek 'discovery' of naturalism evidently had something of the fairy-tale about it – 'Sleeping Beauty', as it were. Still, there could be no mistaking the momentous importance of these Greek developments. The fourth chapter of Gombrich's *Art and Illusion* (first published a little later in 1959) drives home the point. The 'Great Awakening', writes Gombrich, was nothing less than a 'Greek Revolution': by stirring art from its primeval slumber, Greek artists established our western regimes of both the image and imagination.

Gombrich did more than any other twentieth-century historian to popularise a certain narrative of ancient art history. The story revolves around a type of monumental sculpture that modern critics have come to call kouroi (the plural of the Greek noun *kouros* – literally a 'male youth').

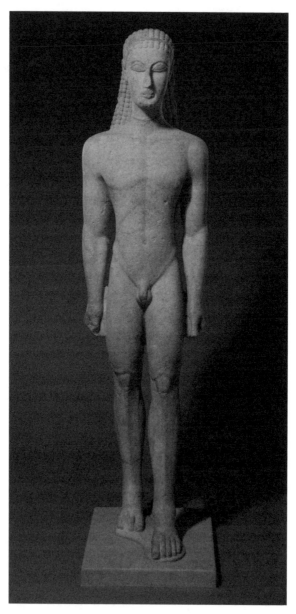

Fig. 17: 'New York kouros', first quarter of the sixth century BC. The kouros stands at a (for us) roughly life-size 1.84 metres (6 feet). Its figure, though, is structured around a series of non-lifelike rhythmical patterns: the belly-button (*omphalos*) is carved at the centre, and a series of diamond-ridges ripple out from it – at once down to the groin, and up to the ribcage. This ornamentation is mirrored in all manner of other 'anatomical' details – knees, elbows, even the central tie of the choker.

Rendered in monumental materials like marble and limestone, kouroi became an ever more conspicuous feature of sixth-century BC life. They evidently served a miscellany of purposes: some functioned as statues of the gods; others were dedicated as votive offerings; others still, especially around Athens, were erected as funerary commemorations. 'Stand and mourn at the *sema* of dead Croesus, whom raging Ares slew in the front line', as one inscription reads, attached to the so-called Anavyssos kouros (erected c. 540 BC). In Attica – i.e. the area near Athens – funerary kouroi were explicitly figured as *semata*: they did duty not just as 'tombs', but as 'signs', 'markers', and 'tokens'.

Despite their varying functions, kouroi adhered to a recognisable formal pattern [**figs. 17–21**]. While different regions adapted the blueprint to suit their own geographical tastes, and although, as we shall see, details change over time – proportions, facial expression, hair, etc. – the kouros' essential pose remained more or less the same: the figure steps forwards with the left leg, holding both hands by the sides, and distributing his weight equally. From the late seventh to the early fifth centuries, the kouros embodied a more or less symmetrical idea of balance, poise, and equilibrium. To encounter this statue was to engage (and be engaged in) the direct frontal gaze of the sculpted subject.

Where does this statue type come from? As Gombrich rightly explains, the ultimate inspiration seems to have been Egyptian. In practical terms, such cultural interaction is relatively easy to explain. The eighth century saw increasing contact between the Greek Mediterranean and the east – so much so, in fact, that the period from the mid-eighth to mid-seventh centuries has come to be labelled 'Orientalising', after the eastern appearance of so much contemporary Greek imagery. The Aegean island of Samos was one prominent place of intercultural traffic, not far from the coast of modern-day Turkey. The small Cycladic island of Delos likewise attracted a multicultural array of pilgrims: it's surely no coincidence that one of the earliest monumental Greek figurative sculptures known to us, inscribed as an offering from a certain 'Nikandre', was dedicated on Delos in the middle of the seventh century.

Entrepreneurial Greek merchants were quick to capitalise on such cultural interchange. Some even set up their home in Egypt. We know of at least one certified Greek colony situated not in the area around Greece, Turkey or Southern Italy, but rather in the Upper Nile Delta – albeit within easy reach of the Mediterranean Sea. The residents of Naukratis adopted a Greek name to define their 'power' (*kratos*) of or over 'ships' (*naus*); one Greek historian tells that Amasis II (Pharaoh 570–526 BC) officially handed over the colony to Greek settlers (Herodotus, 2.178). Still, there could be no denying Naucratis' Egyptian context, located some hundred miles north-west of Cairo. By the sixth century, imports and exports between Greece and Egypt were evidently turning into big business.

This two-way exchange of goods went hand-in-hand with a bartering of ideas. 'The Greek masters', declares Gombrich, 'went to school with the Egyptians.' Ancient writers were not unaware of the debt. One first-century BC author even explains how the proportions of early Greek sculpture derived from Egyptian canons of proportion. According to Diodorus Siculus, a Greek historian working in first-century BC Rome, a pair of artists named Telekles and Theodoros used the Egyptian scheme to practical advantage. Collaborating on a statue set up in Samos, the two brothers were able to finish the statue despite working miles apart: Telekles made one half of it in Samos, while Theodoros made the other half in Ephesus. 'When the parts were joined together, the whole work so fitted together as to have the appearance of having been made by one man' (*Library*, 1.98.6–9):

> This kind of work is not practised among the Greeks, but among the Egyptians it has been especially perfected. For with them the symmetrical proportions of statues are not judged according to what appears to the eye [*kata tēn horasin phantasias*], as they are with the Greeks; rather, when the Egyptians lay out their stones, they divide them up and set to work on them – and it's only at that stage when they determine the modular proportions [*to analogon*], from the smallest to the biggest. They divide the layout of the body as a whole into twenty-one parts plus a quarter, and in this way they attribute the figure with

its overarching system of proportional symmetry. Whenever the craftsmen agree an absolute size with one another, they then work separately and harmonise the respective sizes of their works. So accurately [*akribōs*] do they do so that the peculiarity [*tēn idiotēta*] of this practice causes amazement. Made in accordance with this ingenious Egyptian technique, the wooden statue [*xoanon*] on Samos was split into two parts, divided down the middle from the crown of the head to the genitals. And yet the two sides matched exactly at every point, each part mirroring the other. They say that this Samian work is – at least for the most part – comparable to those of the Egyptians, in that the hands are stretched down by the sides, and because of the outstretched legs.

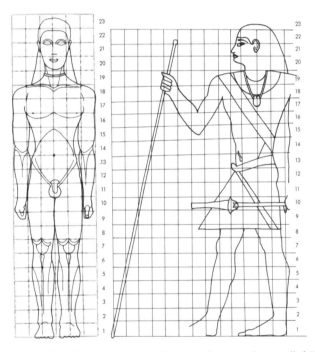

Fig. 18: The 'New York kouros', shown in schematic relation to the so-called 'Second Egyptian canon' (after c. 680 BC). The artist has evidently adapted as well as adopted Egyptian models. The kouros, for example, adheres to the vertical dimensions of the canon more strictly than the horizontal: perhaps this explains the chubby breadth of the face in relation to the lithe waist.

Whatever the truth of Diodorus' story, we can be sure that some sculptors really did base their kouroi on Egyptian canonical schemes, at least by the early sixth century. One of the earliest kouroi known to us – originally from the area around Athens, but now displayed in the New York Metropolitan Museum of Art – subscribes to precisely this sort of system [**fig. 17**]. If the distance from the soles of the feet to the eyes is divided into 23 squares of equal size, the knees occupy the seventh square, the navel fills the thirteenth, and the breast aligns with the sixteenth square [**fig. 18**]; by the same logic, the eyes of both statues occupy the line between the 21st and 22nd grids. As Diodorus notes, the result looks decidedly foreign to western eyes. Even in the first century BC, the naturalistic appearance of Greek art is seen to distinguish it from the peculiarity (*tēn idiotēta*) of eastern schematic forms: unlike the Greek, Egyptian images of the body are 'not judged according to what appears to the eye'.

For all the similarities, there are also conspicuous differences between the earliest Greek kouroi and their contemporary Egyptian counterparts. In terms of attributes, the Egyptian figures wear loincloths, whereas Greek kouroi are almost always unclothed: the New York example [**fig. 17**] has a band in his hair and a choker around his neck, but the kouros is otherwise stark naked (as we shall see in the following chapter, the situation with contemporary Attic sculptures of women – so-called korai – was notably different [**fig. 35**]). More striking from a technological point of view are Greek attempts to isolate the different parts of the body from the solid block of stone. Whereas Egyptian sculptors favoured granite, Greek monumental sculpture tended towards locally quarried materials like limestone and marble. Compared to Egyptian granite, these Greek materials were more easily workable and required less structural support: artists consequently strove to delimit the space between the legs, the hollow between the arms and the trunk, and the gaps between the fingers. Such features were an additional labour (and cost), and added further fragility to an already perilous enterprise. One miscalculated move, and months (indeed years) of labour might be wasted: numerous half-carved kouroi lie abandoned *in situ* within the marble quarries of the Greek Cycladic islands.

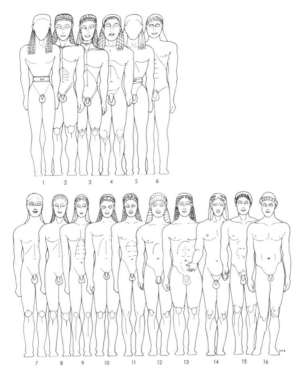

Fig. 19: Supposed 'evolution' of kouroi statues from the late seventh to early fifth centuries BC. The supposed 'Greek Miracle' in action: we're dealing with the evolution if not of man, at least of the kouros type. But what's at stake in the stories we tell of such artistic 'progress'?

For Gombrich, these differences took on an ideological importance all of their own. If Greek artists *adopted* Egyptian forms, they also *adapted* them. 'Not content to follow any formula, however good,' to quote Gombrich, the Greek artist 'began experimenting for himself.'

The point is fundamental to Gombrich's *Story of Art*: Greek art embarked on a journey of 'making and matching'. Comparing their own images of the body to empirical reality, sixth-century sculptors set western art on its course to verisimilitude:

It was no longer a question of learning a ready-made formula for representing the human body. Every Greek sculptor wanted to know

how *he* was to represent a particular body. The Egyptians had based their art on knowledge. The Greeks began to use their eyes. Once this revolution had begun there was no stopping it. The sculptors in their workshops tried out new ideas and new ways of representing the human figure, and each innovation was eagerly taken up by others who added their own discoveries . . . They had set out on a road on which there was no turning back.

Gombrich was certainly not the first to chart the history of Greek art around this supposed objective. Already in 1942, Gisela Richter had published the first edition of her detailed catalogue of kouroi sculptures, assigning relative dates on the basis of their lifelikeness and anatomical correctness: 'progression along naturalistic lines occupied sculptors throughout the Greek world', as Richter writes; and unlike the Egyptians and Mesopotamians from whom they initially learnt, 'the Greeks were a people full of curiosity'. Gombrich's narrative of Greek art might have resonated with those of numerous others. But Gombrich brought the account to the attention of the widest possible public, embedding it within a larger history of western image-making.

For Gombrich, as for Richter, the story of this artistic *revolution* is therefore a story of progressive stylistic *evolution*. **Fig. 19** (adapted from a recent textbook on Greek sculpture) nicely captures the sentiment: the diagram shows how the kouros is assumed to advance from two dimensions to three, from surface to volume, and from symmetrical pattern to studied anatomy. It's a metamorphosis from Egyptianising statues like the one in New York [**fig. 17**, reproduced as number 3 in **fig. 19**], through various adjustments to musculature and attributes (note the so-called 'Archaic smile' of the kouroi in the middle), and finally to experimentations in stance and pose (the bronze 'Piraeus Apollo' with its outstretched arms, for example, presented here as number 14). The penultimate kouros in this series, known as Aristodikos after its inscribed funerary base, embodies the overarching evolutionary thrust [**fig. 20**]: notice the shortened hair of the head, patterned pubic hair, carefully modelled torso, and freestanding arms, tentatively supported with additional struts.

So ravenous was the Greek appetite for artistic animation, we are told, that it could no longer be sustained by the kouros form. The Aristodikos kouros already highlights the limitations of the scheme. But it's a slightly later statue, produced in Athens c. 480 BC, that's usually billed as the cover-boy for the 'Greek Revolution' [**fig. 21**]. Measuring a mere 1.17 metres, and named (on spurious evidence) after an Athenian artist known from later literary sources, the 'Critian Boy' occupies the conventional boundary between the so-called 'Archaic' art of the sixth century and the 'Classical' art of the fifth and fourth. On the one hand, this statue looks back to the kouroi of the previous century: the arms are still held by the side, and the statue stands with one leg in front of the other. But the schema of the legs

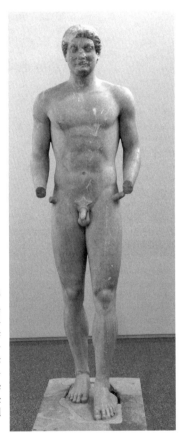

Fig. 20 (cf. **pl. 3**): Inscribed 'Aristodikos' kouros from Attica, c. 510 BC. Stylistically speaking, this statue looks both backwards [**fig. 17**] and forwards [**fig. 21**]. Notice, though, how the body remains a site for patterned embellishment. Most conspicuous is the star-shaped pubic hair above the penis: the detail both accentuates erotic desirability (the statue as believable stand-in), and emphasises the geometric ornamentation (the statue as abstract symbol or *sēma*).

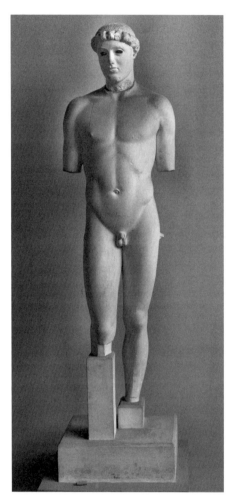

Fig. 21: 'Critian Boy' from Athens, c. 480 BC. This sub-lifesize statue (1.17 metres or 3 feet 10 inches), wrote Sir Kenneth Clark, is 'the first beautiful nude in art': 'here for the first time we feel the passionate pleasure in the human body which is familiar to all readers of Greek literature' (*The Nude*: 2nd edition; London, 1960; p.29).

has been reversed, so that the right leg is advanced rather than the left. Perhaps most significantly of all, the movement of the lower body is made to engage the torso above: the left hip is raised considerably higher than the right, laying the way for the celebrated *contrapposto* of Polyclitus and others a little later in the century [**fig. 2**]. The slight twist of the head crowns the overarching effect: the direct frontal gaze between viewing subject and viewed object has been broken.

Unlike so many Classical archaeologists, predisposed to treat the

inventions of Archaic sculpture separately from those of Archaic painting, Gombrich's story of the Archaic and Classical cuts across different media. For Gombrich, the sorts of developments witnessed in three-dimensional kouroi are clearly related to those in two-dimensional painting. Indeed, the durability of painted pottery, compared with the perishable statuary materials like wood, means that we can trace the development of figurative painting even more decisively than we can in other media.

Few would deny the essentials of Gombrich's story about 'Geometric' painting in Athens. Almost every account of early Greek art paints the same picture: 'Protogeometric' pots begin with circular outlines and continuous bands; the ninth century witnesses the proliferation of figurative forms (horses, deer, birds); by the 'Late Geometric' period of the eighth century, we duly find vases decorated with recognisable human figures – triangular torsos, a schematic rendering of the face, and frequently some articulation of gender. Eventually we end up with the familiar forms first of Attic black-figure pottery (figures painted onto the pot, but with their details scratched out), and then finally, from the last quarter of the sixth century, the inverted world of red-figure vase-painting (the background now swathed in black, the figures left unpainted, and the figurative details sketched on rather than scraped off: e.g. **figs. 25, 61**).

Fig. 22 testifies to one key transitional moment in the middle of the eighth century (i.e. some 150 years before the 'New York kouros'). This so-called 'Dipylon krater' is named after its archaeological provenance in a cemetery near the 'two-gated' Dipylon entrance to Athens. The burial context sheds light on the various scenes depicted. In the upper band, we see a group of mourners framing a central corpse laid out prior to burial (*prothesis* was the later Greek term); in the lower frieze are various warriors, some standing astride horse-drawn chariots. In one sense, these figures are a mere extension of the geometric designs above and below: they are arranged in symmetrical horizontal bands, each comprising a repeated series of patterned motifs. In both bands, though, the painter has employed a series of schematic and abstract pictorial devices: notice how a chequered shroud is laid quite literally over the reclining corpse;

Fig. 22: 'Dipylon krater' from Athens, c. 750 BC. Large-scale vessels like this were placed on top of Athenian graves – with krater shapes apparently preferred for male burials, and amphorae for female. Holes were frequently knocked through the base, allowing libations to be poured directly to the dead.

44

or compare how the horses in the frieze below are conveyed one in front of the other. It's as though viewers were meant to count the heads of the horse – one, two, three – and then count the twelve linear legs that correspond below.

To our eyes, such images can seem simple, even 'childlike'. But it would be wrong to dismiss **fig. 22** as naïve. True to the remit of any satisfying funeral, the picture privileges the pattern over the specifics: the particular has been subjugated to the ritualised conventions. But another force is also at work. Already in the eighth century, we see how Greek painters were manipulating painted space to summon up a world of pictorial fantasy. The image is designed to *engage* viewers, inviting them to pose questions of what they see: how do we suppose these figures relate to one another, both within each band, and indeed between them? The painted images gesture towards narrative, in other words, while leaving viewers free to choose their own individual adventure. It's a game of look and tell, but without a *definitive* story in sight: does the lower frieze explain how the deceased died, re-enact some sort of funerary procession, or depict what lies in store for the reclining corpse (and for all of us?) in a heroic afterlife beyond?

In the fourth chapter of his *Art of Illusion*, Gombrich turns the point into a grander argument about the 'Greek Revolution' at large: for Gombrich, the invention of western naturalism has to do with the invention of western narrative itself. Gombrich assumes (by no means unproblematically!) that Greek poets – unlike those in Egypt and the Near East – concerned themselves with not just *what* a mythical story conveys, but also *how* it unfolds. Read Homer's *Iliad* or *Odyssey*, and we find all the things which define western story-telling against its 'Oriental' antecedents – plausibility, character development, suspense, direct speech, empathy, etc. 'When classical sculptors and painters discovered the character of Greek narration, they set up a chain reaction which transformed the methods of representing the human body.' Foreshortening, linear perspective, anatomical detail: Greek epic encouraged painters to portray not just *what* things are, but also *how* they look. The rest, as they say, is history.

The *Story of Art* and the history of art history

The decision to label this a 'Greek Revolution' was not accidental. For Gombrich, Greek naturalism did not only present a radical new aesthetic. That aesthetic was itself radically politicised.

Story-telling therefore forms only part of Gombrich's explanation for the 'Great Awakening'. Greek narrative might be a long-term cause. But it was thanks to the social and cultural enfranchisement of Greek artists that art realised its revolutionary vision. As Gombrich knew full well, Athenian democracy was said to have been founded when the 'Greek Revolution' was nearing its height: in 507/506 BC, Cleisthenes implemented a set of political reforms that paved the way for democracy, just as kouroi were breaking free from their schema, and just as the so-called 'Pioneers' of red-figure Attic vase-painting were proving their most pioneering. In the Greek world, writes Gombrich, 'there was no divine ruler . . . who could or would have forced a whole people to slave for him'. 'It was at the time when Athenian democracy had reached its highest level that Greek art came to the summit of its development': the Parthenon marbles are duly said to 'reflect this new freedom perhaps in the most wonderful way' [**fig. 59**].

Readers may or may not agree. Even if we herald the end of the sixth century as the 'dawn of democracy', Gombrich's explanation hardly makes sense of the conspicuous changes in the century before. Although we might know more about Athens than any other Greek city-state, moreover, it's emphatically not the case that Athenian political innovations held true for Greece as a whole: one need only remember how Polyclitus hailed not from Athens, but from Argos in the Peloponnese (never quite the radical democracy of fifth-century Athens [cf. **fig. 2**]).

It's very easy to play the spoil-sport. But it's also easy to see why Gombrich's particular 'story' appealed in 1950. For an Austrian émigré working in London – in the immediate aftermath of World War Two, and with Russian–American relations freezing into Cold War – art must have seemed more political than ever. No wonder, too, that Gombrich wanted Classicism to embody something very different from the ideologues of the 1930s and

'40s: not for him those bulky bullies of Breker and Thorak [**fig. 12**]. Gombrich's comments about pictorial narrative should be understood in similar light. His particular account of Greek art delivers a knowing rejoinder to those contemporary critics who were pushing for a 'pure' sort of modernist media in the 1940s: given his own first-hand experience of Third Reich propaganda, Gombrich must have seen things rather differently from Clement Greenberg, who famously proscribed that the picture should 'exhaust itself in the visual sensation it produces'; 'narrative' was one effective way of combating Greenberg's idea that pictures should have 'nothing to identify, connect or think about, but everything to feel'. The *Story of Art*, in short, had an immediate latter-day context: a series of modern ideologies were at stake in this story of antiquity.

But it's not just *how* Gombrich explains the 'Greek Revolution' that's been influenced by the latter day. A series of modern ideological assumptions also governed *what* history Gombrich chooses to tell. This is the issue that I explore in the remainder of this chapter: as we shall see, the supposed course of modern image-making – in particular, the recovery of naturalistic representation – has directed our accounts of ancient art; by the same token, we have allowed our histories of the ancient to direct the stories told of the modern.

For Gombrich, as for almost every other art historian, it's the Renaissance that's judged to hold the secret. The ancient 'discovery' of naturalism is assumed to mirror a parallel process during the thirteenth to sixteenth centuries: the 'Greek Revolution' prefigures the Renaissance revolutions in the art, culture and politics of late-Mediaeval Europe. Observe, for example, how Gombrich introduces the transition from the 'archaic' Middle Ages to the 'classical' Renaissance:

> The public which looked at the artist's works began to judge them by the skill with which nature was portrayed, and by the wealth of attractive details which the artist managed to bring into his pictures. The artists, however, wanted to go one better. They were no longer content with the newly acquired mastery of painting such details as

flowers or animals from nature; they wanted to explore the laws of vision, and to acquire sufficient knowledge of the human body to build it up in their statues and pictures as the Greeks had done. Once their interest took this turn, medieval art was really at an end. We come to the period usually known as the Renaissance.

Renaissance artists are said to do just as 'the Greeks had done': they resurrected the *same* attitudes as those that had prevailed in the Classical heyday of fifth-century Greece. The stories of the ancient and modern are presented as parallel narratives of progressive evolution, oriented towards the same end of artistic naturalism.

This parallelism is not particular to Gombrich's account alone. It's a story written into the very fabric of 'art history' as a discipline, steeped in the cultural reception of the Italian Renaissance. Exactly four hundred years before the publication of Gombrich's *Story of Art,* the first systematic survey of Renaissance image-making wove its narrative around a similar set of assumptions. When Giorgio Vasari published the first Italian edition of his *Lives of the Most Excellent Painters, Sculptors and Architects* in 1550, the story he told about the Renaissance's 'rebirth' of antiquity was deliberately modelled on an assumed history of the ancient. Vasari looked to one ancient text in particular: Pliny the Elder's *Natural History*, written in the AD 70s. Unlike Vasari, Pliny had touched upon artistic production only tangentially. Concerned with natural resources in their widest sense, and treating representational media only in its final five (of 37) books, the *Natural History* is a far cry from the sorts of 'art history' that we practise today. But Pliny was also interested in the different innovations introduced by different craftsmen (e.g. *Natural History*, 35.53–148). What's more, Pliny structured his analysis around the primacy of natural appearances: artistic progress equates to the progressive ways in which ancient artists mimicked nature. It's here that Pliny's influence lies. Following in Pliny's footsteps, Vasari's *Lives* also judged art's highest goal to be naturalistic simulation.

For Vasari, the story of modern image-making was necessarily bound up with the ancient. The very name used to delineate the 'modern' confirmed

as much: in order to count as a 'Rinascimento' ('rebirth'), didn't the trajectory of Renaissance painting, sculpture and architecture have to replay that of Graeco-Roman antiquity? Just as Pliny the Elder's *Natural History* charts a series of individual artistic modifications, Vasari explains the history of Renaissance art around the progressive imitation of nature – from the likes of Cimabue, Giotto, Simone Martini, and Duccio to Michelangelo, Titian, and indeed Vasari himself. The result of his labours, writes Vasari, would be to the benefit of his fellow artists:

> Once they have seen how art reached the summit of perfection after such humble beginnings, and how it had fallen into complete ruin from such a noble height (and consequently how the nature of this art resembles that of the others, which, like human bodies, are born, grow up, become old, and die), they will now be able to recognise more easily the progress of art's rebirth and the state of perfection to which it has again ascended in our own times.

Posing as the Renaissance's answer to Pliny, Vasari figures artistic progress in organic terms, attributing it with a birth, adolescence, maturity, and death: the art of the body becomes an embodied entity in its own right. While recycling Pliny's artistic cycle, then, Vasari also delivers a narrative of *regressive* evolution. The history of modern art in the fifteenth and sixteenth centuries becomes a reverse-step march away from Gothic abstraction, back towards the naturalistic standards of Graeco-Roman antiquity.

Like Pliny before him, Vasari certainly prefigured aspects of Gombrich's narrative. But neither Pliny nor Vasari tells a *story* of art in the way that Gombrich does: Pliny offers a technological taxonomy of natural resources, while Vasari chronicles the lives of different artists and their different *maniere*. By offering a *history* of art per se, and one that unfolds over time, Gombrich's chronological account is markedly different. In this sense, Gombrich's foremost debt is not to Pliny nor to Vasari. Rather to the first self-styled *historian* of art: Johann Joachim Winckelmann [**fig. 23**].

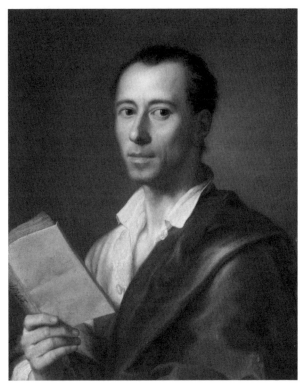

Fig. 23: Anton Raphael Mengs, *Portrait of Johann Joachim Winckelmann*, c. 1755. Many think that it was his homoerotic interests which first attracted Winckelmann to the sculpted male bodies of Greek antiquity – that Winckelmann was not just the founding father of 'art history', but also its founding 'queen'. What's most striking about Winckelmann's descriptions, though, is their abstraction rather than their sensuousness. Mengs (to whom the 1764 *Geschichte* is dedicated) captures his friend's high-brow aspirations in this portrait: Winckelmann is shown reading Homer's *Iliad*.

Trained first and foremost as a Classical philologist, and working in Rome in the 1750s, Winckelmann knew both his Pliny and his Vasari. Winckelmann's various labours culminated in his *Geschichte der Kunst des Alterthums* – a 'History of the Art of Antiquity' – published in German in 1764. Winckelmann came up with a new mode of structuring his account: 'art' (*Kunst*) was his self-contained subject, and the task Winckelmann set himself was to chart its chronological 'history' (*Geschichte*).

Drawing his inspiration from the supposed evolution of Greek literature,

Winckelmann classified its material into four chronological periods. First there was an austere 'older' phase (*der ältere Stil*), defined in relation to the second, 'high' phase (*der hohe Stil*), when artists first 'drew nearer to the truth of nature – [when] they were taught to throw aside, for flowing outlines, the hardness of the older style'. This 'high' period was in turn followed by a third 'beautiful' phase (*der schöne Stil*), associated with the likes of Praxiteles in the fourth century BC. Finally there was the 'style of the imitators' (*der Stil der Nachahmer*): having reached its peak, Greek art goes quite literally over-the-top in its 'baroque' decadence. Winckelmann associated this last phase with the conquests of Alexander the Great at the end of the fourth century BC, a period known since the nineteenth century as the 'Hellenistic': for Winckelmann, as for Gombrich, good art required free artists – 'art, which received its life, as it were, from freedom, must necessarily decline and fall with the loss of freedom'.

As its title suggests, Winckelmann's account is concerned with the history of ancient art, not modern. And yet what's most remarkable about Winckelmann's *Geschichte* is its sustained recourse to the latter-day. Just like Gombrich, or indeed Vasari before him, Winckelmann premises his history of the old on an interpretation of the new. Indeed, his four categories of the 'older', 'high', 'beautiful', and 'imitatory' phases overtly prefigure the stylistic changes of the Mediaeval, Renaissance, Late Renaissance and Baroque. 'The fate of art in general in more recent times is, with regard to periods, like that of antiquity', as Winckelmann puts it; 'there are likewise four major changes.'

Winckelmann is explicit in his thinking: each of the four periods of Greek art is introduced in relation to its supposed modern counterpart. As we have said, Vasari's *Lives* told that the likes of Cimabue, Giotto, and Duccio overthrew the schematic abstractions of the Byzantine east; in similar vein, Winckelmann describes how early Greek artists threw off their Oriental heritage. 'The characteristics of this more ancient style also prepared the way for the high style of art and guided it to strict accuracy and high expression – for in the hardness of the former style, the precisely described contour and the certainty of knowledge whereby everything is laid bare to

the eye become manifest.' Think, Winckelmann continues, of the art before Michelangelo and Raphael – 'these two men [who] were responsible for restoring art to its heights'.

The 'older' style, then, leads in turn to the 'high' phase of ancient art, with its celebrated qualities of 'noble simplicity and quiet grandeur' (*edle Einfalt und stille Größe*). The clearest explanation as to why this art is 'high' – and how it relates to the Renaissance – came in a short 1755 treatise, namely his 'Reflections on the imitation of Greek works in painting and sculpture' (*Gedanken über die Nachahmung der griechischen Werke in der Malerei und Bildhauerkunst*):

> This noble simplicity and quiet grandeur is also the truest charac-teristic mark of the best and maturest Greek writings, of the epoch and school of Socrates. Possessed of these qualities Raphael became eminently great, and he owed them to the ancients.

According to Winckelmann, the art of the modern Italian Renaissance reincarnates the 'high' period of the ancient, reflected in Raphael's paint-ings on the one hand, and Michelangelo's sculptures on the other: Raphael is deemed responsible for the 'discovery of the true character of the ancients'; and Michelangelo is presented as the 'Pheidias of latter times', whose sculpted bodies alone, 'perhaps, may be said to have attained the antique'. Winckelmann even fantasises about how Italian artists gained access to the 'high' Greek, rather than later (*viz.* 'inferior', 'derivative', 'second-rate') copies from Roman Italy: 'we know that [Raphael] sent young artists to Greece, to copy there, for his use, the remains of antiquity'.

The same comparative logic informs the two later periods of Winckelmann's *Geschichte*. The 'beautiful' styles of the fourth century, Winckelmann explains, 'have the same relation to their predecessors as among the moderns Guido [Reni] has to Raphael'. Finally comes the ancient 'style of the imitations': Winckelmann's disdain for such *Kunst* is prefaced by his modern-day invective against the baroque and rococo. Contemporary art must take its inspiration from the 'high' Greek (and Renaissance): 'there

is but one way for the moderns to become great, and perhaps unequalled; I mean, by imitating the ancients.' Winckelmann's history of ancient art is not only bound up with the Renaissance: it is also implicated within his aesthetic aspirations for the present-day, as indeed for the future.

The burden of the Renaissance

Gombrich was one of the last great art historians to come clean about this assumed parallel trajectory between the ancient and the modern. Inspect almost any textbook on Graeco-Roman art, though, and you'll find a remark-ably similar account. Following the essential scheme of Winckelmann's *Geschichte*, Classical archaeologists almost always discuss ancient art according to its supposed 'Archaic', 'Classical', and 'Hellenistic' history (with 'Classical' sometimes divided into the 'High Classical' of the fifth century and the 'Late Classical' of the fourth). The ancient art of the body is assumed to have progressed in the same way between the 'Archaic' and 'Classical' periods as the modern did between the Mediaeval and Renaissance; by the same token, our very language of discussing the later art of the 'Hellenistic' age is founded on a supposed assimilation with the 'Baroque', 'Rococo', and 'Mannerist' styles of the late sixteenth to eighteenth centuries.

Only rarely has this narrative been called into question. Of course, some will no doubt think that the Renaissance really *is* a useful comparandum for thinking about the 'Greek Revolution'. So embedded is this story of art, that it takes a seismic effort to think otherwise – that the two 'Great Awakenings' might *not* be parallel after all. But the question I want to ask is what gets lost in the analogy: what might we overlook in collapsing the 'Classical' Greek into the 'classical' Renaissance, and the 'classical' Renaissance into the 'Classical' Greek?

In my view, fifteenth-century Italy is as much a hindrance as a help when thinking about the artistic developments of sixth-century Greece. The reason has to do with the teleological goal that we moderns ascribe to Archaic artists: swayed by Vasari and the story of Renaissance artistic progress, we assume that naturalism has *always* been an objective and empirical standard.

What's more, we think that naturalism serves as an objective yardstick for measuring artistic evolution over time: doesn't *all* art set out to replicate the material world around us? But to map progression in such terms is to impose a set of anachronistic standards back onto antiquity. The result, as one scholar (Richard Neer) nicely puts it, is 'a bit like suggesting that Columbus set out deliberately to discover the New World, and not a round-about way to the East Indies'.

To demonstrate what I mean here, take another look at the 'New York kouros' and 'Critian Boy' [**figs. 17, 21**]. We have already noted that there are conspicuous differences in appearance between these two statues: the one stares out at the viewer in full frontal mode (the body inscribed with a series of surface symmetrical patterns); the other has very clearly been moulded in the round (remember the twist of the hips and three-dimensional turn of the head). As Jaś Elsner has argued, there is a consequent difference in visual subjective response: 'in place of the participant observer, whose viewing fulfilled the work of art by creating a temporary bridge across worlds in Archaic art, the Classical generated its viewer as voyeur'.

But are we really dealing – as another scholar puts it – with 'the aban-donment of the archaic manner for a greater fidelity to natural appearance'? Such a 'novel and compelling' statue, writes Andrew Stewart, is to be understood 'like a breath of fresh air' that renders 'the kouros obsolete at a stroke, substituting for its automatonlike stride and blithe optimism a pause in action and a calculated introspection that immediately engages a whole world of contingencies, physical, psychological and religious':

> At last conscious of their surroundings, [such statues] seem to live, breathe and think, to consider alternatives which call for judgment and decision. Quietly musing before the gods, they invite us to join them in contemplation.

Such rhetoric of the Archaic-cum-Mediaeval merging into the Classical-cum-Renaissance smacks very clearly of Gombrich's 'Greek Revolution'. Had he been able to see such a 'High' period object in the flesh, no doubt

Winckelmann would also have approved. (In fact, Winckelmann never visited the Ottoman province of Greece: his 'history' is derived almost entirely from the 'Age of the Imitators' copies that were available in 1760s Rome, whereas the 'Critian Boy', like most Greek originals known to us, was discovered in the second half of the nineteenth century.)

But Stewart's story of Greek 'humanism' is not the only story that could be told of this ancient material. The assimilation of the Greek to the Renaissance assumes four things in particular: first, that there is a radical break between the early Archaic period and the 'revolutionary' images of the body that follow in its wake; second, that this is a shift away from abstraction towards naturalism; third, that the naturalistic is objectively superior to the abstract; and fourth, that the ancient 'Greek Revolution' initiated our own modern subjectivities of seeing. Each of these assumptions might be differently called into question. Each of them, moreover, revolves around ideologies of artistic simulation that are as modern as they are ancient.

When we see a statue like the 'Critian Boy', modern viewers see images replicating real-life appearances. Renaissance art (or rather our narrative of Renaissance art history) makes us think that naturalism is not only natural, but that it has always been art's objective. Our histories of the 'Archaic' Greek are subsequently filtered through this lens: the more accurately a statue imitates bodily appearances, the more advanced its attributed chronology [cf. **fig. 19**]. Dates are assigned accordingly – reinforcing the impression that this relative assumption holds absolute weight.

To contemplate what might get eclipsed in this story, consider once again Polyclitus' *Doryphoros* [**fig. 2**]. As we noted in the previous chapter, Polyclitus was said to have made the bronze sculpture in the middle of the fifth century – some 20 or 30 years later than the 'Critian Boy'. But the statue goes even further in its apparent naturalism. As numerous scholars have noted, the *Doryphoros* corresponds to the anatomy of the human body in various details – so much so, that some have suggested a close affiliation between sculptors and physicians in fifth-century Athens. According to this logic, the ancient sculptor morphs into 'Renaissance Man' – the prototypical polymath.

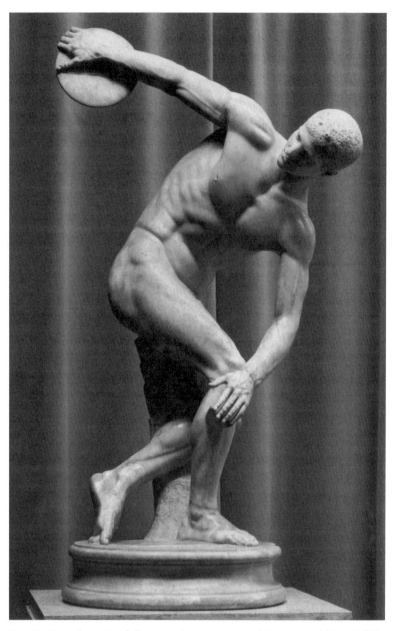

Fig. 24: 'Lancellotti *Discobolos*': second-century AD marble version of Myron's fifth-century BC bronze statue. 'What other work is as spinning and crafted [*distortum et elaboratum*] as the *Discobolos*?', asked Quintilian in the first century AD (*The Orator's Education*, 2.13.10). This is a marble re-interpretation of Myron's bronze statue – hence the added tree-stub, required to support the marble weight.

But modern crtics have sometimes homed in on anatomy at the expense of the *Doryphoros'* synthetic pose. True, the various muscular tensions and relaxations correspond in some ways to those of a real figure. This particular position, however, is an artificial construction: it brings together an assemblage of schematic parts, arranging them according to a physically impossible aesthetic of opposition. Quintilian recognised as much in the first century AD: that Polyclitus bestowed the human body with a form that went *beyond* the real (*supra uerum*: *The Orator's Education*, 12.10.8). The overall effect may look rather different from that of a sixth-century kouros. But to collapse these differences into a story of all-out representational revolution – to equate this 'revolution' with the supposed artistic shift from the Mediaeval to the Renaissance – would be to force assorted round pegs through one proverbial square hole.

The *Doryphoros* is by no means the only example. Compare Myron's statue of a discus-thrower, or *Discobolos*, made at around the same time. As with the *Doryphoros*, this sculpture is known only through later Roman versions [e.g. **fig. 24**], and we cannot be sure of the statue's original location or purpose. It's nonetheless clear that Myron's sculpture adopted a pose as knowingly artificial as that of Polyclitus' own. Leni Riefenstahl must have realised the point only too well, trying to render Myron's ideal back into flesh [**fig. 11**]: by bringing together a plurality of different moments – backswing and foreswing 'synoptically' at once – the *Discobolos* embodies a fictional schema that no living model could ever replicate. What the great German archaeologist Emmanuel Loewy called the 'mental images' (*Gedächtnisbilder*) of the Archaic Greek imagination remained part of the Greek economy of seeing long after the Greek 'discovery of nature' that Loewy and others assumed.

Something similar can be said about fifth-century Athenian vase-painting. Traditionally, this material has been used to sustain the idea of an almost obsessive attention to naturalistic detail. Didn't Classical Greek painters busy themselves with the accurate and scientific portrayal of anatomy and musculature? In doing so, moreover, didn't they prefigure the endeavours of fifteenth-century artists? The legacy of the Renaissance means that western

viewers almost inevitably see ancient images as scientific adventures in accurate pictorial description. Ancient depictions of the body are consequently viewed in modern muscular terms. Renaissance writers openly voiced the assumption: an artist, writes Leonardo da Vinci, must (like his ancient forebears) 'make the rule and the measurement of each muscle and give the reason for all their uses'; 'if to paint figures, you must first draw them nude and then dress them,' according to Alberti, 'so to paint nudes you must first situate the bones and muscles before you cover them with flesh and skin in order to show clearly where the muscles are'.

But do such fifteenth-century Renaissance instructions hold true for the images of the late sixth and fifth centuries BC? Indeed, are *our* ideas of empirical 'accuracy' the same as those of Athenian vase-painters? Most scholars have assumed a straightforward 'yes'. Specific 'Grand Master' painters are duly picked out for their accurate anatomical attention. A red-figure vase-painting of Heracles, attributed to the Berlin Painter, is just one example. Discussing the image, Donna Kurtz even reproduces an anatomical écorché alongside it, labelling each supposed muscle in turn [**fig. 25**]: 'these are the features visible to the sensitive eye of an artist . . . and which the Berlin Painter . . . drew in lines of black or brown paint'.

As Shigehisa Kuriyama has suggested, this sort of comparison runs the risk of collapsing our concepts of musculature – and the Renaissance objective of artistically reproducing them – into the very different conceptual frameworks at work in the fifth century. Discussing **fig. 25** (among other examples), Robin Osborne has persuasively developed the point: that the ancient Greeks knew nothing of what we conceptualise as muscles; rather, they imagined the body as a system of interconnecting *neura* – not only 'muscles', but also 'nerves', 'sinews', 'tendons', 'ligaments', and 'cords'. What seems to have motivated an image like **fig. 25**, then, is not the 'rule and the measurement of each muscle', but – in Kuriyama's words – the '*aesthetics* of articulation'. Interested in both character and ornamental pattern, the ancient painter privileges external symmetrical surface, not the sorts of inner anatomy that modern viewers take for granted. In this regard, it's worth observing how the 'Berlin Painter' renders Heracles' torso as a series

Fig. 25: Painting of Heracles attributed to the Berlin Painter, juxtaposed with an écorché. Donna Kurtz sets this pot-painting against an anatomical drawing of its human figure ('checked by the author against dissections for accuracy'). But Kurtz also notices some interesting anomalies: while the artist is 'capable of observing natural forms closely and of reproducing them accurately . . . , he often chooses to distort them for artistic effect'.

of conjoining lines, patterns and traces: the hardened three-dimensional texture of Heracles' body is defined against the speckled softness of the limp lion-skin borne around his shoulders. We're meant both to look *and* to imagine.

Of course, a schematic écorché like the one reproduced in **fig. 25** exposes the artifice of our own Renaissance-derived views of the body. Such concepts are founded upon modern modes of human dissection; for anyone outside this western tradition, there is absolutely nothing 'natural' about our views at all. The point I wish to emphasise, though, is slightly different: that these post-Renaissance conventions are also removed from fifth-century Athenian attitudes; better, that the conventions informing the 'Classical' art of the fifth century are both similar to *and* different from those that have prevailed since the Renaissance. Looking back at Athenian images of the fifth century in relation to those of the sixth, there can be no denying that the

conventions have changed. But once we recognise the very continuity in *convention*, the 'Greek Revolution' loses something of its revolutionary force. For all our abiding attempts to conflate the two, the images of fifth-century Athens are not those of fifteenth-century Italy.

Owning up to such modern visual investments helps us to see ancient imagery in a wholly different light. To demonstrate the point, let me turn not to posthumous copies, nor to Athenian vase-paintings, but rather to a pair of original bronze statues, discovered off the coast of Reggio Calabria in 1972. These so-called 'Riace bronzes' are among only a handful of large-scale bronze statues that have survived from the fifth century BC. We shall probably never know who crafted them, for what purpose, or indeed where they were set up: buried at the bottom of the sea, they were most likely subject to a (botched) attempt at later Roman import. What interests me about these two statues, though, is less their original display context than their mode of formal presentation. For all their apparent concern with the appearance of the human body, the Riace bronzes were evidently interested in representing things that could *never* be seen: these bodies gesture *beyond* both the natural and the naturalistic.

Take the figure known as 'Warrior A' [**fig. 26**]. On first impression, this sculpted bronze body appears like a real body in the flesh. Legend has it that the diver who discovered the statue even supposed, on first impression, that it was a corpse: the Mafia, after all, run (rife in) Calabria. Those who've subsequently set eyes on the statues invariably note the virtuoso precision of the torso musculature and the bulging veins of the wrists. The detailing (or patterning?) of the statuary is indeed extraordinary, from the eyes rendered in bone and glass to the copper nipples and silver teeth.

What is equally striking about the sculpture, though, is its impossibly symmetrical anatomy. A conspicuous example is what critics have come to call the 'iliac crest'. The delineation is in fact mistaken. Medically speaking, the iliac crest is the thick upper ridge of the pelvis bone; scholars, on the other hand, mean the attached layer of muscles, ligament and tendons, running upwards and outwards from the groin. It's possible to develop such definition through vigorous athletic training. Appropriately enough, gym

Fig. 26 (cf. **pl. 4**): Riace bronze 'Warrior A', cast between c. 470 and 430 BC, as seen from both the front and back. The two statues retrieved near Riace were surely once displayed together. The lost shields and weapons (together with the helmet worn by 'Warrior B') suggest a larger victory monument – perhaps at Delphi, Olympia, or else somewhere more locally.

aficionados (or at least the more aesthetically minded among them) some-times refer to this as an 'Apollo's belt' or 'Adonis girdle' – a classic case of reality mirroring art, rather than the other way round.

But the sort of furrowing curve seen on the Riace bronzes is beyond the reach of even the most zealous body-builder. A similarly artificial line pattern is to be found on other Greek images – Roman copies of the *Doryphoros* [**fig. 2**] and *Discobolos* [**fig. 23**], or indeed the 'Critian Boy' [**fig. 21**]; compare too how symmetrical patterns are employed to delineate the torso from the

legs on contemporary vase-painting [e.g. **fig. 25**]. And yet on the Riace bronzes, as on earlier kouroi (including the one in New York [**fig. 17**]), this ornamental contour is also extended around the *back* of the statue. From an anatomical point of view, such detailing is impossible. As with the deep groove of the chest, or the extended leg-to-body proportions, however, anatomy seems to have been only part of the point: the Greek art of the body embodies both more and less than the imitation of nature alone.

Seeing double

Just to be clear, I'm not denying that ancient images of the body have a history. What this chapter has sought to emphasise, rather, are the ideological stakes underpinning the particular histories that we have written. The cycles devised for discussing the ancient and modern are themselves locked in a circular logic: Renaissance writers have conceptualised the story of modern figurative art as refiguring the ancient; in turn, post-Enlightenment writers have told their histories of the ancient in terms of the modern.

Our narratives of the 'Greek Revolution' are only the most conspicuous demonstration of the point: that far from being innocent or objective, our tales of ancient art are invested in a set of modern ideas and assumptions. The stories look so unobjectionably objective. Laid out in linear order, chronology possesses a mirage of impartiality: who could deny the forward march of time? And yet, working behind it, ideological assumptions belie *every* attempt at periodisation.

This isn't just historiographical navel-gazing. It's important to acknowledge our modern ideological stakes so as not to jump the proverbial gun. All manner of explanations have been advanced for the 'Greek Revolution'. Gombrich's political account – uneasily coupled with his critique of Greek narrative – is just one among many, derived ultimately from Winckelmann's own Enlightenment rhetoric of *Freiheit* and *liberté*. Within our own western democracies, it's clear why the particular explanation should have proven so popular (witness the blockbuster 1992 exhibition in America, celebrating the supposed 2,500th anniversary of western democracy: *The Greek Miracle:*

Classical Sculpture from the Dawn of Democracy, the Fifth Century BC). But this is not the only story to have been told: all manner of other, rival explanations have likewise been advanced. Is naturalism the logical consequence of Greek religion, for example (anthropomorphic ideas of the gods leading to lifelike images); does it stem from a Greek 'gym' culture (artists lusting over fellow Muscle-Maries – and subsequently idolising their sunkissed six-packs back in their studio); or do these stylistic changes come down to more banal technological factors – like the invention of the so-called 'lost wax technique' of bronze casting (the greater tensile strength of bronze encouraging sculptors to depart from the marmoreal poses of time immemorial)? We could go on. Is this a revolution in visual subjectivity? A development in the function of art rather than its form? Are we dealing with the invention of 'art' per se ('an increasing number of people began to be interested in their work for its own sake,' as Gombrich writes, 'and not for the sake of its religious or political functions')?

To my mind, all these explanations prove somewhat premature. Before we can assess the causes of the 'Greek Revolution', we have to be absolutely clear about just what 'revolution' we (think we) are explaining. Herein lies the difficulty. For our various interpretations of the 'Great Awakening' go hand in hand with preconceived ideas about the images awakened. We've thought about ancients without thinking about moderns; in doing so, moreover, we've retro-projected onto antiquity our own modern ideas about artistic realism, replication, and illusion.

Of course, these ideas aren't *wholly* modern: the Graeco-Roman world bequeathed our own western conceptual frame for thinking about representation. This is where things get especially complicated: for ancient stories about art's virtual reality abound; what's more, following the likes of Vasari, these anecdotes have been written into our modern narratives of European 'Grand Master' painters. One might think, for example, of the numerous Greek and Latin epigrams on Myron's bronze statue of a heifer, said to be lifelike to the point of mooing – almost. Pliny the Elder likewise describes artistic competitions, staged to determine whose particular make-believe proved the more believable: most famous is the story of

Zeuxis and Parrhasius, the one convincing animals through his art (birds flocked around Zeuxis' tantalising painting of grapes), the other deceiving a human artist (Zeuxis himself reached to draw the curtain from his rival's painting, only to realise that the curtain *was* the picture: fifteen/love to Parrhasius – *Natural History*, 35.65–66). This same Parrhasius is said to have gone to particular extremes in his quest for verisimilitude. Take the purported painting of Prometheus (Seneca the Elder, *Controversies*, 10.5). In order to determine how Prometheus might have looked during his ex-cruciating torture, Parrhasius bought an old slave from his local market. Playing Zeus to the slave's Prometheus, Parrhasius tormented the man to death: yes, those mangled throes were simply *perfect* for the painting!

Examples could be multiplied: there are stories of sculptures which move, talk, and interact; anecdotes about sexually arousing simulacra – and viewers who have it off with them (cf. pp.86–8, 98–9); myths about images magi-cally metamorphosing into life (the robotic *automata* crafted by Hephaestus, the bronze-man made by Talos, Pygmalion's Galatea, Daedalus' talking statues, etc., etc.). There followed an almost voodoo-like fetishisation of the image. Think, for instance, of Roman practices of *damnatio memoriae* whereby, when an emperor was judged *really* bad, revenge could be executed on his image, even after the emperor's death (cf. e.g. Pliny the Younger, *Panegyric of Trajan*, 52.4–5).

Already by the fourth century BC, we find this rhetoric foreshadowed in the writings of Plato, who turned images into an overt philosophical problem. According to Plato's theory of ideal forms, the material world obfuscates abstract truths; by the same logic, images of that material world – or at least those images prevailing in fourth-century Athens – prove doubly distracting. For Plato, the whole universe is a sort of imitation or *mimesis*, so that the representative arts constitute an imitational double-bind – *mimesis* squared, as it were. The classic discussion comes in the tenth book of *Republic*: a visual image of a couch, Plato has Socrates explain, is a replication of a couch which itself replicates the *idea* of couch. To lose sight of that idea once is unfortunate, as Oscar Wilde might put it; to do so twice is careless – and morally opprobrious.

These are discourses about image-making that must strike us as intrinsically familiar. Just as Pliny's stories of competitive mimicry merge into stories about more modern artists (thanks again largely to Vasari), our western aesthetic traditions have been knowingly forged out of Greek and ancient texts ('western philosophy is a series of footnotes to Plato', as Alfred North Whitehead memorably put it). My point, though, is that cultural familiarity brings with it both advantages *and* disadvantages.

Two interrelated issues are worth teasing out here. The first is about the historical development of *mimesis* within antiquity. Because these ideas are not a cultural given (despite our proclivity to think otherwise), they must have emerged only gradually over time. This is significant when thinking about the history of Greek kouroi, or indeed the Pioneers of red-figure Athenian vase-painting: because naturalism was never a foregone conclusion, we should be wary of judging what was 'pioneered' during this time in terms of later, anachronistic concepts. 'The drama of late Archaic Greek art is the emergence of a concept of naturalism that had not existed hitherto', as Richard Neer nicely puts it: 'it is interesting precisely because it is the last art in the entire tradition of the west that does not know the Classical'.

The issue of a *developing* rhetoric of artistic simulation leads to a second observation: namely, that Classical Greek discourses of naturalism have continued to develop ever since. We are not dealing with static concepts. Just as sixth-century ideas are not the same as those elaborated by Plato, later Roman ideas both adopt and adapt earlier Greek ideas of *mimesis*. By the same token, Roman concepts are themselves a far cry from those prevailing in the Renaissance. And our twenty-first-century conceptual frameworks – informed by new technologies like photography – are emphatically different again.

To demonstrate what I mean, let me end with an ancient Greek passage that discusses image-making explicitly. The text was written in the first half of the fourth century BC by an Athenian named Xenophon: among other things, Xenophon was an acolyte of Socrates, and Xenophon's *Memorabilia* is one of our most important sources for reconstructing Socratic thought.

The philosopher, we are told, frequently visited craftsmen, and on one occasion Socrates embarked upon a succession of related conversations with a painter (Parrhasius), a sculptor (Cleiton), and an armourer (Pistias). The exchange with Parrhasius – of painted curtain and tormented slave fame – is particularly interesting. Socrates begins with a deceptively straightforward question: does painting represent things that are actually seen (*ta horōmena*), or does it reproduce through artificial means (above all through colours – *chrōmata*)? After establishing that Parrhasius necessarily combines the physical features of *numerous* models, Socrates cuts to the chase (*Memorbilia*, 3.10.1):

> 'Well now,' Socrates said, 'do you also replicate the character of the soul – that character which is the most captivating, the most delightful, the most familiar, the most fascinating and the most desirable? Or is it impossible to replicate this?' 'Oh no, Socrates,' replied Parrhasius, 'for how could one replicate something which has neither shape nor colour nor any of the other qualities you just mentioned – something which we are not even wholly able to *see*?'

Artists might replicate the image of things seen, it seems, but not even a virtuoso painter like Parrhasius could render visible the invisible character of the soul: for this is something that no image can capture. As Parrhasius subsequently concedes, only the rendition of a figure's gaze could come close: the eyes are seen as the window to the soul – a point ironically brought to bear on painting itself (i.e. something destined not to look, but to be looked at).

The passage makes for an appropriate conclusion to this chapter because of both its strangeness *and* its familiarity. The fourth century is the period when Gombrich's supposed process of 'making and matching' is said to have reached its height: Socrates, we remember, was executed in 399 BC, and Xenophon himself died around fifty years later. And yet, even at this time, there was still evidently more to the art of the body than the replication of appearances alone. A concern with empirical appearances seems to have been coupled with an intense self-consciousness about the promise

and failure of representation. This particular piece of memorabilia reminds that there is something *non*-replicable in Greek images of the body, whether in the sculptural round or the painted surface.

The philosopher Richard Wollheim would diagnose a related phenomenon in the twentieth century, explaining it in terms of the difference between 'seeing as' and 'seeing in'. Images, writes Wollheim, embody a two-sided impulse: on the one hand, they invite viewers to equate representation with reality; on the other, they uncover the fiction that this involves. 'Seeing in' exposes the make-believe of 'seeing as': we recognise that that thing we have seen (those grapes of Zeuxis, or indeed Parrhasius' curtain) in fact stems from an act of creative visual volition. If looking entails a suspension of disbelief, it also involves a suspension of that suspension: aren't we just staring at a stretch of canvas, a painted wall, or a mass of stone or metal?

As Wollheim describes them, these two modes are simultaneous, and inform anthropologies of image-making the whole world over. Still, it seems to me that the Greek art of the body derives from a *particular* self-awareness about this representational double-bind. The earliest Greek images of the body are knowingly duplicitous – they both are and are not imitations [e.g. **fig. 17**]; better, perhaps, they imitate things that both can and cannot be seen, just as Xenophon's Socrates and Parrhasius discuss. Richard Neer argues a related point about the development of vase-painting between the late sixth and fifth centuries, drawing attention to what he calls its 'chiastic tension'. Early red-figure pot-painting, writes Neer, oscillates between the empirically convincing and the artificial trace – hence the 'ambiguities', 'ambivalences', 'riddles', 'puns', and 'tensions' with which the Pioneers toyed. To my mind, Greek sculpture is informed by a similar principle, and within a much longer time-frame. Doesn't the 'iliac crest' embody a related sort of visual tension? Don't such details likewise play upon our 'seeing as' and 'seeing in'? Indeed, isn't this *both* a material trace and a believable anatomical fiction – something that is at once general *and* specific?

Whether this amounts to a 'revolution' in Greek art will depend on one's cultural and individual perspective. For my money, we are not dealing

with the invention of (what later writers would rationalise as) 'naturalism' at all: the transition from (what we call) the Archaic to the Classical is not a self-contained change in style per se; rather, these changes in presentational mode are bound up with changing cultural, intellectual, and theological ideas about figuration on the one hand, and about the individual viewing subject on the other. Above all (in my view), it was challenges of (re-)presenting the gods that were at issue: like earlier and later developments, Archaic and Classical changes in figuring the body are *religiously* orientated – although, as we shall see, it does not follow that real-looking images made for more sacred cult images (cf. pp.163–4).

Religion is a word we hear far too seldom in our 'art histories'. This no doubt has to do with the invention of art history in the late eighteenth century: what role could there be for religious superstition in the brave new world of the Enlightenment? The remainder of this book will have increasing reason to put this right: as I hope to show, the ancient – and thereby modern – art of the body can *only* be understood in cultic terms. The point leads to the theme of our following chapter. For the iconic Graeco-Roman statue of the unclothed female body also stems from a cultic prototype: as we shall see, moreover, the western tradition of the 'female nude' derives from that literal and metaphorical unveiling of feminine divinity.

THE ANCIENT 'FEMALE NUDE' (AND OTHER MODERN FICTIONS)

On 10th March 1914, a Canadian-born suffragette by the name of Mary Richardson staged a spectacular publicity stunt. Outraged by the latest arrest of Emmeline Pankhurst – the leader of the Women's Social and Political Union (WSPU) – Richardson entered London's National Gallery and set upon Velázquez's *Rokeby Venus* [**fig. 27**]. Meat-cleaver in hand, she hacked away at the canvas, inflicting several wounds upon the body of the reclining female figure.

Quite what Richardson hoped to achieve is difficult to gauge. 'I have tried to destroy the picture of the most beautiful woman in mythological history', she explained, 'as a protest against the Government for destroying Mrs Pankhurst, who is the most beautiful character in modern history.' Only much later – after leading the women's section of the British Union of Fascists – did 'Slasher Mary' justify her action in terms of (what men call) 'art': she disliked the way in which men 'gaped' at this unclothed and recumbent feminine object.

Regardless of her original political aims, Richardson's response to the *Rokeby Venus* has been mythologised as the paradigmatic act of feminist aesthetic defiance: Mary Richardson bound women's twentieth-century struggle for political equality with a ball-busting crusade against images. By making the suffrage movement quite literally iconoclastic, the *Rokeby Venus* affair set the agenda for so-called 'second-' and 'third-wave' feminism later in the twentieth century. 'Do women have to be naked', as a

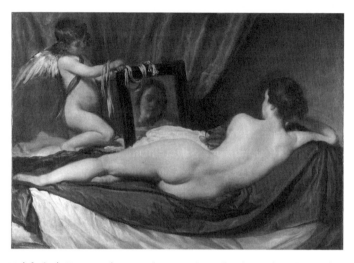

Fig. 27 (cf. **pl. 5**): Diego Rodríguez Velázquez, *The Toilet of Venus* (*Rokeby Venus*), 1647–51. In his sole 'female nude' painting, Velázquez shows his feminine subject from behind: the ancient 'Borghese Hermaphrodite' statue, discovered earlier in the seventeenth century, seems to have been one inspiration.

famous group of New York 'Guerrilla Girls' first asked in 1989, 'to get into the Met. Museum?' [**fig. 28**].

The story of Mary Richardson and her sister suffragettes necessarily forms part of our own story about ancients and moderns. For antiquity, or so it's often claimed, lies at the head of this gendered western economy of seeing. Greek sculptors were the first to represent the unclothed female body, at least as subsequent western artists would recognise it: they moulded the paradigmatic image of western 'woman' that has endured ever since. Just look back at Velázquez's painting. Not for nothing does this modern woman purport to be Venus, the Roman goddess of love, known to the Greeks as Aphrodite.

The modern feminist struggle against pornographic objectification – the rallying cry to reject the debasements of 'art' – is therefore, in part, a struggle against the Graeco-Roman inheritance. But to what extent did ancient representations of the unclothed female body solicit the same sorts of responses as the modern? Is this story of 'antiquity and its legacy' a narrative of straightforward continuity, or also of change? And why have these

70

questions counted for so much within our own gender politics during the twentieth and twenty-first centuries?

In tackling these questions, this chapter sets out to explore the intertwined relations between the ancient and modern art of the female body. As I hope to show, modern images shed important light on the gender hierarchies at work in ancient visual culture. At the same time, the ancient material can bring new perspectives to the modern. When examined alongside each other, ancient and modern representations of the female body spark a process of two-way illumination: Graeco-Roman antiquity foreshadows subsequent western cultural horizons on the one hand, and exposes their finite parameters on the other.

V-ness

English has a unique phrase to describe images of unclothed women like Velázquez's *Rokeby Venus*: 'the female nude'. The term refers not just to pictures of women without clothes. Also implicit is the assumption of 'artistic' merit rather than mere 'pornographical' arousal. However controversial the claim, it is enshrined in law. In Britain, at least, you have to be 18 to buy *Playboy*. Even toddlers, though, are allowed to enter the National Gallery. An established social, cultural, and legal consensus still

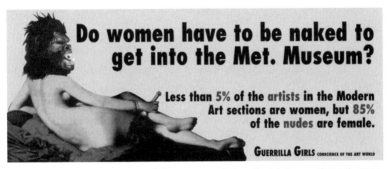

Fig. 28: 'Guerrilla Girls' poster (adapting Ingres' *Grande Odalisque* of 1814), 1989. 'Going ape' at the sexism of art, these masked avengers continue to demand change. This poster was billed on New York buses in 1989. Fifteen years later, the Guerrilla Girls claimed that things were still worse: in 2004, 83 per cent of the museum's nudes were female, as opposed to just 3 per cent of its represented artists.

71

holds the images of the museum to be different from the cellophane-wrapped pages of the porno: anyone (or so the author hopes) will be allowed to purchase the book in hand.

It's not just *modern* artworks that are deemed 'female nudes'. Ancient statues are also commonly referred to as 'female nudes' in this established aesthetic sense [e.g. **fig. 29**]. The prototypical example – to which we shall return in the latter part of this chapter – is Praxiteles' statue of Aphrodite, set up on the promontory of Knidos on the Carian coast (in south-west Turkey) in around 360 BC [**fig. 34**]. The image has been interpreted as the quintessential western 'female nude': a 1995 book on the statue, for instance, is subtitled 'a historical review of the female nude in Greek art'. In some sense, *every* subsequent western statue of the female body is a reinterpretation of the Knidian statue [cf. e.g. **figs. 4, 16, 27–32, 37–40**]. An almost endless array of 'Aphrodites' and 'Venuses' has followed – Venus sleeping, Venus at her toilette, Venus embraced; there is Giorgione's *Dresden Venus*, Titian's *Venus of Urbino*, and Pistoletto's postmodern *Venus of the Rags*.

'Venus', of course, could provide a convenient excuse. Hallowed antiquity sanctioned a degree of female nudity that might otherwise prove *too* shocking. While a German Renaissance painter like Lucas Cranach the Elder could paint pictures of an unclothed ancient 'Venus with a veil', 'Venus in a landscape', 'Venus and Cupid', each of Cranach's modern-day portraits (not to mention his religious paintings) decorously covered up their female subjects.

Even when they went unnamed in associated titles, 'ancient' allusions have served as an alibi. Nowhere more so than in Victorian Britain. Take Lawrence Alma-Tadema's life-size portrait of *A Sculptor's Model* [**fig. 30**]. As the title suggests, we're not dealing with a 'Venus' here at all. And yet the model for this 'model' is nevertheless an ancient statue, discovered in Rome in 1874 (the so-called 'Esquiline Venus'). Like other artists, Alma-Tadema alludes to that sculpture's pose while restoring its lost arms. In case we hadn't realised the reference, Alma-Tadema cunningly hides the Esquiline Venus behind the 'real-life' nude: a palm frond teasingly covers it from sight. The rough surface of the verdant plant, moreover,

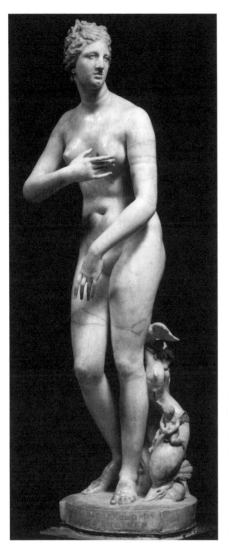

Fig. 29: 'Medici Venus', probably first century BC. Already known in the sixteenth century, this statue quickly became *the* ancient 'female nude'. The ultimate model is Praxiteles' lost statue of the Knidian Aphrodite [**fig. 34**]: here, though, the schema of the legs and arms is reversed, as is the turn of her head. Observe too how Aphrodite's right arm is now used to shield the breasts – a teasing prompt *not* to look?

contrasts both with the spongy curves of the girl's rouged flesh and the soft red silk of her headband; one leaf even stands to phallic attention against her peachy thigh. The clothing of the sculptor, along with the marble reliefs behind him, projects this wet-dream back into antiquity: in Victorian Britain, sexual fantasies were best staged after Greek and Roman models [cf. **fig. 9**].

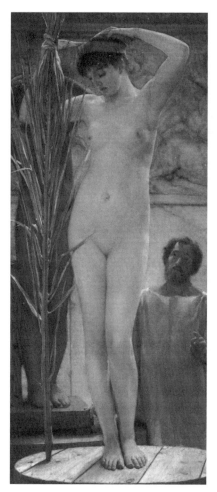

Fig. 30 (cf. **pl. 6**): Sir Lawrence Alma-Tadema, *A Sculptor's Model*, 1877. On seeing this life-size painting, the Bishop of Carlisle wrote that his 'mind had been considerably exercised'. 'In the case of the nude of an old master much allowance has been made . . . But for a living artist to exhibit a life-size, life-like, almost photographic representation of a beautiful naked woman strikes my inartistic mind as somewhat if not very mischievous.' Just how life-like, though, is this supposed 'photographic representation'?

What, then, do all these modern 'Venuses' have in common? According to John Berger, whose influential *Ways of Seeing* was first published in 1972 (accompanying the BBC television series), the western 'female nude' is about more than stripping down. At stake are much larger issues of power:

According to usage and conventions which are at last being questioned but have by no means been overcome, the social presence of a woman is different in kind from that of a man. A man's presence

is dependent upon the promise of power which he embodies . . . By contrast, a woman's presence expresses her own attitude to herself, and defines what can and cannot be done to her . . . One might simplify this by saying: *men act* and *women appear*. Men look at women. Women watch themselves being looked at. This determines not only most relations between men and women but also the relation of women to themselves. The surveyor of woman is herself a male: the surveyed female. Thus she turns herself into an object – and most particularly an object of vision: a sight.

For Berger, the history of western imagery can be divided along gender lines. Our rhetoric of 'art' relies on the assumption that men are active observers, whereas women are passive objects. The 'female nude' is no mere artistic 'form' or 'type', in other words. It reflects, performs, and perpetuates notions of gender that are burrowed deep within our western cultural subconscious.

One need only look back at the paintings of Botticelli [**fig. 4**], Velázquez [**fig. 27**] and Alma-Tadema [**fig. 30**] to realise the point. The hand gestures of Botticelli's goddess, Berger might suggest, together with her coy downward gaze, confirm an awareness of being seen: this made the resurrected 'Venus' of antiquity all the more titillating to her Renaissance viewer-voyeurs. By putting the male spectator back into the painting, Alma-Tadema goes still further: note how the (dressed) male looks, whereas the (unclothed) female looks absently away; through the very act of looking at the picture, external viewers take on the role of its internal Peeping Tom. Velázquez's *Rokeby Venus* hints at what this all means for women at large. Not only is this reclining female figure supine, submissive and subservient. Venus also peers into the mirror held out before her: she gazes out at the viewer of the painting, in other words, through her own nebulous self-reflection. Like 'Venuses' the western world over, Velázquez's Venus is shown at her toilette, preparing for the penetrating gaze of men. And yet what Venus sees is her own mirage – a reflection of how she is passively looked at. The mirror, like such other familiar trappings, 'make the woman connive in treating

herself as, first and foremost, a sight'. These are the conventions of art. And they have long subjugated women under the patriarchal gawp of men.

Those sceptical of such readings need only pose the question: was there ever a 'Grand Master' painting that *reversed* these gender roles – making the viewing subject a clothed female, and the viewed object an unclothed male? Of course, such images can occasionally be found. Indeed, they have become a favourite conceit of twenty-first-century marketing. In the dreamlike fantasy-worlds of the glossy magazine or television commercial, images of suave women looking at bare-chested men continue to market chocolate treats, slimming snacks, or some other guilt-free indulgence. Almost always, though, these images are aimed at a predominantly female (or alternatively gay male) target audience: they purport to offer, via their products, a wholly different landscape of gender and sexuality – a perpetual 'Diet Coke' break, so to speak. These, then, are the exceptions that prove the rule. Watch almost any MTV video, and we find the same viewing hierarchies that Berger first diag-nosed almost forty years ago. Between 'Action Men' and 'Barbie' dolls, western popular culture still figures 'his' and 'hers' in the same way as the gallery and museum. This is 'womanufacture' in the making: men act, women appear.

Berger ends his third chapter with a famous distinction between 'nudity' and 'nakedness'. Previous art historians had claimed this to be a simple question of aesthetics: according to Sir Kenneth Clark, being 'naked' is to be deprived of clothes ('the word implies some of the embarrassment which most of us feel in that condition'); to be 'nude', on the other hand, 'in educated usage, carries no uncomfortable overtone', but refers instead to 'an art form invented by the Greeks in the fifth century BC'. Berger sees things differently. Nudity, he argues, is itself a convention of gender, bound up with the institution of the western 'male gaze':

> To be naked is to be oneself. To be nude is to be seen naked by others and yet not recognized for oneself. A naked body has to be seen as an object in order to become a nude . . . Nakedness reveals itself. Nudity is placed on display. To be naked is to be without disguise. To be on display is to have the surface of one's own skin, the hairs

of one's own body, turned into a disguise which, in that situation, can never be discarded. The nude is condemned to never being naked. Nudity is a form of dress.

For Berger, the 'female nude' is an inherently voyeuristic (and capitalist) fabrication: it perpetuates a western hierarchy of gender that dresses itself up as 'art'.

Of the many images that demonstrate the phenomenon, few are more poignant than a woodcut from a Renaissance manual by Albrecht Dürer [**fig. 31**]. On the left we see an unclothed, reclining female model; on the right is an artist who draws her. Between the two figures stands a device to transform the real-life, three-dimensional female subject into an objectified, two-dimensional representation. Following Renaissance theories of linear, mathematical perspective – especially Leon Battista Alberti's ground-breaking *De Pictura* of 1435 – the latticed screen through which the draughtsman sees (and the model is seen) corresponds to the grid on the table: the draughtsman can chart each undulating curve of the female body within the corresponding series of rows and columns before him. The effect is to give the semblance of scientific objectivity: in Alberti's terms, the two-dimensional image serves as a 'window' onto the real three-dimensional world, just like this rectilinear woodprint itself (notice the two windows at the 'back' of the picture). But while purporting to contain and order reality, the picture exposes its own fallacy – no less than the phallic assumptions behind it. The screen, itself rendered in perspective, separates more than just the unclothed model from the clothed draughtsman: it delineates between the female and the male, the viewed and the viewer, and the wild and the domesticated (notice how the landscape behind the woman is transformed into a jug and household plant behind the man). If perspective is exposed as symbolic form (as Panofsky put it), western 'ways of seeing' are here founded on an *engendered* polarity between the active and the passive.

Subsequent critics have elaborated Berger's theories, analysing (male) representations of the feminine body, and in all manner of modern-day media. In her seminal 1975 article on 'visual pleasure and narrative cinema',

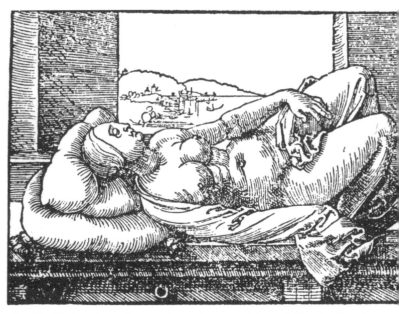

Fig. 31: Woodcut from the second, posthumous edition of Albrecht Dürer's *Underweysung der Messung mit dem Zirckel und Richtscheyt* ('Instruction in measurement with the circle and rectangle'), 1538. Scrutinised by the draughtsman, the reclining female body is rendered into something regulated, charted and controlled:

for instance, Laura Mulvey turned to Sigmund Freud's psychoanalytical theories to explain how film offers the ultimate fetishisation of the female. Cinema, Mulvey argued, delights in the erotic frisson of 'scopophilia', structured around the poles of active-male viewer and passive-female object, and mediated through the penetrating gaze of the camera: 'in their traditional exhibitionist role women are simultaneously looked at and displayed, with their appearance coded for strong visual and erotic impact so that they can be said to connote *to-be-looked-at-ness*' (her emphasis).

How, then, to deal with this legacy? One extreme suggestion has been to abolish imagery *tout court*. Supposing that every representation is implicated within ideologies of voyeurism, victimisation, and violence, Susan Kappeler has argued that all (western) images necessarily infringe upon the pornographic. If women are to break free from the conspiracies of western patriarchy, if they are ever to achieve equality, they must break free from

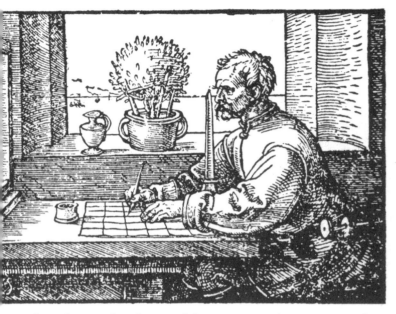

the result arouses the male voyeur all the more – witness the erect measuring device protruding from the table. As for the female figure's iconographic derivation, turn the image on its side and compare e.g. **fig. 29**: ancient Venuses stand behind this twist of the body, turn of the head and positioning of the hands.

the shackles of their visual inheritance. An artistic revolution will no longer suffice: 'art' itself must be done away with, and done away with altogether.

Crying, talking, sleeping, walking – *living* dolls

Many of these arguments have been carried out in isolation from ancient materials. Despite his Classicising subjects, Berger does not reproduce a single Greek or Roman image in his book: his Marxist grudge is against the 'Grand Master' oil paintings of the last half-millennium, not antiquity per se. Throughout his essay, though, Berger frequently talks of a continuous 'European' and 'western' tradition. Almost by definition, moreover, that tradition is assumed to extend back to ancient 'nudes': Botticelli's *Birth of Venus* [**fig. 4**] gives rebirth to 'ways of seeing' that were themselves born with Greece and Rome.

The publication of Michel Foucault's *Histoire de la sexualité* changed things considerably. For Foucault, modern concepts of sexuality and gender could only be understood in relation to the ancient. Graeco-Roman antiquity became central to Foucault's project, especially in his second and third volumes (concerned with *The Use of Pleasure* and *The Care of the Self*, both published in French in 1984). After Foucault, it would become impossible to think about modern western gender without thinking about antiquity, even if art historians have been less active in bridging that ancient–modern divide.

Take, for example, debates over the history of pornography. The term 'pornography' may only have been coined in the nineteenth century, at least in the current sense. But there's no denying the Greek etymology: literally understood, pornography refers to writings (from the verb *graphein*, 'to write' or 'draw') about *pornai* (the lowest sort of Athenian female prostitute). Just as gravity existed long before the apple hit Newton on the head, the argument runs, wasn't pornography around before it was labelled as such? Others have drawn attention to the earliest uses of the term, used in connection with ancient objects – the 'naughty' antiquities locked away in Naples' 'Gabinetto Segreto' ('Secret Cabinet'), for example. Hasn't 'art' *always* been complicit in turning women into prostitutes?

Various ancient myths have also been cited. For many, including Berger himself, the paradigmatic story of western male gazing is the Judgement of Paris. The myth is mentioned in the earliest work of Greek literature (*Iliad*, 24.25–30), and in such a way as to imply its widespread familiarity already at this time. There are three essential components to the story: a trio of highly strung goddesses; a golden apple, inscribed with a fateful dedication to 'the most beautiful female' (*kallistēi*); and an unsuspecting Trojan prince named Paris. Spying the inscription, Hera, Athena, and Aphrodite each claimed the golden apple as their own. A terrible argument arose, just as Eris ('Strife') had always intended. Tempers quickly frayed, and Zeus was called upon to arbitrate. But the 'father of gods and men' knew better than to get involved: wouldn't a mortal like Paris prove the better judge? The goddesses duly descended on Mount Ida, each

courting the Trojan price with her own distinctive bribe: Hera promised imperial power, Athena military victory, and Aphrodite the most beautiful woman on earth. Paris let his groin do the thinking: Aphrodite won. There would be a sting in the tail, of course: Helen, the most beautiful woman on earth, was already married; by abducting Helen from Menelaus in Sparta, Paris would bring on the whole Trojan War – as well as his own destruction.

According to Berger, the ancient myth of Paris is already laden with the whole gendered ideology of viewing and being viewed. The delight with which Renaissance artists visually depicted the story, moreover, has only strengthened the bond between the ancient and the modern, perpetuating the 'male gaze' represented. 'Today the judgment of beauty has become the beauty pageant', Berger concludes: just as the three goddesses sought to be deemed 'the most beautiful', so too does each aspiring Beauty Queen compete for 'Miss World' status, as judged in the eyes of men.

If the Judgement of Paris has provided a paradigm for viewing western women, it's also provided a paradigm for conceptualising their visual representation. Already in antiquity, we find the mythical pageant replayed in the mythologised artist's studio. According to one legend, Zeuxis – a fourth-century BC painter from Heraclea – starred in the role of Paris, while modern-day women took on the part of the three goddesses. Zeuxis was commissioned to paint a 'silent image [*muta . . . imago*]' that embodied 'the surpassing beauty of womanly form [*excellentem muliebris formae pulchritudinem*]'. But where to find a model? Try as he did, Zeuxis was unable to identify a woman who lived up to his ideals. Cicero and Pliny the Elder provide the two most substantial accounts, writing in the early first century BC and late first century AD respectively; although each author differs in detail (Cicero locates the story in Croton, Pliny in Agrigentum), both tell how Zeuxis was permitted to strip the nubile population and take his aesthete's pick. He eventually settled upon five specimens. Because each maiden coupled some individual advantage with another individual defect, Zeuxis would reproduce the *best* parts of each. 'He selected five . . .', as Cicero puts it, 'for he did not think that all the qualities which he sought

to combine in his image of beauty could be found in a single body' (*On Invention*, 2.1; cf. Pliny, *Natural History*, 35.64).

The story of Zeuxis and his five model maidens has reverberated in the post-Renaissance cultural imaginary: Alberti's *De Pictura* extolled Zeuxis' decision (deemed the 'most excellent painter of all'), while Dürer exaggerated the number of maidens surveyed (was it only five maidens – or some two or three hundred?). As a subject of 'Grand Master' art, the myth provided yet another excuse for stripping down the female subjects: western (male) viewers were invited to check out the meat market depicted – comparing these women to the Woman-painting *within* the painting.

That Helen should have been the subject of Zeuxis' picture (at least according to Cicero) is also significant. On the one hand, the detail connects the mythical Judgement of Paris with the real-life inspections of a legendary artist: not only does Zeuxis act like Paris (Zeuxis as 'the supreme adjudicator of beauty', according to Cicero), but his painting attempts to figure Paris' own feminine prize. At the same time, antiquity understood Helen as the ultimate in Mulvey's 'to-be-looked-at-ness'. She was the archetypal shaggable object – the passive pawn of patriarchal power, passed from one owner to the next. Ogling her from the walls of Troy, even the Trojan Elders decide that it's 'no reproach for the Trojans and well-greaved Achaeans to suffer prolonged troubles over a woman such as this: to gaze upon her is as wondrous as to look upon some immortal goddess' (*Iliad*, 3.156–8). Zeuxis, in other words, looks at a series of real-life stripped and naked women, all modelling as *the* ultimate model of being looked at.

From our modern western perspectives, two things seem particularly striking about Cicero's story. First, its structured opposition between reality and ideal. No real woman, it seems, could ever live up to Zeuxis' male imagination: the perfect female body, at least as fetishised by men, is necessarily *un*attainable. No wonder that the western world has developed such problems with anorexia nervosa, bulimia and body dysmorphia disorder (BDD – a preoccupation with some imaginary defect in bodily appearance): isn't this *modern* condition an inheritance of *ancient* 'ideals'? A second significant aspect of the story lies in its figuring of the ideal female body as a

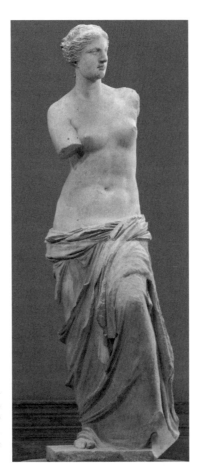

Fig. 32: The Venus de Milo, late second century BC. Despite the draped lower body, the Knidian Aphrodite [**fig. 34**] seems to have provided the inspiration for this image: observe the position of the legs, curve of the torso and twist of the head.

segmented series of pull-apart-able parts. Here is the paradigmatic tale of artistic, vis-à-vis pornographic, objectification: 'woman' is reduced to a line-up of fetishised segments: 'legs', 'hips', 'pussy', 'booty', 'arms', 'tits', 'head' – the particular qualities go unspecified. If the myth of Zeuxis' maidens constitutes the archetypal anecdote of the fragmented female body, ancient objects have sustained the modern fantasy. None more so than **fig. 32**. Ever since its discovery on the Greek island of Melos in 1820, this statue has been admired for its disfigured fragmentation as much as for its surviving parts. When the protagonist of Walt Disney's 1997 *Hercules* strikes a

look-alike Knidian Aphrodite with a stone [**fig. 34**], revealing the Venus de Milo in its stead, the cartoon's slinky heroine replies not to worry: the statue actually looks *better* this way. 'Venuses', it seems, are all the more alluring when mutilated.

Like the real-life maidens surveyed by Zeuxis (or indeed **fig. 34** when viewed against **fig. 32**), the 'real' female body has frequently failed to measure up to imaginary expectations. One much-quoted anecdote tells how John Ruskin, the celebrated Victorian art critic, was so shocked upon seeing his wife naked in his bridal suite that he left the marriage forever unconsummated: it was annulled six years later. Art had led Ruskin to expect something quite different [cf. **fig. 30**]: was there ever anything so vulgar as a vulva?

Whatever the truth of the Ruskin story (itself mythologised into a tale of Victorian prudishness), it reveals something interesting about western traditions of the 'female nude', especially in relation to the male. As we saw in the last chapter, Classical art has been almost universally celebrated for its 'lifelike' naturalism: unlike so many other cultural and artistic traditions (including the stylisations of the Byzantine [e.g. **fig. 66**] and Mediaeval) Graeco-Roman bodies are lauded for their believability. When it comes to the female body, though, desirability seems to have been figured around a very different rhetoric – a factured fiction of femininity, premised on the wholly unconvincing absence of pubic hair and genitals.

Every woman reading the book must have silently appreciated the point: this is emphatically *not* what fannies look like. There's no evidence to suggest (as some maintain) that more 'realistic' details were painted onto statues like the Knidian Aphrodite [**fig. 34**]. Even if they were, we would still be faced with a different mode of figuring the feminine as opposed to moulding the masculine. After all, ancient artists had no qualms in adorning male statues with delicate tufts of pubic hair [e.g. **fig. 2**], and subsequent western artists have very much followed suit [e.g. **fig. 5**]: western art, it seems, is comfortable with the penis, but it's been much more squeamish about the female (non-)equivalent.

This small observation has a much larger cultural significance. Historians

Fig. 33: Ivory statuette of the Hindu goddess Lakshmi, from a house on the Via dell'Abbondanza in Pompeii, first century AD. Flanked by two handmaidens, Lakshmi reveals why Vishnu made her his bride. As well as demonstrating the cultural diversity of even a small provincial town like Pompeii, the figurine demonstrates the peculiarities of our western conventions of the 'female nude': the prominent genitals and pubic hair reflect the female subject's active rather than passive sexuality.

like Thomas Laqueur have long since shown how Greek writers enshrined our definitive western image of the female body in relation to the male: western thinkers have conceptualised the feminine around a series of comparative excesses (flabbiness, emotionality, breasts) and lacks (musculature, discipline, order – and above all the penis). But the *visual* representation of the female body has arguably done more than any text to shape and perpetuate such assumptions. When a character in Apuleius' second-century AD *Golden Ass* wants to appear at her most alluring, for example, she deliberately poses in the position of a painted Venus, 'even for a time holding her rosy little hand in front of her smooth-shaven genitals [*glabellum feminal*] – purposely casting it in shadow, but not modestly hiding it' (2.17). To be sexy, it seems, western women have long had to make their bodies look *un*-natural – whether by shadowing the vagina, or waxing their pubes (as is still the case in most porno magazines and films today). In this physical place above all others, female bodies constitute a taboo that male bodies do not: the female *pudenda* manifests a *visual* embarrassment, and one that has translated into a western cultural taboo at large. Not for nothing is 'cunt' the most offensive *faux pas* in the English language – much worse than 'cock', 'dick', or 'nob'.

In the ancient world, as in the modern, this figuration of the female must have been all the more conspicuous in the light of other cultural traditions. Compare the 'female nudes' illustrated in this chapter to a very vulva-ed ivory figure of the Indian goddess Lakshmi [**fig. 33**], for example, and we immediately see how *unnatural* our western depictions of the female body really are: in contrast to the allure of the masculine, the desirability of western women is premised upon the specific *elision* of the natural. What's more, the fact that this image is itself ancient – from first-century AD Pompeii – reminds us that, even in the Graeco-Roman world, alternative visual languages might flag the visual, cultural, and social peculiarities underpinning western artistic conventions.

John Ruskin was not the first (male) viewer to feel disappointment before Real Woman: such modern myths find their counterpart in an ancient story – the legend of Pygmalion. The most famous version comes in the *Metamorphoses* of Ovid, written in the early first century AD (10.243–297).

Pygmalion, writes Ovid, was scornful of the real-life courtesans of his native Cyprus: he was 'disgusted with the vices that Nature bequeathed upon the female mind, and in such abundance'. He turned to art by way of consolation:

> With marvellous artistry, Pygmalion skilfully carved a statue out of snowy ivory and made it more beautiful than any mortal-born woman. He fell in love with his creation: it had the appearance of a real girl – it seemed alive, as though longing to move (did its modesty not forbid). So did the art conceal its art. Pygmalion gaped in wonder, his heart aflame for this semblance of body [*simulati corporis*].

An unlikely love affair ensues, playing upon other stories of so-called *agalmatophilia* ('love of statues'). Pygmalion pets his darling object – covering it in kisses, embracing it, squeezing its limbs; he courts it with gifts, he dresses it in jewellery, he even takes it to bed . . . Oh, gods, the frustration! Would that the 'it' would become a 'she'! If only Aphrodite would turn this manmade manikin into mortal muff – *this* is the 'ivory maiden' (*eburnea uirgo*) that Pygmalion longs to marry! Aphrodite didn't intervene for John Ruskin. But the goddess duly answers Pygmalion's prayer:

> When Pygmalion returned, he headed straight for the statue of his girl, leaned over the couch and kissed her. She seemed warm. Again he put his mouth to hers, fondling her breast with his hands: had the ivory lost its hardness? It softened at his touch, yielded to his fingers; it gave way, just as Hymettian wax softens in the sun – moulded by the thumb, shaped into many forms, rendered usable through use itself. The lover stood dumbfounded: he was joyful, he was doubtful, he was afraid that he was mistaken. Again and again, he re-examined the object of his prayers with his hands. Yes, it really was flesh. The throbbing veins pulsed beneath his probing finger . . .

Corpus erat: the fantasy has become real – 'it was a body'! Pygmalion thanks the goddess, and in the way Aphrodite knows best: consummation ensues.

For Pygmalion, the result was a son called Paphos ('from whom the Cretan island takes its name'). For subsequent readers of Ovid's poem, the outcome was a myth that symbolised the 'dream of the moving statue'. Not for nothing was the story most popular in the late nineteenth century, as witnessed by the paintings of Ernest Normand, Jean-Léon Gérôme, Edward Burne-Jones, Auguste Rodin, and Franz von Stuck (among others). At a time of rapid technological advancement, Pygmalion's dream seemed to prefigure the modernist reality – the fantasies of photographic replication, no less than the 'moving images' of film.

But it's the gender hierarchies behind the Pygmalion myth that deserve emphasis here. Pygmalion uses art to realise his fantasy of the feminine, just as Zeuxis was said to have done. And yet by being brought to life – and being converted into three dimensions – Pygmalion's statue goes even further than Zeuxis' painting: with the help of Aphrodite, Zeuxis' 'silent simulacrum' (*mutum . . . simulacrum*: Cicero, *On Invention*, 2.1.2) metamorphoses into penetrable flesh. With a little artistic invention, and a little help from one's goddess-friends, ideal idol turns living idle doll. Could there ever be a more succinct synopsis of western 'male gazing'?

Looking at Aphrodite

So far in this chapter, I have stressed what links ancient and modern 'ways of seeing' women. I have also tried to emphasise the stakes of the arguments – why the ancient material *matters* within modern-day debates about gender, pornography, and representation. At this point, though, I'm going to change tack. Turning to one particular image, I want to show how ancient and modern 'male gazes' are as different as they are similar.

My particular case study is Praxiteles' marble statue of Aphrodite, made in the middle of the fourth century BC: set up on Knidos, the statue was the sculptural centrepiece to a cult of 'Aphrodite Euploia' ('Aphrodite of the Fair Voyage'). Any talk of the image must begin with the customary note of caution: Praxiteles' marble original is lost. As one of the most celebrated artworks of all antiquity, it was removed to the western world's first

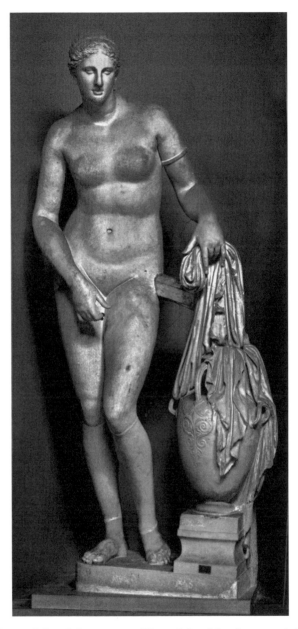

Fig. 34: 'Venus Colonna': Roman copy of Praxiteles' mid-fourth-century Aphrodite of Knidos. Unlike most Roman 'copies' of earlier Greek statues [e.g. **figs. 2, 24**], this marble imitation mirrors the marble medium of Praxiteles' mid-fourth-century original. Did Praxiteles judge marble more 'feminine' than bronze – in texture, shine or colour?

mega-museum in Constantinople, where it was probably destroyed by fire in AD 476 (cf. pp.186–7). In addition to the odd engravings of later coins, we have to make do with a range of replicas and modified 'versions'. True to form, Classical Archaeology has given each of these Aphodite-Venuses a title, and a hypothetical chronology to match: there's the 'Medici Venus' [**fig. 29**], 'Capitoline Venus', 'Melian Aphrodite', 'Crouching Aphrodite', 'Sandal-binding Aphrodite', 'Aphrodite Anadyomene', 'Capuan Aphrodite', 'Aphrodite of Arles', 'Aphrodite Kallipygos' ('delightfully derrièred') – to name but a few.

How, then, to reconstruct Praxiteles' original statue? Numerous replicas are known, each of them slightly different: the sculpture was imitated in a variety of shapes and sizes, and in miscellaneous media, all over the Mediterranean world. Like Zeuxis with his five maidens, Classical archaeologists have consequently compared the statues with one another: by putting together the 'best' parts of each copy, (male) scholars have tried to reconstruct their own 'idea[l]' of what Praxiteles' original must have looked like – German *Kopienkritik* and *Meisterforschung* in action ('critiquing copies', and 'searching for the master' behind them). The standard textbook image is a statue in the Vatican Museums, named after Rome's Colonna family, and towering at a super-lifesize 2.04 metres (just over 6½ feet) [**fig. 34**]. But even this 'most authentic' image has been deemed somewhat disappointing – excessively 'fleshy', 'stodgy', or 'flabby'. Almost every academic reaction has smacked of that fateful night *chez* the Ruskins: no flesh, it seems, could ever live up to the ideal.

One solution has been to turn to ancient texts. Greek and Latin authors were especially enthusiastic about the statue, contributing all the more to its post-Renaissance hype. By at least the first century AD, a series of anecdotes were circulating to explain the Knidian Aphrodite's origins. As ever, it's Pliny the Elder's discussion that has proved most influential (*Natural History*, 36.20–21):

Now, Praxiteles we have already mentioned in terms of sculptors in bronze. But the fame Praxiteles achieved in his marble works has

surpassed even Praxiteles' own. There are works by Praxiteles in the Kerameikos in Athens. But above all the others – not only those of Praxiteles, but in the whole wide world – is his Venus, which many people have sailed to Knidos to see. Now, Praxiteles made two Venuses and he put them up for sale together. The other Venus took on a draped appearance [*uelata specie*], and because of this the people of Cos preferred it – for they had first choice of the statues, even though they were both offered at the same price. The Coans thought this chaste, honourable, and proper [*seuerum id ac pudicum arbitrantes*]. But what of the Venus that they turned down? This was taken by the people of Knidos, and it achieved immeasurably greater renown [*inmensa differentia famae*]. Later Nicomedes, as King of the Coans, wanted to buy back the Venus from the Knidians: he promised that he would discharge their entire state debt (which was very large). But the Knidians preferred to endure anything but this. And how right they were! For it was Praxiteles who made Knidos famous, thanks to this statue [*signo*]. The shrine in which it stands is entirely open in construction so that the effigy of the goddess [*effigies deae*] can be seen from all sides – and the goddess herself condoned this, or so it's believed [*favente ipsa, ut creditur*]. She is equally wondrous from whichever way you look. There is a story that a man even fell in love with it: after hiding by night, it is said that he slept with the statue [*simulacro*] – and that there is a stain to prove it, testimony to his lustful desire.

Revealingly, Pliny never states that Praxiteles' second statue, displayed at Knidos, was depicted without clothes: so famous is the image that this critical detail goes unspoken, demonstrating Pliny's overarching point. But what's striking about Pliny's description is less his particular explanation of the statue's nudity than the assumption that it needed explaining in the first place. The story of Praxiteles' two statues was evidently useful in rationalising *how* an unclothed image of a goddess came to pass: at least from a first-century AD perspective, Praxiteles' statue was judged not only

a watershed, but also potentially shocking: the Coans turned down statue number one because they thought this the 'chaste, proper, and honourable' thing to do (*pudicum* at once connoting sexual chastity and moral decency).

So just how shocking was Praxiteles' Aphrodite in the fourth century BC? Some have rightly pointed out that, only one and a half centuries previously, stately clothed korai represented Greek art at its most *avant-garde* (*kore* literally means 'maiden', although the categorising artistic label is more modern than it is ancient). The most striking aspect of these statues, surviving in number from the sixth-century Athenian Acropolis, is what they wear. Where Archaic kouroi strutted their stuff in the buff [e.g. **figs. 17–21**], korai were never naked: whether serving as votive offering or funerary markers, they were always decorously clothed, decked out in *peplos* or *chiton* (and indeed sometimes both). By the end of the sixth century, Athenian artists had become masters at modelling the suggestive curves underneath the drapery. But the Archaic female body, as opposed to the male, was above all a site for decoration. The feminine resembled an empty canvas that had to be ordered, clothed, and adorned; a panoply of polychrome, moreover, was used to ornament the body around a series of geometric shapes [**fig. 35**]. Like Archaic women themselves, korai functioned as objects symbolising (male) social exchange. Yes, korai might allure, bewitch, and cajole (nudity and eroticism, after all, never correlate quite so directly). And yet female korai were not eroticised – at least not in the same way, or to the same extent, as male kouroi.

Standards of propriety seem to have been somewhat relaxed during the course of the fifth century. Inspect the figures of Aphrodite and Dione on the Parthenon's east pediment, for example, and we find the diaphanous drapery accentuating as much as occluding the voluptuous breasts. According to one drawing of the west pediment (made before so much of the Parthenon was destroyed in 1687), Aphrodite might just possibly have been shown unclothed on the Parthenon's opposite side. Later Roman copies suggest that the mortal Niobe was also figured at least half-naked in another temple pediment sculpture, dating to the mid-fifth century.

As Athenian vase-painting testifies, female bodies *could* be shown without

Fig. 35 (cf. **pl.** 7): Painted recon-
struction of the 'Peplos kore', erected
on the Athenian Acropolis c. 530 BC.
The exact restoration of colour and
attributes remains disputed: some
argue that this female figure held a
bow in her left hand, and the
patterned dress was certainly yellow,
not red. But an image like this demon-
strates how removed from ancient
reality our modern ideas about 'the
ancient art of the body' can be: the
vast majority of marble statues were
originally painted, and often in bright
(and gaudy?) colours.

clothes, and there are plenty of examples from both the fifth and sixth
centuries. To appear naked on a painted pot, though, was more or less
synonymous with being a *hetaira*, or 'companion' prostitute; what's more,
these images were usually associated with the male *symposium* drinking-
party – they occupied a topsy-turvy world of their own. True, Greek myth
sometimes necessitated the unclothing of more reputable female protago-
nists: from the early sixth century onwards, Cassandra was depicted naked
before the Younger Ajax (Ajax raped Cassandra in Athena's sanctuary during
the sack of Troy). But Cassandra's state of undress had particular narrative
connotations, conveying her desirability on the one hand, and her vulner-
ability on the other. In any case – and this point is crucial – Cassandra was
no goddess. So how could such associations be squared with the image of
a *deity*?

Aphrodite's nakedness evidently did require a degree of narrative expla-
nation. Observe, for instance, how Praxiteles presented an alibi for his
stripped-down statue [**fig. 34**]. The water jar at Aphrodite's side, crowned

Fig. 36: Reconstruction of Aphrodite's *tholos* temple at Knidos. This watercolour impression of the Knidian temple is based on research in the 1960s and early 1970s. More recent excavators, though, deem this to be a later building constructed only in the second century BC.

with her clothes (grasped in the goddess' left hand and cascading down the jar), provides the fictional excuse for the naked presentation: we see Aphrodite either before or just after her bath. This is not just a tell-tale sign of the 'Roman' copy, designed to support an upright marble figure. Praxiteles' statue was originally made of marble, not bronze, and this feature is clearly distinguishable on coins emblazoned with the statue.

Those keen to emphasise the ancient derivation of the modern 'male gaze' will see this as the quintessentially 'feminine' *baigneuse* moment. Just as later female nudes are shown in the act of beautifying themselves – preparing themselves to be surveyed by men [**fig. 27**] – the Knidian

Aphrodite busies herself with her objectified 'to-be-looked-at-ness'. In this context, we should recall what Pliny says about the statue's original shrine at Knidos, 'openly constructed so that the effigy of the goddess can be seen from all sides'. Archaeological excavations have sometimes been thought to confirm Pliny's suggestion. Although our knowledge of the fourth-century context at Knidos is decidedly shaky, the statue appears to have been displayed in a circular temple overlooking the sea, at least by the second century BC: viewers were encouraged to walk around the image, in other words, stealing a variety of views between the columns [**fig. 36**]. This architectural setting

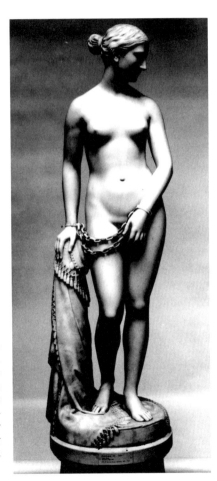

Fig. 37: Hiram Powers, *Greek Slave*, 1844. Working in Florence, the American sculptor took his inspiration from the 'Medici Venus' [**fig. 29**]. The statue is 'Greek' not only in style, but also in modern-day subject: Powers imagines his female 'slave' to be an innocent Greek islander, sold into sex by the terrible Turks during the Greek War of Independence (hence the Christian cross beneath her right hand).

appears to have become almost as famous as the statue itself. When the Emperor Hadrian included a Knidian section within his Disney-style world-in-a-park at Tivoli, for instance, he secured replicas of *both* the statue and its temple.

For some, the echoes with John Berger will prove deafening. 'Woman, thus fashioned, is reduced in a humiliating way to her sexuality', writes Nanette Salomon of the Knidian statue: 'the immediate and long-term implications of this fiction in the visual arts are incalculable'. Subsequent artists would complete the patriarchal subjugation. When Hiram Powers' infamous statue of a *Greek Slave* added chains to his own adaptation of the statue [**fig. 37**], for example, wasn't he literalising the shackles that already imprison post-Praxitelean Woman? Carved in Florence, and a *cause célèbre* during the 1851 Great Exhibition in London, the *Greek Slave* was set up on its own automatically revolving turntable. Powers' statue therefore embodies the ultimate in female *dis*empowerment, perpetuating not only the body of the Knidian Aphrodite, but also her passive 'to-be-looked-at-ness'. Modern woman is enslaved through the ancient Greek: the female nude performs a revolving dance for her cocksure male scopophiliacs.

Aphrodite looks back

But is this the only story to be told of the Knidian Aphrodite?

To my mind, what gets squeezed out of this account – what *always* gets squeezed out of our modern art histories – are questions of religion. Aphrodite might be female, but she was also a goddess. Whatever the erotic frisson, responses therefore had to negotiate a complex set of religious issues: just exactly what *was* 'Aphrodite', and how did she relate to this sculpted power-portal on earth?

For modern western viewers, the statue's 'divinity' can seem something of a formality. Conditioned by two millennia of Christian thinking, swayed by the renewed Renaissance resort to allegory [cf. **fig. 4**], and brainwashed by the Reformation's secularisation of 'art' [cf. **fig. 70**], few modern-day western viewers could ever imagine *fearing* Praxiteles' image (except, perhaps,

via some Freudian neurosis). At most, 'Aphrodite' and 'Venus' are empty and disembodied personifications: neither the goddess, nor the statue that figures her, are in any sense 'real'. Viewing an image like the Knidian Aphrodite, we find it nigh on impossible to shake off this theological conditioning. But could ancient viewers disentangle themselves from their own, very different, religious assumptions?

Even among those Greek and Roman authors who 'rationalise' the Knidian Aphrodite – removing it from its cultic frame, re-situating it within the grand history of Greek masterworks – religion continued to inform their response. So it is, for example, that Pliny the Elder – that supposed 'encyclopaedist' of enlightened Imperial Rome – seems rather uncertain about the statue's phenomenology. Recall Pliny's aside about the statue's display context (p.91): just what does Pliny mean when he claims that 'the goddess condoned this herself'? For that matter, note how Pliny talks of Praxiteles' material statue (*species*, *signum*, *simulacrum*, *effigies*), and yet introduces the image as 'Venus' per se. This 'effigy of the goddess' is both a sculpture *and* a divinity: the Knidian Aphrodite is at once an 'it' *and* a 'she'.

The *Erotes* – a Greek dramalogue ascribed to the second-century AD writer Lucian – helps to elaborate the point (the text's real authorship and date need not distract us). As the title suggests, the discourse revolves around different objects of sexual desire, or *eros* – hence Michel Foucault's celebrated interest. The text takes the form of a dialogue between two friends, one from Corinth, the other from Athens: the Corinthian advocates sex with women, the Athenian (predictably) commends shagging boys. But standing before Praxiteles' image on Knidos, both men find themselves equally turned on. Such is the erotic power of the Knidian Aphrodite that the statue arouses homo- and hetero-erotic desire alike: the one collapses into fay eulogy 'under the spell of the (sight of the) goddess' [*entheastikōs*]; the other weeps in silent adulation – as though *he* were in fact the petrified statue.

At this point, our narrator notices something strange. There's a mark on the statue, and in rather a curious place (*Erotes*, 15):

When our surfeit of wonder had peaked, we saw a mark on one of the thighs: it looked like a stain on a dress, and the dazzling resplendence of the stone in every other way made the blemish all the more conspicuous. For my part, I hazarded a likely guess at the truth: I reckoned that we saw a natural defect in the stone. After all, even these sorts of things are subject to trauma – works of potential beauty can be handicapped through the vicissitudes of chance. Supposing that the black mark was a physical blemish, I therefore marvelled at this aspect of Praxiteles too: for he had concealed the stone's blemish among the parts that couldn't be scrutinised so closely.

No sooner does the speaker voice this first explanation than the female warden proffers a second – related to the story already told by Pliny (cf. p.91), as well as by several others (e.g. p.173). Once upon a time, a nobleman visited the precinct and fell in love with Praxiteles' statue. To begin with, his actions feigned piety: like the locked-out lover of Classical love elegy, the nobleman passed each night outside the shrine – last out at sunset, and first in at sunrise. But fanatical obsession quickly set in: the man dedicated all his possessions to the goddess (or her statue?) and carved her name on every tree ('Aphrodite – Beauty'). He even worshipped Praxiteles as a god – as Zeus himself, no less. Finally, desire overwhelmed him (*Erotes*, 16):

> While the sun was sinking toward nightfall, quietly and without being noticed by the people present, the man slipped in behind the door. Standing unseen in the innermost sanctum, he kept still, barely drawing breath. When the attendants locked the door from the outside, according to the usual practice, this new Anchises was locked inside. But why am I rambling and telling you in such scrupulous detail about the reckless goings-on during that unspeakable night? These traces of his sex-soaked clinches were spotted after daylight returned: the deity had this stain to prove the traumas she had suffered. As for the young man himself, according to the tales of the townspeople, he's reputed to have launched himself over a cliff or

else down under the waves of the sea. Either way, he's said to have utterly disappeared.

The predictable effect of all this is to sanction our 'male gazing' all the more (albeit through the obfuscating-cum-enlightening filter of this text). To validate the story, don't we have to take a long, hard look *between* the Knidian Aphrodite's legs?

But this is not quite the 'male gaze' as we know it. There are hints that the viewed female object controls the situation after all. Consider what becomes of the story's protagonist. The poor man finds out the hard way, as it were, that the Knidian Aphrodite is *more* (and indeed less!) than just a statue. In some sense, this is the Pygmalion story turned tragic: Praxiteles' image arouses something wholly uncontrollable in our male viewer, testifying to the embodied goddess' power; but instead of intervening to save the day (or revealing herself in the flesh, as she did to the 'original' Anchises of the *Homeric Hymn to Aphrodite*), the goddess now punishes her assailant. The man is said 'to have utterly disappeared' (*pantelōs aphanē genesthai*), perhaps subsumed within the swell of the sea – an appropriate ending for all concerned given Aphrodite's 'foam-born' origins [cf. **fig. 4**].

The warden's story leaves our protagonists debating the homo- and hetero-erotic ins and outs: had Aphrodite been taken 'as a boy' or 'as a girl'? But for the readers of Pseudo-Lucian's text, the story unleashes a panoply of unsettling questions. Does the viewer lord it over the statue, or does the statue control the viewer? Is this an image, or a goddess? Do we look at Aphrodite, or does *she* look at *you* (looking at her looking at you looking at her looking at you . . .)?

The issue of a *reciprocal* gaze between viewing subject and viewed object might remind us of the mini-trauma reported by renowned twentieth-century French psychoanalyst, Jacques Lacan. Lacan relates how, as a young boy accompanying local trawlers out at sea, he saw a sardine-tin floating on the ocean's surface. 'You see that can? Do you see it?', shouted one of the fishermen to the lad; 'well, *it* doesn't see *you*!' Lacan would later regale the story to expound his theories of visual subjectivity: technically speaking

– on the level of light falling upon objects – the can *could* see the young boy; what the object lacked, Lacan explains, were the subjective faculties that make the act of gazing – *le regard* – so fundamental to the formation of the human ego.

Reading Lacan's story alongside ancient anecdotes about the Knidian Aphrodite, we see that distinctions between agent and object could be still more complex and confused in the Graeco-Roman world. Was Praxiteles' Aphrodite an object (a representation), or was she an actual being (the goddess herself, present before us)? The story in the *Erotes* swings both ways. On the one hand, the fatal folly of our nameless protagonist was to mistake the statue for a *real* woman (or for that matter a real boy). On the other hand, we need only recall the story's sticky ending: doesn't the 'disappearance' of the man suggest some vengeful, totemic, all-powerful presence after all? This *eikon* is both a likeness and an illusion: the statue slips back and forth between the poles of possession and possessor – between subjective being and hollow sardine-can. As the object of *le regard*, it (or should that again be she?) is always ready to mirror our gaze – and avenge the potential transgressor. To repeat Richard Wollheim's terms (cf. p.67), the statue encouraged its audience both 'to see as' and 'to see in': viewers at once equate image with goddess (the statue *as* Aphrodite), and dismiss it as a material support (the identification with the goddess projected within from without).

Some of the most interesting meditations on this question are to be found in a sequence of epigrams preserved in a much later Byzantine poetry book: the so-called *Planudean Anthology*. Twelve poems on the Knidian Aphrodite are known in total (*Anth. Plan.*, 159–70): the majority are anonymous, and just a handful can be attributed to Hellenistic authors of the third to first centuries BC. The epigrams revolve around a single question, spoken by the goddess: 'where did Praxiteles see me naked [*gymnos*]'? This was a dilemma that evidently perplexed ancient critics. One favourite response was to claim that the statue was modelled not after the goddess, but rather a fourth-century prostitute named Phryne. Enamoured with the young Phryne ('more beautiful in her *unseen* parts', according to Athenaeus,

13.590f), Praxiteles promptly immortalised her in marble: this was the statue to be seen on Knidos. Whatever the truth of the story, it served as a convenient let-out for a wholly more 'mortal' mode of looking. If the statue was modelled not after a goddess, but instead a glorified hooker (Phryne literally means 'toad'), can we not wank away at will – and without fear of divine reproach or retribution?

But Phryne goes unmentioned in the *Planudean Anthology* poems. In response to Aphrodite's question – 'where did Praxiteles see me naked?' – the epigrams toy with a more diverse set of answers, each knowingly trumping the last. Most imagine Aphrodite appearing to some famous mythological male viewer: the statue renders the goddess as she revealed herself to Paris, Anchises, or Ares. So what about the markedly less heroic artist – how could *Praxiteles* have seen Aphrodite naked?

Operating behind the various responses to this question, most of them just two lines in length, lies a single poetic conceit: that Praxiteles' Aphrodite is really 'the' Aphrodite. First, there is the game of direct address – a favourite tactic of Greek epigrams on artworks: the fact that Aphrodite herself speaks makes it deliberately unclear as to whether the voice comes from the statue, or rather from some unseen power behind it. This is matched by a second, more upfront confession: namely, that the Knidian statue is in fact no statue at all. Either the image is the work of Praxiteles, as one poet puts it, or else Aphrodite has descended to Knidos (*Anth. Plan.*, 159); this is not a crafted image, in the words of another, but the statue reveals the goddess herself, frozen in the position adopted for the Judgement of Paris (*Anth. Plan.*, 161).

Behind these poems lies the enduring ancient rhetoric of naturalistic illusionism, already explored in our second chapter: the Knidian replication is so convincing that it stands for the referent replicated (cf. pp.63–4). But the epigrams also contest grander questions about exactly *what* that referent is, and *how* it came to be materially embodied. Each poem self-consciously explores the different degrees of representation – better, the 'ontology' – figured through Praxiteles' 'nude' goddess. Wishing to see her image, as one poet relates, Aphrodite travelled to Knidos: she found that,

yes, Praxiteles really had revealed her *gymnos* (*Anth. Plan.*, 160) – both 'unclothed' and, in the more metaphorical sense, 'stripped bare'. With Aphrodite standing before Aphrodite, image before goddess, is there any way of determining which 'Aphrodite' is which?

As Verity Platt has argued, such poetic play on the boundaries between reality and artifice was evidently good to think with in the context of 'ecphrastic' epigrams like these, written as pithy verbal rejoinders to visual stimuli: the ambiguities of the mirroring Aphrodites – embodied goddess and embodied image – at once figure and reflect the ambiguities of translating seeable subject into sayable poem. At the same time, this 'metapoetic' mode of reading the Aphrodite of Knidos epigrams is itself predicated upon ideas about 'facing the gods' in the first place: the 'uncovered' (image of the) Knidian goddess provides a subtext for thinking through Aphrodite's 'naked' numinal power. Just what might it mean to encounter a *gymnos* godhead?

Fatal attraction

These are themes to which we'll return in the fifth chapter. When it came to 'cult statues' of the gods, as we'll see, the ancient world might be said to have had its cake and eaten it: images both did and didn't materialise the divine (compare the epigrammatic *mise-en-abyme* of Aphrodites with the mirroring Apollos of **fig. 60**, for instance). For now, though, I want to think about such theological questions in relation to 'ways of seeing' the Knidian statue. If Praxiteles' statue was not just some representation, but in some sense the present goddess herself, how might this complicate the dynamics between male viewing 'subject' and female 'object' viewed?

In considering this question, antiquity possessed a very special cultural resource: the parallel world of myth. An endless array of stories was constructed to theorise the dynamics of looking, each set in the misty half-light of the past. The majority bound narratives of viewing with stories of subjective desire. There was Narcissus, for example, who fell in love with

his own 'narcissistic' reflection. Or think of Orpheus, forbidden from gazing upon his dead wife Eurydice until they had reached the light of day – albeit in vain. The visual depiction of such stories implicated their own material forms within the discourses of viewing that they mythologised. Did ever a culture weave so intricate a web of meta-pictorial thinking?

Still more myths addressed the issue of looking upon gods specifically. Stories were invented to explain why divinities fell in love with mortals, as well as how the gods appeared to them. When Zeus had his wicked way with nymphs and mortal concubines, he took on a variety of shapes and sizes: a phallically suggestive swan (for Leda); a bull (for Europa – an inversion of the story of Io, who played heifer to the *torero*-like Zeus); even a cascade of gold (Danae's prototypical 'golden shower'). The fate of poor Semele demonstrates what might happen when due precautions were not followed. Tricked by Hera, Semele insisted that Zeus reveal himself to her *without* disguise – *gymnos*, so to speak. As Hera knew all along, the consequences were disastrous. With Semele instantly consumed by fire, Zeus had to salvage his progeny from its mother's incinerated limbs: the embryo would gestate into Dionysus.

These are all stories about a male divinity appearing to lesser female mortals or nymphs. Needless to say, they helped to police male–female hierarchies of gazing. Women know your limits: just see what happens when the likes of Semele aspire to the masculine realm of 'gazing' rather than the feminine realm of 'being gazed at'! But these myths also threw gods into the equation. In the scissors-paper-stone stakes, male divinities would always win out over female humans. But what about *mortal* men gazing at *immortal* women: how were earthly hierarchies of gender to be squared with the higher supremacy of gods and goddesses?

Once again, Greek mythology was at hand to provide an answer, or at least a discursive framework. One particularly famous story concerns the hunter-goddess Artemis (known to the Romans as Diana) and an unsuspecting Theban youth named Actaeon. As with the story of Pygmalion, the most enduring version comes in Ovid's *Metamorphoses* (3.138–252). In this case, though, we can be sure that earlier versions of the myth were

already circulating in the sixth century BC – depicted on Athenian vases, among other media.

Ovid's story runs something like this. Once upon a time, hunting in the wild thickets of a far-off forest, the young Actaeon came across a strange and wonderful sight: he saw the goddess Artemis bathing naked in a spring. Ovid is at pains to protest Actaeon's innocence: he hadn't *meant* to stumble across the goddess; in any case, he'd been heading homeward, 'straying with aimless steps'. But the hero wasn't given a moment to explain. The goddess gathered a handful of water and threw it in Actaeon's face: 'now tell, if tell you can, of having seen me naked!' We hear no more from Actaeon – at least, no more *words*. His neck lengthens, his ears stretch, a dappled hide extends over his body. Terrified, Actaeon races off, stealing a glimpse at his reflection along the way: were those *horns* on his head?

At that moment, staring at his reflection, the poor creature is spied by his hunting hounds, replaying the moment when Actaeon caught sight of Artemis in the water. The man-stag's fate is sealed, as the dogs chase him across the craggy wilderness (vv.237–52):

Actaeon groans – making a noise that no deer could sound, but still not quite human. He knows these ridges so well, but now fills them with mournful cries. Down on his knees, beseeching the dogs like one in prayer, he turns his silent head from side to side – as though stretching his arms out in human supplication. His hunting companions, unaware of the struggle, urge on the ravenous pack with their wanton cries. They look around them for Actaeon. 'ACT-AE-ON!', they shout, each one vying with the other; they think him far away – though Actaeon turns his head upon hearing the name. They grumble that he's not there: is it through sluggishness that Actaeon misses the sight of the prey?

Well might Actaeon wish to be absent. But he isn't: he's here. Well might he wish to see the ferocious accomplishments of his very own hounds. But he doesn't: he feels them. The hounds now surround him on every side, muzzling their fangs into his fleshy body. In the

deceptive shape of this deer, the master is mangled into mouth-sized morsels. The wrath of Quiver-bearing Diana, they say, was only appeased when Actaeon's life was ended – and ended in innumerable traumas.

Ovid leaves the ethics of all this decidedly vague (vv.253–9). Some, he explains, deemed the punishment out of proportion with the crime (hadn't Actaeon only seen Artemis' face?); others heartily approved (divine virginity must be protected at all costs!). Only Juno kept shtum – busy plotting against Semele. Still, the moral stood nonetheless: woe betide the man who sees a goddess naked!

What has all this to do with the Knidian Aphrodite? The story of Actaeon's exemplarily transgressive view of the naked Artemis must at some level *always* have intersected with responses to the Praxitelean statue. Recall the water jar and drapery at the Knidian statue's side: not for nothing was this Aphrodite also shown in the act of bathing. Of course, the reasonable objection might come that Artemis and Aphrodite were very different goddesses, the one freeze-framing a sexless ideal of maiden virginity, the other embodying the pleasures beneath the navel. The polarity already informs Euripides' *Hippolytus* in the late fifth century, where statues of the two goddesses seem to have occupied stage left and right, each steering the dramatic plot in polar directions. As the embodiment of pleasure beneath the navel – the 'genital-loving' goddess (Hesiod, *Theogony*, 200) – was it *alright* to spy the naked Aphrodite in a way that it was not alright to see the naked Artemis?

But matters were never quite that simple. Significant here is the way in which the myth of Actaeon could in fact be replayed in relation to other naked goddesses (and vice versa). Take, most famously, Callimachus' *Hymn to Athena*, composed in the third century BC. According to a myth stretching back to at least the fifth century (it's cited by an Athenian genealogist named Pherecydes), Callimachus tells of a bath not of Artemis, but of Athena. The protagonist is Teiresias, renowned throughout antiquity for his powers of prophecy. But how were those powers acquired? Callimachus'

story provides one 'aetiological' answer. Just as Actaeon had caught sight of Artemis, the poet explains, Teiresias accidentally happened upon Athena while she was bathing naked. Punishment was immediate: Athena blinded Teiresias because he 'had unwittingly seen that which is not lawful to see' (*Hymns*, 5.78). When Chariklo, Teiresias' mother, bitterly protests against her son's fate, Athena cites the example of Actaeon (vv.107–16): how much worse the punishment could have been; besides, Teiresias' blindness will be offset by the gift of prophecy (such is Athena's mercy, or rather Artemis' vindictiveness). In the course of her monologue, Athena is made to say something very revealing: such matters, Athena declares, are out of her control. The goddess had no choice. She was only following the rules. The supreme law of Kronos dictated it so: 'whosoever beholds any of the immortal gods, when the god himself chooses otherwise, beholds this god at a heavy price' (vv.101–2).

When looking back at Praxiteles' statue at Knidos, we therefore have to ask ourselves: did Aphrodite *choose* to be seen in this way? In answering that question, viewers had to wrestle with a distinctive formal feature, evident in countless surviving copies. As numerous critics have noted, interpretations of the statue differ according to the angle from which it's viewed. Approach **fig. 34** from up-front, and the hand prohibits visual access to Aphrodite's most revealing parts. Proceed just a few steps to the right, though, so as to meet the goddess' gaze, and the genitals are now uncovered: the right hand turns into a handy pointer – showing us where to look. So does the statue attempt to stop us from viewing? Or does it invite our gaze? Our answers quite literally go round in circles as we take part in this drama of undress. Is the hand a warning not to go any further? Does Aphrodite recognise the viewer as reprobate or worshipper? Can Aphrodite still see us as we proceed around the back of the statue and full circle back round to the front?

My point is that, at least in antiquity, such questions could solicit no straightforward answers. Indeed, regardless of the statue's original architectural context, the shrines at Knidos and Tivoli seem to have been designed with this idea of perambulation in mind [**fig. 36**]. Just as the statue vacil-

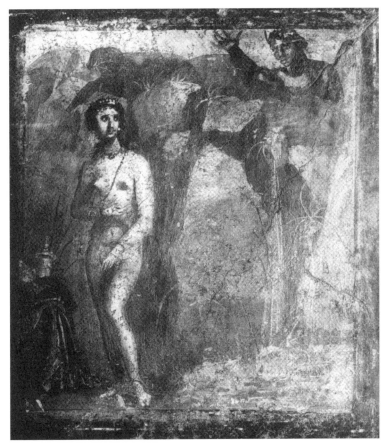

Fig. 38: 'Fourth Style' wall painting from a cubiculum in the Casa degli Amorini Dorati, Pompeii VI.16.7. Actaeon stumbles across a rather statuesque Artemis – and suffers the consequences (note the emerging horns on his forehead). Artemis' pose combines the lower schema of the Knidian Aphrodite [**fig. 34**] with the upper body of the 'Medici' [**fig. 29**] and 'Capitoline' Venuses. The two adjacent walls featured related panels of a half-naked Aphrodite and a naked Leda with the Zeus-Swan.

lates between goddess and image – between divine presence and removed representation – so too it at once prohibits and invites our gaze. To put it another way, issues of divine consent are laid over the statue's ambiguity between image and deity. Our shuffling views of the statue contribute to the sense of animation: there's a religious rhetoric to this game of genital peekaboo.

There could be no easy way of making up one's mind about the nature of the image, or indeed the permissibility of its form. Unlike a bathing Artemis and Athena, perhaps a bathing Aphrodite would *not* punish an Actaeon or a Teiresias: after making love in the *Homeric Hymn to Aphrodite*, the goddess is said to have explicitly invited Anchises to look upon her naked godhead (vv.177–9). In any case, isn't this just a celebrated Praxitelean masterpiece – Pliny's must-see tourist destination (the tutelary talisman governing over the local economy, and at certain times over its coinage)? But then that niggling doubt creeps back in. Maybe the quintessential *femme fatale* does return our gaze? Are these fellow-tourists, or fellow-pilgrims? Should we stroke our crotch, or look away (remember Pliny's description of the 'chaste, honourable, and proper' Coans)? To view the statue is to partake in a visual version of Russian roulette: there's *always* the threat that we too might go the way of Actaeon, Teiresias, or indeed the poor assailant of Pseudo-Lucian's story. The danger makes the whole experience more carnally real, erogenous, indeed more venereal: Aphrodite's epiphany becomes all the more *divine*.

With these issues in mind, it's worth adding a final footnote. By the time Pompeian artists came to represent the Actaeon myth, they chose a highly significant schema for the naked Artemis: the goddess is revealed in the established post-Praxitelean iconography of the naked Aphrodite. The myth of Artemis and Actaeon was among the favourite subjects of Pompeian wall-painting in the first century AD, with over 21 instances known. Second-century sarcophagi also favoured the theme, albeit much more rarely: the myth of Actaeon viewing Artemis was evidently appropriate for figuring the gaze between the living and the dead. But in almost every case, Artemis was shown adopting the naked guise of the Knidian Aphrodite and her descendants – whether the 'Crouching Aphrodite' (as in the dining *triclinium* of Casa del Frutteto, Pompeii 1.9.5), or the so-called 'Capitoline' Aphrodite type (as in **fig. 38**).

Whatever we make of such images of the naked *Artemis*, they demonstrate the interwoven problematics of encountering the naked *Aphrodite*. The translation of the three-dimensional sculpture of one goddess into a

two-dimensional painting of the other teases out the interconnecting theological stakes: the legend of Praxiteles' Knidian Aphrodite, as celebrated masterwork, is quite literally inscribed into the myth of Actaeon and Artemis (and the other way round). The implications of this connection are left unspoken. And yet, as with the Knidian prototype, a series of questions ensues. Is a two-dimensional picture of the three-dimensional statue of the naked body of the goddess now sufficiently removed from that 'real' deity? Should the Aphroditean pose pardon the Artemisian subject? Does the change in medium exonerate Pompeian viewers? Or is this all special pleading – do we face the same danger as Actaeon after all (*caue canem* – 'beware the dog!')?

Slapping with slippers

We have ended this chapter on a markedly different note from the one on which we began. Graeco-Roman 'ways of viewing' a female image like the Knidian Aphrodite are necessarily removed – theologically and, therefore, culturally – from later western modes of approaching the aestheticised images of modernity. For all the evident bonds between ancient and modern representations of the 'female nude', ancient 'ways of seeing' were tempered with anxieties of transgression quite different from the 'male gaze' as we know it.

This chapter has therefore demonstrated in its own right how ancient and modern imagery can inform one another. It's of course understandable to have sought to emphasise the connections binding Graeco-Roman traditions to our own; in doing so, moreover, it's surely right to have challenged the gendered power hierarchies at stake. But there are dangers in weaving too essentialist a tale: historical difference gets collapsed. The perspectives of posterity illuminate some things about Graeco-Roman representations. Hindsight, however, necessarily occludes others. Just as the subsequent tradition of the western 'female nude' therefore enables us to see the gender politics involved in ancient representations of the unclothed female body, perhaps ancient images can help to reconstruct more nuanced 'ways of

seeing' gender in the modern world. Might the Knidian Aphrodite demonstrate how power can lie on *both* sides of the looking and being-looked-at divide, while simultaneously complicating that divide in various ways?

If ancient 'female nudes' can therefore reveal something about contemporary concepts of gender, they also raise important questions about modern sexuality. When we think about the art of the female body within the larger Graeco-Roman visual repertoire, what is perhaps most striking is how few ancient unclothed female images there were in relation to 'male nudes'. Berger's diagnosis of 'man' and 'woman' in western art – the one looking, the other being looked at – assumes certain norms of sexuality that are, at least to some extent, the product of our own modern making. To put it another way, our whole notion of the 'male gaze' is predicated upon modern heterosexual norms which do not easily map onto the ancient world: just remember the gender-bending terms in which Pseudo-Lucian talks of the Aphrodite of Knidos – celebrated as much for its *boyish* as for its *girlish* looks.

It's also worth noting how much our western 'ways of seeing' have changed since 1972. With undressed *male* models now occupying a greater share of American and European print-ads than ever before, the 'male gaze' has turned distinctly 'homospectatorial' – with men increasingly looking at nude men being looked at: just walk into any Abercrombie & Fitch store, or think about modern-day adverts for sexy male underwear, aftershave, even new 'just for men' cosmetics. Contemporary models of the ideal masculine physique are likewise becoming just as impossible (not to mention contradictory) as contemporary models of feminine beauty. In 1974, soon after Berger was writing, the dimensions of a 'GI Joe' action figure translated into a male body with a 44-inch chest, 31-inch waist and 12-inch biceps; today, the same male model would have a 50-inch chest, a 28-inch waist and 22-inch biceps – impossibly bigger *and* thinner. No wonder that 'manorexia' is on the rise: have western men begun to experience the sorts of objectification that were once the prerogative of western women alone?

I want to end this chapter, though, with a statue group that might be said to straddle 'ancient' and 'modern' ideas of 'female nudity' [**fig. 39**].

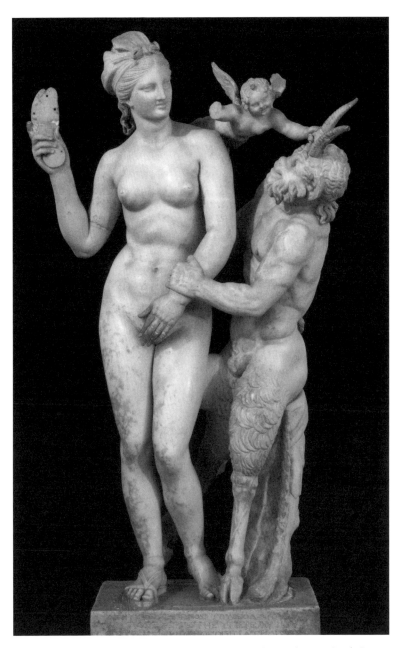

Fig. 39 (cf. **pl. 8**): Statue group of Aphrodite, Pan and Eros from Delos ('Slipper-Slapper' group), c. 100 BC. Pan's two phallic horns make him literally 'horny' – a common word-play in ancient Greek. But how do external mortal viewers relate to the divine voyeur within the statue?

The sculpture, just under life-size, was found in a house on the Cycladic island of Delos (the so-called 'House of the Poseidoniasts'); it dates to around 100 BC. Scholars have long taken a dislike to the group, condemning its 'Carry-On' kitsch: they have disapproved of the sculptural joins, criticised Aphrodite's elongated right arm, and censured her comedy 'page-3 girl' breasts (with their almost Pamela-Anderson look of silicon enhancement). For our purposes, though, questions of 'quality' are of little relevance. What interests me, rather, is the way in which the statue negotiates the different issues navigated in this chapter.

To explain what I mean, take a closer look at the group's iconography and composition. The schema of Aphrodite clearly echoes that of the Knidian statue [**fig. 34**]: while the legs are in the Knidian position, and the head turned in the same direction, the goddess shields her crotch with her left hand rather than her right, following the so-called 'Medici' [**fig. 29**] and 'Capitoline' types. The rationale is clear: Aphrodite's right hand is freed to hold a slipper, and the left arm now stands at the centre of a dramatic struggle. Beside Aphrodite – where Praxiteles rendered the goddess' water jar and clothing – the marble support has been turned into a shaggy goat-man of a god. This is Pan, associated with the rustic wildernesses of Arcadia, and he is trying to prise away Aphrodite's concealing hand. Between the two figures flies a winged Eros, springing from his mother's back. Eros' right arm is lost, but he grips Pan's horns with his left.

What is so sophisticated about this group is its reworking of the Knidian model. On the one hand, our 'Slipper-Slapper' group has come clean about the prying prurience of the Praxitelean prototype. The male voyeur is here rendered *within* the drama, embodied in the randy figure of Pan. Where viewers of the Knidian Aphrodite had to walk around the statue to magic away the goddess' arm, this peeping Pan uses physical force. This is not just a memorial to female objectification, nor a monument to sexual harassment: in some sense, the group might be said to literalise the concept of representation as rape. Aphrodite becomes passive victim – 'looked at and gazed at and stared at by men'. Indeed, following Mulvey's prognosis of western woman, we might even say that this feminine subject is not really

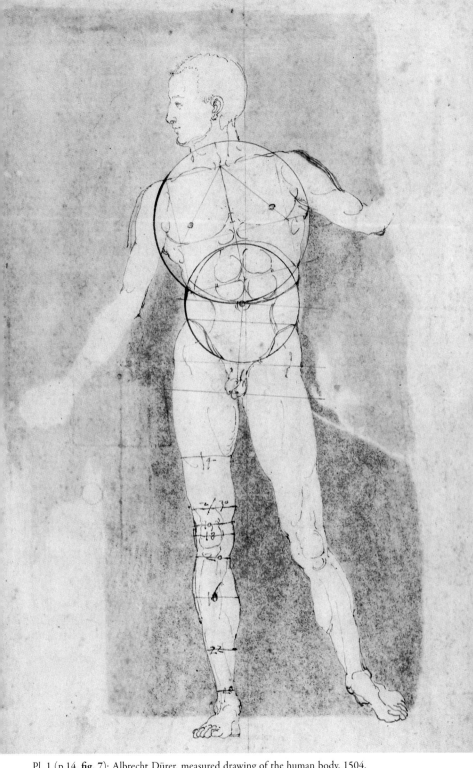

Pl. 1 (p.14, **fig. 7**): Albrecht Dürer, measured drawing of the human body, 1504.

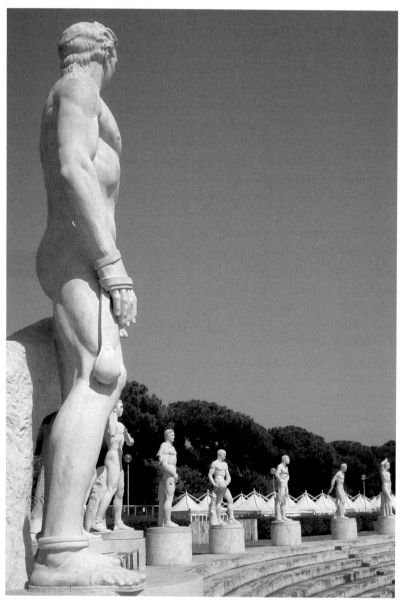

Pl. 2 (cf. p.23, **fig. 13**): View of the Carraran marble sculptures surrounding the Stadio dei Marmi in Rome's Foro Italico, inaugurated in 1932.

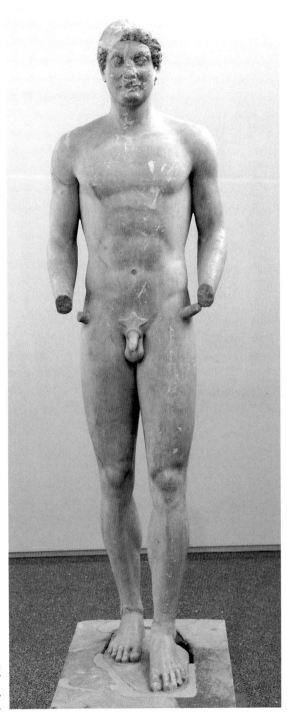

Pl. 3 (p.41, **fig. 20**):
Inscribed 'Aristodikos'
kouros from Attica,
c. 510 BC.

Pl. 4 (p.61, **fig. 26**): Riace bronze 'Warrior A', cast between c. 470 and 430 BC.

Pl. 5 (p.70, **fig. 27**): Diego Rodríguez Velázquez, *The Toilet of Venus* (*Rokeby Venus*), 1647–51.

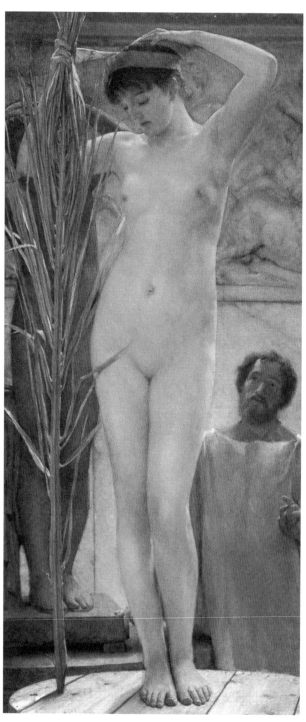

Pl. 6 (p.74, **fig. 30**): Sir Lawrence Alma-Tadema, *A Sculptor's Model*, 1877.

Pl. 7 (p.93, **fig. 35**): Painted reconstruction of the 'Peplos kore', erected on the Athenian Acropolis c. 530 BC.

Pl. 8 (p.111, **fig. 39**): Statue group of Aphrodite, Pan and Eros from Delos ('Slipper-Slapper' group), c. 100 BC.

Pl. 9 (p.137, **fig. 50**): Marble Prima Porta Augustus, perhaps an early first-century AD copy of an earlier statue (c. 20 BC).

Pl. 10 (p.150, **fig. 55**):
Portrait and mummy
case of Artemidorus,
from Hawara in Egypt,
early second century AD.

Pl. 11 (p.155, **fig. 56**): Tommaso Laureti, *Triumph of Christianity*, c. 1585.

Pl. 12 (p.164, **fig. 58**): Reconstruction of Pheidias' chryselephantine ('gold and ivory') statue of Athena Parthenos in the Athenian Parthenon, c. 440 BC.

Pl. 13 (p.166, **fig. 60**): Fragment of an Apulian red-figure krater in Amsterdam's Allard Pierson Museum, c. 380 BC.

Pl. 14 (p.171, **fig. 62**): Michelangelo Merisi da Caravaggio, *The Incredulity of Saint Thomas*, 1601–2.

Pl. 15 (p.185, **fig. 66**): Restored dome mosaic from the Orthodox Baptistery in Ravenna, AD c. 458.

Pl. 16 (p.188, **fig. 67**): Painted icon of Christ from St Catherine's Monastery in Sinai (wax encaustic on wood), probably mid-sixth century AD.

here at all. If woman is 'the scenery onto which men project their narcissistic fantasies', the marble strut makes Aphrodite spring directly out of Pan's groin: she is the fallacious construct of masculine phallocracy. *Those men!*

But it's never quite so easy to draw the modern out of the ancient. For all the muscular tensions of Pan's bulging arm, his masculine strength seems to avail him none: observe how the delicate arm of the goddess is locked firm in position, without the slightest hint of strain. Viewers are consequently left rather unsure as to how the tragi-comedy will play out. We wonder who (or what) is directing the drama. Does the embodied Eros ('Desire', 'Sex', 'Attraction') force the two figures apart in an effort to protect his mother, or is he mischievously bringing them together? Is Aphrodite preparing a coy protest (she wants it really . . .), or will she deliver a freeze-framing blow (her senior Olympian status figured through her higher physical stature)? Just what does the slipper portend – a gentle slap on the wrist (Aphrodite's womanly weapon thereby adding to her strip-tease), or a tragic blow (Ovid's Artemis needed a mere handful of water against Actaeon . . .)?

These questions make this a highly ambiguous group. Once again, moreover, divine–human hierarchies come into play. Pan might stand for all man's bestial interests (hence the hind, horns, and hooves), but there's no doubting his higher footing in the immortal–mortal stakes. If the divine Pan gets the boot, just what might *our* punishment be as mortal voyeurs? Important here is the triangulation of viewing relations: while standing outside the drama, we look at Pan looking at Aphrodite (who does not return Pan's gaze); at the same time, we notice the cheeky little Eros, staring back at the viewer who stands directly in front of the group. Move a little to the right in an effort to escape Eros' gaze and something even more disconcerting happens. Aphrodite herself now looks the viewer in the eyes, slipper in hand. We *are* involved in this drama after all. Perhaps that's why Aphrodite had paid so little attention to Pan – she had her eye on us more mortal assailants. It all seemed like a tongue-in-cheek hoot. But look who's laughing now . . .

Of course, such 'religious' interpretations must have been more pressing for some ancient viewers than for others. There are plenty of Greek and Roman 'female nudes' that seem – at least to our eyes – to have had little to do with ancient cultic practice. Still, we might do well to remember Clement of Alexandria's second-century AD claim that *all* naked statues are in fact 'Aphrodites': 'if one sees a woman depicted naked, he understands it as "Golden Aphrodite"', despairs the Christian apologist (*Exhortation to the Greeks*, 4.50).

The Delian 'Slipper-Slapper' group itself demonstrates the follies of delineating the 'religious' from the 'secular' in the ancient world. As we have said, the group was found in the 'House of the Poseidoniasts' – a clubhouse welcoming merchants, above all from Berytus (modern-day Beirut). 'It is tempting', writes one recent textbook, 'to regard this as "motel art" for ancient businessmen.' But I'm not convinced. For one thing, the Greek inscription on the base of the statue informs that religion was never too far away: 'Dionysios, son of Theodoros of Berytus, benefactor, [dedicates this] on behalf of himself and of his children to the ancestral gods'. Whatever its other functions, the statue was also a *religious* monument – a votive offering dedicated by someone whose name is descended from the Greek god of wine, and whose father evidently saw himself as 'Mr God's Gift' (*Theo-doros*). An artistic homage to Praxiteles it may be. But the cultic complexities of the ancient 'female nude' persisted nonetheless. We ignore them at our peril.

STRIPPING DOWN AND UNDRESSING UP

The Delian 'Slipper-Slapper' group [**fig. 39**] was by no means the last to appropriate (and comment upon) the image of the naked Aphrodite. As **fig. 40** demonstrates, artists continued to allude to Praxiteles' statue in all manner of self-referential ways. On the one hand, the statue's body descends from the hallowed Knidian mould (filtered through the so-called 'Medici' type: the distribution of weight is reversed, and the right hand covers the breasts [**fig. 29**]). Inspect the distinctive 'Flavian' coiffure, though, and there can be no doubting the comparative modernity of this late first-century AD *matrona*. If our female subject has dressed up (or rather stripped down) as *Greek*, the hair-do simultaneously insists that she is *Roman*: she has been dolled up and doled out in the latest Imperial trends.

This curious Aphrodite-matron, now housed in the Copenhagen Ny Carlsberg Glyptotek, was no one-off. Although we know relatively little about the statue's original display (it was found near Lake Albano, 15 miles south-east of Rome), we can compare some 15 or so contemporary female portraits, all attired in similar unclothed guise. Where findspots are known, everything points to funerary contexts: this sort of image was evidently deemed appropriate as a final commemoration for the dead.

So why might Roman women – or rather their families – have opted for so unlikely looking a pose? It was scarcely imaginable that the deceased should have appeared in this manner during her lifetime: unabashed nudity did not tally with Roman notions of the respectable wife and mother; even in the Greek world, there was no social or institutional excuse for an unclothed

Fig. 40: Marble Copenhagen *matrona*, c. AD 90. Is this a mortal, or a goddess? The remains of the boy-god Eros' feet on the left confirm the divine aspirations [cf. **figs. 39, 50**]. But the fusion of Greek body with Roman head summons up a particular mental image: this is as much Virgil's *Venus Genetrix* (i.e. founding protectress of Rome) as the fun-loving Aphrodite of Ovid's *Metamorphoses*.

female portrait in the same way that there was for the male. And yet, as commemorative gesture, there was clear social or cultural mileage in forging a Roman female body out of a Greek sculptural prototype. Nudity could be appropriated as a sort of conventionalised formula to sum up the life and death of the deceased – 'nudity as a costume', as one scholar nicely calls it.

The present chapter investigates this phenomenon in comparative ancient and modern perspective. My objective is to explore images like the Copenhagen matron alongside more recent 'Classicising' portraits of western historical figures. As we shall see, the body has proved a key site for negotiating one's relationship with the Classical past. But such self-conscious posing has also brought with it problems. Stripping down can evidently risk baring *too* much – and compromising one's own identity in the process. The dangers of this process are conspicuous in the sorts of self-images fashioned by modern leaders, tyrants, and dictators. But we find the same issues surfacing in Roman antiquity. Quite literally inheriting the Greek world – engulfing it within their Imperial super-power – the Romans were among the first 'neoclassicists': their images of the body negotiated what it meant to be Roman in a visual landscape dominated by the Greek.

Indecent exposure

We've already come across this term 'Neoclassical' in relation to Canova's image of *Napoleon as Mars the Peacemaker* [**fig. 1**]. Among art historians, the term is used to describe the shared cultural aspirations of Europe and North America between the mid-eighteenth and nineteenth centuries. Whether in painting, sculpture, or the decorative arts – or indeed architecture, music, and theatre – Neoclassicism meant paying heed to an established canon, founded above all on the Classical precedents of antiquity.

To pay heed to the Classical tradition in the context of historical portraiture, though, has always been a tricky business. Consider once again Canova's statue of Napoleon [**fig. 1**]. The nudity, the pose, the various Classical allusions: all of this aimed beyond the particulars of the early nineteenth century. Canova explicitly theorised the process: where clothing betrayed the historical particularities of a given subject (the period in which s/he lived, country, profession, wealth, etc.), nudity proved universal. As the ancients well understood, a nude portrayal transcended the limits of time and space, allowing the artist to 'consecrate his work to all people, to all times, calling upon remote posterity for judgement'.

Within artistic circles, Canova's decision to depict Napoleon naked seems to have been well received – at least initially. 'The most perfect work of the century' was how François Cacault, French ambassador in Rome, heralded the design in 1803. Dominique Vivant, the Baron de Denon and sometime director of the Musée Napoléon in Paris, was no less optimistic in 1806: the statue would not only belong in the Musée Napoléon (subsequently known as the Louvre), but specifically 'among the emperors and in the niche where the Laocoön is, in such a manner that it would be the first object that one sees on entering'. This would be 'the statue of the greatest military leader of the world', according to Giovanni Battista Sommariva, rendered by the 'most skilful sculptor of the century'.

But Napoleon's reaction would prove quite different. As soon as he finally set eyes on the statue in April 1811, the *Empereur* banished it into storage. Much to Canova's chagrin, the portrait would remain hidden in the Salle des Hommes Illustres, hurriedly concealed with planks and canvas. Only with the subsequent defeat of Napoleon was the statue finally uncovered. It was purchased by the British Government in 1816, and presented to the Duke of Wellington in recognition of his victory over Napoleonic France at the Battle of Waterloo (at £3000, the statue came with a hefty price-tag: during the same year, the government paid £35,000 to purchase all the Parthenon marbles from Lord Elgin). The statue has remained in Apsley House ever since. Caged between banisters, it presides, rather un-heroically, over a dark and gloomy staircase.

So why did Napoleon take against the statue? A clue comes in the letter with which Denon first broke the news to Canova:

His Majesty viewed with interest the beautiful execution of this work and its imposing aspect. But he thinks that the forms are too athletic [*trop athlétique*], and that you to some extent disregard that characteristic which eminently distinguishes him: namely, the calm of his movements.

The problem cannot have been with the 'imposing aspect' of the naked

body per se: Napoleon flooded Paris with ancient sculptures – the antiquities paraded to the Musée Napoléon following the conquest of Italy, for example. Nor was Napoleon averse to showing off his new-found treasures: witness a contemporary print of Napoleon standing before the Apollo Belvedere in his eponymous museum [**fig. 41**]. But to present *oneself* in exposed Classical form was a wholly different matter. Consider, once again, the anonymous print of Napoleon. For all Napoleon's imagined boasting, the image occasions a rather unflattering comparison. Although Napoleon strikes the same pose as the ancient statue (notice the legs and outstretched left arm), the image makes it painfully clear: our 'Petit Caporal' is no Greek Adonis. Looking back at Canova's twice life-size portrait – with its iron-tight buttocks, swelling chest and defined abs – we can see why a middle-aged, round-shouldered and slightly pot-bellied emperor might have found it *de trop*. This sort of body might have appealed to Canova's sense of 'Art' (capital 'A' firmly understood); the ancient allusions, moreover, were evidently in tune with Napoleon's grander political vision (modelled after Imperial Rome). But wasn't this ancient guise somewhat ridiculous for a modern-day ruler? Much safer to settle on some military action shot (as

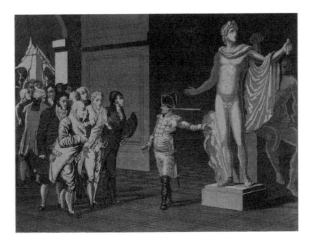

Fig. 41: Anonymous line and aquatint etching of Napoleon Bonaparte, c. 1797. 'There, gentlemen: worth two million!', read the original French caption below. The boast proved somewhat premature: the Apollo Belvedere was returned to Italy in 1816, along with some 5000 other stolen artworks.

in Jaques-Louis David's widely copied painting of Napoleon crossing the Alps), or else to commemorate the emperor in quiet, uniformed repose (consider David's paintings of the demure Napoleon in his study at Les Tuileries).

Canova was devastated. He shared his dismay with fellow aesthete Antoine Quatremère de Quincy: could it be that the French simply lacked the aesthetic sensibilities of the Italians? Still, the sculptor swiftly learnt his lesson. When the General Assembly of North Carolina commissioned a portrait of America's 'Founding Father' in December 1815, singling out Canova for the privilege, the artist knew better than to render George Washington in similar unclothed guise. 'The style should be Roman,' advised Thomas Jefferson, 'the size somewhat larger than life . . . the attitude to be left to the artist.' The statue that resulted no longer survives: installed in the Senate House at Raleigh in 1821, it was destroyed by fire ten years later. But we know that rather than strip down America's late first president, Canova opted for a *clothed* Classical guise. Washington was shown seated, dressed in military cuirass, with additional tunic and mantle for good measure. A stylus was held in one hand, an inscribed tablet in the other ('George Washington to the people of the United States – Friends and Fellow-Citizens'): a thinker as well as a doer, this Washington.

As Canova must have known only too well – especially after the whole Napoleon débâcle – representing George Washington was an *artiste*'s headache. On the one hand, it was necessary to show Washington embodying everything venerable in venerable antiquity ('the style should be Roman'): as the Classical trappings of his eponymous capital testify, Washington had founded the American constitution on Roman political models; ever the savvy politician, moreover, the first president had ensured that latter-day descendants would remember his Classical credentials ('Cincinnatus of the West', according to Lord Byron's famous sobriquet). On the other hand, *visualising* those credentials proved distinctly problematic. Just how 'ancient' would modern Americans go in Classicising their late leader? Could the country's founding father – remembered for his powdered hair, wigs and false teeth – be reconciled with the rather different ideals of the Classical

body? How to balance an ancient visual language of the body with the norms, values and expectations of modern-day America?

The overarching difficulty is best demonstrated by a statue which, unlike Canova's portrait, got its Washington famously wrong. The colossal statue – measuring some 3.5 metres or 11½ feet, and weighing 30 tonnes – was commissioned by the American Congress in 1832 (the year after Canova's image was destroyed); it was to commemorate the centenary of Washington's birth. Hopes ran high: America could at last give this sort of commission to a born-and-bred compatriot, not to a European outsider. After studying in Italy in the 1820s, Horatio Greenough opted for a seated Classical pose: Washington would be rendered after Pheidias' famous fifth-century statue of Zeus at Olympia [**fig. 61**]. All seemed to be boding well . . .

But when it was finally unveiled in the rotunda on Capitol Hill in 1841, Greenough's statue was greeted with gasps and guffaws [**fig. 42**]. How downright disrespectful for an artist to have stripped his political subject! And how preposterous to combine that ripped torso with this stern facial portrait (derived from a bust by Jean-Antoine Houdon)! Like Canova's Napoleon, Greenough's Washington was embarrassedly banished: various locations were tried out – first on the Capitol's East lawn in 1843, later the Patents Office. But even this proved too conspicuous. Something less prominent was needed – something less public, less in-your-face, less exposed: yes, a *museum* would do the trick.

At the beginning of the twentieth century, the statue finally came in from the cold: it was removed to the clandestine cloisters of the Smithsonian Institution, where it can still be seen in the National Museum of American History today. Still the jokes have continued. Is Washington offering a sheathed sword to the American people, or is he to plunge it into his chest in embarrassed shame? Does Washington point to the heavens, or does he reach up for his clothes? *Simulacrum istud ad magnum libertatis exemplum, nec sine ipsa duraturum, Horatius Greenough faciebat*: 'Horatio Greenough made this effigy, for a great exemplar of freedom, and one destined only to endure with freedom itself.' But Greenough's dedicatory boast proved immature: the artist had been *too* free with his Classical licence.

Fig. 42: Horatio Greenough, marble statue of George Washington, completed in 1840: this photograph by Frances Benjamin Johnston shows a group of Afro-American school children visiting the statue on the Capitol Hill in 1899. If the ultimate inspiration here is Pheidias' Zeus at Olympia [**fig. 61**], Greenough also looked to a fragmentary statue of the Emperor Constantine in the same pose: the sculptor had seen the remains in the Musei Capitolini in Rome.

The fates of Canova's Napoleon and Greenough's Washington demonstrate the essential problem of integrating the ancient with the modern. As we have seen, artists end up in a sort of representational paradox. To show the subject's Classical credentials means stripping down. But the artificiality of this naked costume simultaneously exposes a cultural remove. The resulting images consequently have precisely the opposite effect from the one intended: rather than command respect, they provoke scoffs, sneers, and sniggers.

At no time were the stakes of this dilemma more conspicuous than during the second quarter of the twentieth century. With the polarisation of the political landscape – and both Communists and Fascists alike laying claim to the Graeco-Roman heritage – Classical art became an emblem of ideological allegiance (cf. above, pp.19–23). But could the ideologues of Europe go the whole hog and represent *themselves* in full Classical splendour? Hitler knew better, of course: to pose before a Classical sculpture was one thing [**fig. 10**]; to pretend to be a Classical sculpture was quite another. Besides, Hitler hardly had a body worth boasting about: Hubert Lanzinger's popular painting of *Der Bannerträger* ('The Standard-Bearer') got round the problem by dressing the Führer as a Gothic knight, dressed in a Mediaeval suit of armour.

But Benito Mussolini fancied otherwise. Billing himself as the new Roman emperor, the Italian leader was not abashed to appear in the manner of Roman emperors before him. Some portraits, like a celebrated equestrian statue by Giuseppe Graziosi, stopped short of undressing their emperor – a Roman-looking cuirass was quite sufficient (compare **fig. 50**). Other artists, including Emilio Florio, stripped Mussolini bare, revealing him either in a loin cloth or else stark naked.

The most infamous example was Giorgio Gori's *Genius of Fascism*, erected outside the Italian Pavilion during the 1937 Paris Exposition ('Exposition internationale des arts et techniques dans la vie moderne') [**fig. 43**]. Here was the definitive statement of Italy's national aesthetic-cum-political allegiance: a heroic figure sits naked astride a horse, his cloak blowing in the wind like an emblematic flag. But the statue became famous for precisely the wrong reasons. Associating the depicted subject with Mussolini himself,

Fig. 43: Giorgio Gori's *Genius of Fascism*, erected outside the Italian Pavilion of the Paris Exhibition in 1937, and photographed during the opening regatta. The colossal naked figure – widely perceived to represent Mussolini himself – surveys the statue-topped pavilions of Communist Russia (left) and Fascist Germany (right). Both left and right political factions claimed the Classical legacy as their own: war would break out two years later, and some sixty million soldiers and civilians would be killed.

Paris responded first with quiet consternation, then jabbing jeers. Was this really the same balding Mussolini with the prominent jaw, pockmarked face and pasta-packing pouch? Climbing onto the base, irreverent onlookers lined up to see what (if anything) could be seen between Il Duce's legs. With Mussolini's artistic vision rendered a laughing stock, extra forces were called in to stand Fascist guard against a smirking international public.

Compromising traditions

What's so interesting about the challenges faced by Canova, Greenough, and Gori is that they were also prefigured in antiquity. To demonstrate the point, I turn in the remainder of this chapter to think about Roman portraits, above all portraits of the Roman emperor. First, though, it's necessary to say something about earlier Greek traditions – from the Archaic world to the Hellenistic-cum-Roman portraits of the first century BC.

The origins of Greek portraiture are rather misty. Despite earlier statues from Athens and elsewhere (did kouroi function as portraits of sorts?), the first political portrait is often said to be a bronze statue group of the Tyrannicides Harmodios and Aristogeiton (following Pliny, *Natural History*, 34.17). Erected at public expense in the late sixth century BC, the group presented the deceased 'tyrant-slayers' as the heroised martyrs of the new democracy at Athens. Harmodios and Aristogeiton were both killed in the democratic cause (or so the story went): for this reason, the Athenians quite literally worshipped them as heroes. When it came to *living* individuals, though, democratic Athens seems to have been somewhat more reticent. Fifth-century citizens evidently worried about the power of the portrait: images bestowed authority, and those set upon propagating their image therefore posed a threat to democratic ideology. Consider the anecdote about Pheidias, involved in designing the Athenian Parthenon (Plutarch, *Life of Pericles*, 31.4): Pheidias was reputed to have hidden portraits of both himself and Pericles amid the mythical scenes adorning the statue of Athena Parthenos [**fig. 58**]; as a result, he was brought to trial in Athens – and found guilty of the charge.

Portraits nevertheless abounded in Athens. Following his death in 429 BC, Pericles himself was honoured in this way – with a portrait attributed to Kresilas and sculpted around 425 BC. If Roman copies are anything to go by, Kresilas depicted Pericles as bearded and middle-aged: Pericles was shown as an ever-ready general, his helmet tipped back over the forehead. This was a formulaic image in the fifth century. At the same time, though, there was already developing an acute sensitivity to different modes and

iconographic styles. When philosophical devotees devised an image for Socrates soon after his death in 399 BC, they deliberately presented him as a round-bellied, pug-faced satyr: true to his philosophy, Socrates was shown to embody a *supra*-physical ideal – an intellectually minded rebuff to established norms of embodied corporeal beauty.

During the fourth century, Greek politicians became ever more attuned to the potential power of the portrait. There had always been a difficulty in distinguishing between Greek images of gods, heroes, and men in Greek art. With the conquests of Alexander the Great in the 330s and 320s BC, however, the lines between mortals and immortals became blurred (almost) beyond recognition.

Following in the footsteps of his father (King Philip the Second of Macedon), Alexander was uniquely successful in propagating his image, adapting it to suit local styles and conventions. Rather than show himself as a bearded general, Alexander made a virtue of his youth – understandably, given that he had conquered the known world (some 5.2 million km²) by the age of 30. Ancient descriptions of Alexander's portrait made much of his leonine hair, languishing upturned gaze and twist of the neck. But he was also shown with a body to match. Modelled on heroes like Achilles and Heracles, Alexander revealed himself in full heroic nudity: *this* was how our princely ruler had achieved so much in so little time. For Alexander's successors, who divided the empire into a series of discrete Hellenistic kingdoms after 323 BC, inheriting Alexander's empire meant inheriting his visual language: the nude portrait was a bare necessity within Hellenistic claims of power and legitimacy [**fig. 44**].

This was the political and visual landscape bequeathed to Rome during its own ascendency to power, especially during the second and first centuries BC. So thoroughly Hellenistic were the conventions of Roman self-presentation that it remains impossible to tell whether **fig. 44** (a bronze statue found on the Quirinal Hill in Rome) was originally intended to represent a Hellenistic leader or an aspiring Roman in Hellenistic Greek guise. The statue recalls a lost prototype of Alexander holding a spear, attributed in antiquity to an artist named Lysippus. But such images of naked power

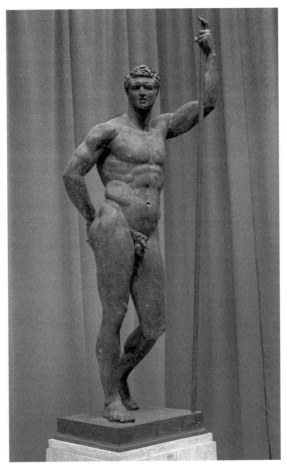

Fig. 44: The bronze 'Terme Ruler' from Rome, third to first century BC. It remains uncertain whether this over-lifesize statue represents a 'Greek' Hellenistic ruler or a 'Roman' Republican of the first century: discussion usually centres around its (lack of) crowning diadem. Notice how small the head is in relation to the body – a trait exaggerated in later Roman statuary [e.g. **fig. 54**].

set the standard for *every* political portrait that followed – from Hellenistic kings to the political leaders of latter-day Europe.

Within the Roman Republic, as within the modern western world more generally, images like figure **fig. 44** also brought with them problems. Quite apart from the associated claims of Hellenistic absolute power (wasn't a republic meant to be different from an absolute monarchy?), there was an

anxiety about the state of undress. 'Romans, like all the other peoples in the ancient world apart from the Greeks, had a strong taboo against being seen naked in public,' writes Christopher Hallett, 'and this seems to have persisted throughout their long history.' The precise connotations of nakedness might have been different for Roman audiences and modern viewers: as Hallett continues, the Roman cultural imaginary associated undress with ideas about vulnerability, criminality, and above all slavery. But the challenge of reconciling *Greek* modes of visual expression with later cultural perspectives is inherently similar. Could the nude body of a Greek artistic tradition be reconciled with one's own ideological values, social norms, and visual styles?

In the Graeco-Roman world of the late first millennium, this challenge was all the more acute thanks to the availability of other artistic traditions. By at least the late second century BC, the Roman Republic was conscious of a markedly different stylistic language, one that defined itself in knowing antithesis to the Greek. According to this tradition, brows are furrowed, heads are balding, and the whole face is creased with age-defining wrinkles [**fig. 45**]. It's not quite fair to call these modes 'native', or even 'non-Greek': cultural interactions between 'Greece' and 'Rome' were always more complex than such academic shorthand implies; it's also worth remembering that 'Greek' artists seem to have executed even the most 'Roman'-looking of images. But whatever its origins, this mode became quickly associated with a distinctively *Roman* way of doing things: it embodied the *mos maiorum*, or 'way of our forefathers', stretching back to a time when Rome knew nothing of the foreign *luxuriae* of Greek art . . .

'Verism' is the nineteenth-century term used to describe this trait, referring to the supposed photographic 'truthfulness' of Republican portraiture. It's a somewhat misleading label. Although we are unable to put 'real' faces to the portraits, veristic images must have been as idealised as the Greek. They were just idealised in a different way. Where Greek visual culture saw heroic and divine power residing in youthful nudity, the political mechanisms of the Roman Republic made a deliberate virtue of age: in a system where candidates had to be at least 42 to stand for consul (the highest political office), there was considerable *auctoritas* in the blemishes of age.

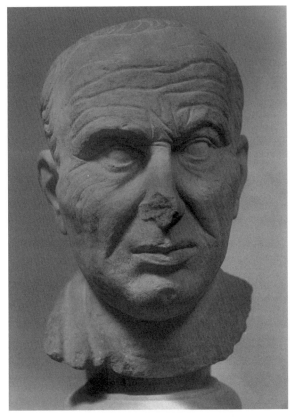

Fig. 45: 'Veristic' Roman Republican portrait, late first century BC. Contrary to the relentless pressure to 'fight the signs of aging' in the twenty-first-century western world, Roman Republican portraits seem to have exaggerated their age at every available opportunity.

Each crow's foot, sag, and facial flaw translated into power, authority, and eligibility. In political terms too, 'ugliness' (as at least defined against the Greek) could connote a certain republican magnificence. Just as Oliver Cromwell allegedly instructed his artists to depict him 'warts and all' – within the new-found British Commonwealth of the 1650s, Cromwell's face had to profess him 'Lord Protector', not king – the 'ugly' appearance of Roman republicans had ideological and political *gravitas*. For all their supposed verisimilitude, the veristic face of the Roman Republic cannot be taken at face-value.

So much for the face. But what about the body? For Roman patrons, this seems to have been something of an embarrassment. The question was how to render the body in a distinctly Roman way – and to the best political advantage of the person portrayed. One response was to extract the head and shoulders from the body, literally de-facing it: the very fact that so many 'veristic' portraits represented their subjects from the shoulders upwards is surely significant; incidentally, this probably also explains why almost all the 'Greek' portraits familiar to us are busts rather than full-

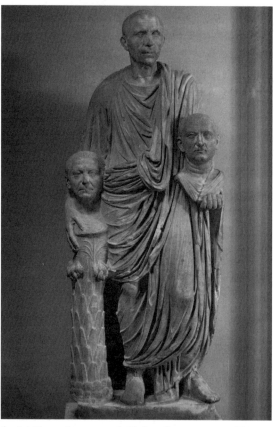

Fig. 46: 'Barberini Togatus' group, probably late first century BC. The toga emphasises the subject's Roman credentials, as do the two ancestral busts paraded. But the deep carving of the drapery suggests a residual Greek aspiration, even in this most Roman of uniforms. Note too the various Greek influences in the two portraits carried (especially the hairstyle of the bust on the left).

body portraits – that was clearly the Roman preference, and Rome bestowed posterity with almost everything we know about Greek portraiture. If dispensing with the body was one way of getting round the dilemma, another was to cover up the body, dressing it in a toga. Draped over the left-hand shoulder, the toga was the Roman dress *par excellence* – so much so that the poet Virgil described the Romans as the *gens togata* or 'togaed race'. Originally, writes Pliny the Elder, Rome was adorned wholly with togate portraits, before naked 'Achillean' figures were introduced (*Natural History*, 34.18 – Pliny seems to be thinking of Polyclitus' *Doryphoros* [**fig. 2**] in particular, hence adding that such 'Achillean' images 'hold a spear').

The so-called 'Barberini Togatus' group nicely demonstrates this Roman Republican rhetoric of both the body and the head [**fig. 46**]. The anonymous subject is dressed in a toga and carries two portrait busts (*imagines*) of his ancestral forefathers. Ironically, the head of the statue does not belong to the body – it was added by eighteenth-century restorers. But the fact only drives home the separate treatment of the face from the body, as conspicuously played out by the two busts below (each revealing just enough shoulder as to convey a similar state of dress). The triangular arrangement of these heads must have sparked a visual game of 'spot the difference'. What sorts of generic resemblances could be found between the three heads? Was our man more like the figure on the left or the figure on the right? How does he strike a balance between their different features, styles and expressions (the bust on the right considerably harsher/more flattering in its verism than the one on the left)?

Whether revealing it in full Hellenic splendour, or else covering it up so as to emphasise the stern Stoic values of the face, the crucial point is that, already in the first century BC, issues of Roman cultural identity were being played out in the representation of the body. The developing uses and functions of such portraits – not only as commemorative funerary markers in the house, for example, but also as civic and honorific talismans – gave all this a pressing cultural and social urgency: who one was (and what one aspired to be) turned upon what sort of body one had. This meant a tricky compromise between Greek associations of nudity with power on

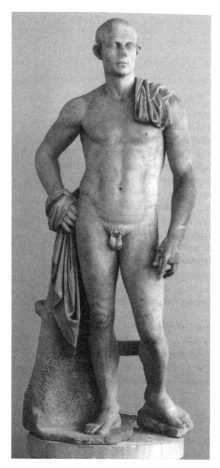

Fig. 47: 'Pseudo-Athlete' from Delos, c. 100 BC. The cumulative implication is that this subject is Greek in body [cf. **fig. 2**], but Roman in mind [cf. **fig. 45**]. Contemporary Delos was famous for its slave trade from the Greek east to the Roman west: might this explain the statue's dual cultural aspirations?

the one hand, and Roman rejections of the Greek on the other. It also meant conceptualising the head separately from the body, focussing on the exaggerated features of the 'veristic' face in particular.

The images that resulted have long seemed strange to modern eyes. Take the 'Pseudo-Athlete', set up at the end of the second century BC in the courtyard of a house on Delos (the 'House of the Diadoumenos') [**fig. 47**]. Portraits like this have derived only derision from traditionalist aesthetes. For Sir Kenneth Clark, they are simply 'errors in taste': 'there is something comic about these academic Phidian nudes, from which every trace of in-dividuality has been erased centuries ago, being surmounted by the likeness

of the unhappy Claudius, or the maniac Caligula'. And yet the Delian 'Pseudo-Athlete', with its nude Polykleitan body, but balding head, furrowed face, and stick-out 'grandpa' ears, provides a fascinating insight into Greek–Roman cultural interactions during the late second and first centuries BC. Distinctive political, social, and artistic languages are being brought together. The carefully placed fold of cloth over the left shoulder nicely captures the point: doesn't this recall the distinctive draping of the Roman toga [**fig. 46**], despite the thoroughly un-Roman state of undress [cf. **figs. 52–54**]?

The emperor's new clothes

Late first-century poets would cash in on Rome's ambivalent attitudes to the Greek, all the while modelling their own creations after Greek literary models. 'Conquered Greece has conquered its rough victor and brought its arts to rustic Latium', writes Horace (*Epistles*, 2.1.156–7); 'let others breathe life into bronze . . . and coax living features from marble', as Virgil's Anchises proclaims to Aeneas – adding that a Roman's first duty should be *imperium* (*Aeneid*, 6.847–53). In the terms of one scholar, first-century Rome witnessed a growing discrepancy between 'Ciceronian' and 'Catonist' attitudes to Greek art: on the one hand were those (like Cicero) who bought in to the collection and display of the Greek; on the other were those (like Cato the Elder) who condemned it as an effete, foreign, and corrupting *luxuria*.

Nowhere are these conflicting attitudes more conspicuous than in the portraiture of the first century BC. With the empire expanding exponentially, and the rewards of supremacy becoming increasingly conspicuous, it became ever more important to forge the *right* portrait. Different politicians struck upon different solutions. There was Pompey the Great, for example, who combined the tell-tale affectations of Roman verism with the mannerisms of Greek royal portraiture (not least Alexander's *anastolē*-'quiff'). Ultimately, there was Julius Caesar, who made a literal mint from his dictatorial self-portrait, stamping it onto Roman coins. But the fate of Julius Caesar – assassinated on the Ides of March, 44 BC – also demonstrated the dangers of

appearing too much the Hellenistic king. Within an ever more volatile Roman Republic, getting the right measure between the Greek and the Roman could prove a literal matter of life or death.

It's in this context that we should approach the portraiture of Julius Caesar's adopted heir and successor, Octavian. Octavian – better known as Augustus ('Consecrated One'), following a title adopted in 27 BC – was Caesar's great-nephew. The tentative family link made spin-doctoring all the more crucial. After struggling first to avenge Caesar's assassination, and then to secure his own single succession (above all, against Mark Antony), the future emperor had to maintain a fine balance between Hellenistic associations of power and the Roman rhetoric of republicanism. Augustus would eventually emerge as *princeps*, or 'first citizen'. But in an Orwellian-sounding turn of phrase, he also presented himself as 'first among equals' (*primus inter pares*). On the one hand, Augustus claimed to have restored the republican status quo in Rome: was he not a consul like any other top-rank senator in the *res publica restituta*? On the other hand, this imperial 'republic' was fundamentally different from the political status quo: while the norm had been to hold office for a single year, Augustus held his consulship continuously between 31 and 23 BC. Augustus ultimately sealed his power by becoming the permanent 'tribune of the people' in 23 BC – the year from which Augustus counted his years of office as *princeps* until his death in AD 14.

As Augustus knew only too well, realising his political objectives meant marketing a successful public image. Like Alexander the Great before him, Augustus flaunted his youth. If anything, Augustus seems to have become younger and more idealised even as the 70-year-old *princeps* grew older and more decrepit. In a world before modern mass media, Augustus' actual age and appearance were only of limited importance: the portrait was the closest most people got.

Although Augustus projected a relatively consistent visage during his reign, he experimented with different images of the body. The trick was somehow to graft the Greek onto the Roman: Greek precedent had to help Augustus' cause, not debunk it. Contrary to widespread belief, there are

numerous representations of Augustus shown either fully unclothed or clad in a skimpy hip mantle. At least some of these were erected in Rome, and some date from Augustus' own principate (**fig. 48** is one example of an 'Augustan prince', although it most likely depicts Augustus' nephew, Marcellus). At the other extreme are images that were 'sexed up' in an entirely different sense, showing the emperor draped from head to toe. A congenial *altera persona* could be found in the role of high priest, or *pontifex maximus*: Augustus' covered portrait peers out from a clump of cloth [**fig. 49**].

Of Augustus' many bodies, none is more culturally revealing than a statue now in the Vatican Museums in Rome [**fig. 50**]. The portrait was found in 1863, excavated from his wife's family villa at Prima Porta (8 miles north of Rome). We know relatively little about the statue's original context: some herald it as a marble copy of a lost bronze original created in c. 20 BC;

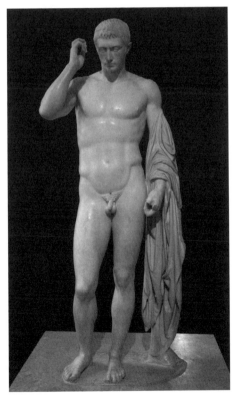

Fig. 48: Life-size marble portrait of an Augustan prince (Marcellus?), late first century BC. This statue – found on Rome's Esquiline Hill – dismantles its Roman imperial subject: the body descends from a mid-fifth-century statue of the so-called 'Ludovisi Hermes', and the tortoise beside the left foot confirms the divine allusion. Such nude depictions of the emperor were rife in the east (witness the Sebasteion reliefs from Aphrodisias in Caria). As this statue shows, though, they were by no means unknown in the west.

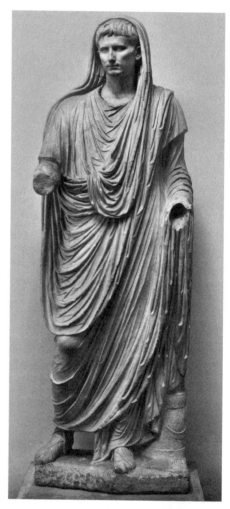

Fig. 49: The 'Via Labicana' Augustus from Rome, early first century AD. Augustus embodies the Roman *pontifex maximus*, or 'highest priest'. The distinctive 'crab-claw' of the hair [cf. **fig. 50**] can leave no doubt about his identity, while the dynamic, three-dimensional carving of the toga clothes an underlying Greek aspiration [cf. **fig. 46**].

others deem it specially commissioned, intended for private display. The recent restoration of the statue has occasioned much speculation about its original decoration: the image was certainly painted, although disagreement remains as to its exact appearance.

There can be no doubting the Prima Porta Augustus' Roman credentials. The emperor is attired in full military garb, shown addressing his public (with right arm raised). This so-called *adlocutio* gesture recalls an established mode of Roman address, whether in the civic assembly or before the troops:

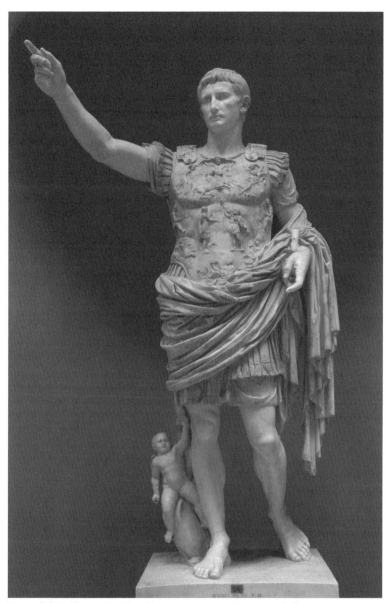

Fig. 50 (cf. **pl. 9**): Marble Prima Porta Augustus, perhaps an early first-century AD copy of an earlier statue (c. 20 BC). The Roman emperor has his proverbial cake and eats it: his cuirass embodies a Greek ideal, while turning it into a surface for Roman myth-making [**fig. 51**]. The controlling hand gesture is also carefully construed: one might compare, for example, the Apollo at the centre of the west pediment of Zeus' fifth-century temple at Olympia in the Greek Peloponnese, as well as more contemporary images of the Roman *adlocutio*.

Fig. 51: Detail of the Prima Porta Augustus breastplate. Observe how the outstretched Roman standard (topped with a winged eagle) points in the direction of Augustus' own outstretched hand. On the rear of the breastplate was sculpted another empty cuirass, dedicated as a trophy – and mirroring the trophic get-up of the *princeps*: here is Augustan *imperium*, embodied.

comparison is often made with the early first-century bronze *Arringatore* in Florence, portraying a certain Aulus Metellus in similar oratorical mode. Just as Aulus Metellus is dressed in toga and boots, Augustus' cuirass and hip mantle ensure that the whole body is concealed save for the arms, lower legs, and head. For a later Latin author like Pliny the Elder, this might have placed the image firmly in the Roman rather than the Greek camp: 'the Greek custom is to leave the figure entirely nude,' writes Pliny; 'in contrast, the Roman military custom was to add a cuirass' (*Natural History*, 34.18).

But the Prima Porta Augustus is much more ambiguous about the cultural identity of this body. To be sure, the *princeps* does not go the full monty like Canova's Napoleon [**fig. 1**]. And yet the genius of the cuirass lies in its allowing Augustus to have his clothes and to divest himself of them: for all

the emperor's Roman military prowess, viewers are assured of the carefully toned Greek body beneath. Inspect the statue closely and we find a series of anatomical details rendered on the breastplate – pectoral muscles, ripped stomach, belly button. Nudity has literally become a costume, and it's donned by our man Augustus: there's a Roman heart behind the sexy Greek six-pack.

Like the body, the pose of the statue also descends from Greek precedent. Regardless of what Augustus originally held in his left hand (a spear reminding of the *Doryphoros'* own?), the schema of the legs, the *contrapposto* of the chest and the carefully styled coiffure knowingly recall the Polyclitan prototype of the mid-fifth century BC [**fig. 2**]. Even such an apparently innocuous detail as the hip mantle proves other than it first seems. While modestly covering up the emperor's crotch, the cloak rather immodestly alludes to the standard attribute of Hellenistic ruler-portraits: yes, the mantle conceals the body; but it also reminds us of images that conspicuously did not.

What is so empowering about the Prima Porta statue, then, is the suggestiveness of its strip-tease: the emperor is made at once to dress up *and* to strip down. This is a statue that simultaneously exposes and covers up its body. We see both volume and surface. On the one hand, Augustus' body is laid bare, to be gazed at for its own sake. On the other, the body serves as a surface for adornment – a Greek *tabula rasa* on which to inscribe a Roman cultural identity.

Perhaps most mind-boggling of all is the way in which the bodies depicted on (and within) Augustus' body offer their own meta-pictorial commentary [**fig. 51**]. At the literal and metaphorical core of the statue is a historical event subjected to the full force of Roman Imperial mass-marketing. The scene refers to the military standards that had been ignobly lost by Crassus at the battle of Carrhae in 53 BC and which Augustus recovered in 20 BC: a bearded Parthian king on the right is shown returning the standards to a Roman officer on the left.

The identity of the Roman figure receiving the standards has prompted much speculation. Although many 'real' names have been suggested, the wolf standing placidly by the soldier hints at a more ambivalent mode of

meaning-making. At least one thing is certain: this cuirassed figure, decked out in its own military cuirass, is made to recall the figure of the Prima Porta Augustus himself. We are dealing with a *mise-en-abyme* of bodies – not just military *insignia* sculpted within this *signum* of Augustus, but also with a costume *within* (and indeed on) this costume, figured in antithesis to the strange, beardy-weirdy body of the 'Oriental' opposite. If the Prima Porta portrait was originally rendered in bronze, as many have suggested, the ambiguities must have been all the more apparent: at the centre of the statue was a (make-believe) bronze cuirass clothing a soldier's body, depicted on a bronze chest which itself vacillates between a bronze cuirass on the one hand, and the brazen body of the emblazoned *princeps* on the other. These are themes about replication that were independently developed by the artist who painted this statue (itself a possible marble replica of a bronze): we can be absolutely certain that the red cloak of the central soldier was made to echo the red rubric of Augustus' own painted hip mantle.

For hardcore Roman militarists, the return of Crassus' standards must have seemed a rather sordid affair: after a back-handed bribe – and the promise of Roman Imperial favour – Phraates IV was only too happy to oblige. But on the chest of Augustus the feat is projected onto the grandest imaginable stage. To the left and right of the central scene are two barbarian female captives: as personifications of Roman provinces, these fleshy female bodies stand in marked contrast to Augustus' own image of dazzling masculinity. Below them, again on each side, are two gods – Apollo (one of Augustus' favourite alter egos) riding a winged griffin, and Diana on the back of a stag (perhaps recalling Augustus' own sister, Octavia). Finally, framing Augustus' chin and groin, are a number of cosmic personifications: Caelus ('Sky') defines the limits of both the world and Augustus' body, with Sol ('Sun') and Aurora ('Dawn') riding beside him; at the bottom of the belly, marking the terrestrial fundament as well as the emperor's own navel, Tellus ('Mother Earth') reclines, cradling two babies and a *cornucopia* or 'horn of plenty'.

An infinite cosmic order is depicted here, and it revolves around the

world-defining moment when Augustan Rome retrieved her standards. The cumulative effect is rather like the 'Shield of Aeneas' described in the eighth book of Virgil's *Aeneid* (vv.626–728). Just as Virgil describes the *longue durée* of Roman history, visualised all at once on the fantastic shield of Rome's founding father, these historical events defy the parameters of space and time. The whole world, from telluric depths to celestial heights, is literally incorporated within the body of the emperor – and indeed on it. Augustus' torso becomes the *new* measure of all things, and the cosmos of Augustan *imperium* is mapped out on his chest. The figure cut by the *princeps* transcends the material confines of its costume – even a costume such as this, adorned with so many material personifications of abstract power.

We will never know how Roman viewers responded to the Prima Porta statue. Historians have to reckon with at least the possibility that ancient viewers saw it as no less ridiculous than modern audiences found the naked Napoleons, Washingtons, and Mussolinis. The case of Ovid, who pointed fun at Augustan propriety and was eventually exiled for a *carmen et error* ('poem and mistake') in AD 8, reminds us that not everyone was amenable to the Augustan 'power of images'.

For my money, though, the Prima Porta statue is much more subtle in its 'neoclassicism'. This is a body that works in the manner of the famous 'duck–rabbit' optical illusion, or the celebrated 'Schröder stairs': viewers switch back and forth between different *sorts* of bodies and modes of perceiving them. The *princeps* projects what W.J.T. Mitchell would call a 'dialectical' or 'multistable' sort of image: his body shuffles to and fro from heroic nude to cuirassed soldier, from undressed superman to attired general, from Greek to Roman. Augustus was the supreme ancient master of body imaging. And all in the pursuit of absolute, totalitarian control.

Inheriting inherited bodies

If Augustus' portraitists dealt with the same essential issues as later Neoclassical artists in the nineteenth and twentieth centuries, there is at least one way in which the Prima Porta Augustus worked very differently.

Those who chuckled at Napoleon's fig-leaf, or Il Duce's crotch, titter at what their leaders failed to wear. They do not laugh at the figure's divine aspirations. For us, portraits do not make gods of men, and unclothed portraits still less so. For first-century viewers of the Prima Porta Augustus, by contrast, nudity could be a serious matter: it was the costume of gods and heroes.

In the Greek world, the issue of dress – or lack thereof – was an important indication of an image's place within immortal–moral hierarchies. Nude statues had long been seen as godly or heroic ('Achillean' in Pliny's terms: p.131). Disclosing a male deity usually entailed unclothing him. As we saw in the previous chapter, the phenomenon is even more conspicuous in the context of female images: as Clement of Alexandria puts it, *all* unclothed statues of women are in some sense 'Aphrodites' (p.114).

Hellenistic kings had long flaunted their nudity to fudge their own (im)mortality, and Roman emperors proved heirs to this tradition. Establishing the trappings of a pan-imperial cult, Augustus started out by claiming divine descent: as the 'son' of Julius Caesar, Augustus became 'son of a god' (*diui filius*) following Caesar's official deification in 42 BC. But the Prima Porta Augustus goes a step further. For one thing, note the lack of footwear: like the gods and heroes of the Greek world, but unlike the cuirassed Roman depicted on the breastplate, the *princeps* had no need of shoes or boots. Then there's the unassuming little infant by the Prima Porta Augustus' side [**fig. 50**]. As the wings make clear, this is Cupid (Eros in Greek), the mischievous son of Venus [cf. **figs. 27, 39, 40**]. Where the gods of the cuirass are represented in two-dimensional relief, this figure occupies the same sculpted space as Augustus himself, tottering astride a dolphin: it's as though Cupid were about to tug Big Brother's skirt, making him look down to the immortal realm beneath him. Cupid might be small – and he's certainly dwarfed by Augustus. But this boy-bodied buddy served to remind viewers that Augustus was descended, via the Julian line, from the goddess Venus herself. Cross him at your peril!

The Prima Porta Augustus' divine allusions raise the question of Augustus' godhead while keeping its viewers guessing. As such, this feature works

alongside other aspects of the statue – the ambiguous nakedness of the cuirass, or indeed Augustus' lack of footwear. We are back with the duplicitous duck–rabbit bind: are we looking at the body of a man, or of a god?

Ironically, Augustus' death in AD 14 removed the ambiguity: by dying, Augustus officially became a bona fide immortal. With the first *princeps* dead and buried, Augustus' successors had to reckon not only with the legacy of the Greek body, but also with that of Augustus himself. Forging an imperial identity would mean negotiating not just one's divinity or mortality, nor simply one's 'Greekness' and 'Roman-ness'; it also meant negotiating one's relationship with Augustus and the political system that he embodied.

Many cultural historians have assumed that the 'Augustan revolution' left a fixed model for the emperors who succeeded it. 'Through visual imagery', writes Paul Zanker, 'a new mythology of Rome, and, for the emperor, a new ritual of power were created.' But in Augustus' wake, the question of *how* to portray the body seems to have become more rather than less complicated. Augustus by no means 'solved' the supposed sorts of Greek–Roman 'identity crisis' embodied in the Delian 'Pseudo-Athlete'[**fig. 47**]: indeed, the tradition of the 'hybrid portraits' very much continued.

Figs. 52–53 provide two different examples of what the post-Augustan emperor looked like in the first century AD. The first is an image of Claudius, emperor between AD 41 and 54 [**fig. 52**]. Rather like Greenough's Washington-Zeus [**fig. 42**], Claudius is depicted half-naked: the artist apparently saw no difficulty in combining an idealised nude torso with an older-looking face. If Claudius' nude upper torso stakes a claim to immortality, the various attributes confirm the divine aspiration – the sceptre in the left hand, the *patera* in the right, the oak wreath on the head, and the eagle by the side. Is Claudius making an offering to the gods? Or is he himself receiving one from us?

A portrait of the emperor Vespasian (emperor AD 69–79) is somewhat similar in its body-head combo [**fig. 53**]. The statue comes from the Collegium of Augustales in Misenum, where it was paired with a complementary statue of Vespasian's son and short-lived successor, Titus. While the nude costume of the body befitted an emperor, the exaggerated veristic

Fig. 52: Marble portrait of Claudius with the attributes of Jupiter, from a theatre in Lanuvium, c. AD 50. Claudius' half-naked body finds a model in Augustus' own [**fig. 50**], and the fringed hairstyle also descends from Augustan portraits of the so-called 'Forbes Type'. But are we looking at a mortal emperor offering a libation to Jupiter? Or is the *princeps* himself an immortal – receiving a libation from us lowly human viewers?

features of the head suited the Flavian boast of having *re*-restored the good old days of the Republic. After the collapse of the Julio-Claudians, and the tribulations of the 'year of the four emperors' in AD 69, the Flavians were keen to present a clean break from former imperial corruption. This was Flavian 'back to basics' – the *res publica restituta* or 'Republic restored'. Still, Vespasian's portrait is not so 'basic' as to clothe the emperor in a toga: the

veristic-looking head is paired with an out-and-proud naked body.

With the corpus of Roman Imperial bodies growing ever larger, new attributes were required to revisit the same issues that Augustus had negotiated in the first century BC. One response – first adopted by Hadrian (emperor AD 117–138) – was to show oneself bearded, in the iconographic tradition of the Greek intellectual. Such Greek-looking heads were duly inserted within a full range of body types – whether in a toga, stripped nude, or decked out in divine get-up: a famous statue from Ceprano (southeast of Rome), for example, shows the bearded Hadrian unclothed, and in the celebrated guise of a fifth-century 'Ares Borghese' type.

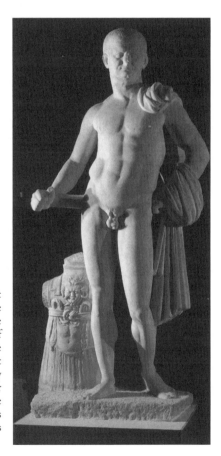

Fig. 53: Naked portrait of Vespasian, last quarter of the first century AD. This statue was found in the Collegium of the Augustales at Misenum (on the gulf of Naples) – a building dedicated to the cult of the deified Flavian emperors. It seems to have been erected posthumously by Vespasian's son, Domitian (emperor AD 81–96). Note the cuirassed statue support, emphasising the emperor's residual Roman military credentials [cf. **fig. 50**].

Fig. 54: Bronze statue of (?)Trebonianus Gallus, mid-third century AD. The schema of the legs and *adlocutio* pose might resemble the Hellenising models of Augustus [cf. **fig. 50**]. But the body of this towering statue (2.41 metres – almost 8 feet) is out of proportion with the expressive head. And how to explain the gladiator-style boots?

This same proclivity to treat the head in isolation from the body remained typical of Roman Imperial art during the course of the second and third centuries. Take **fig. 54**, a larger-than-life-size statue in New York's Metropolitan Museum of Art. The statue has been plausibly identified as Trebonianus Gallus, emperor AD 251–253, and stands some 2.4 metres tall. As with Augustus' Prima Porta statue [**fig. 50**], the naked body descends

from a Polyclitan prototype [**fig. 2**], with the same *contrapposto* effect. The artist was evidently at pains to emphasise the towering subject's bloated chest and tree-trunk legs. But this vast body is combined – to our eyes, it must be said, rather ludicrously – with a tiny head, some two-thirds the scale of the body. The face is also made to display a series of distinctly non-Greek features: observe, for instance, the wrinkled brow, schematic rendering of stubble, and crew-cut hair.

In thinking about the legacy of the post-Augustan body of the emperor, two points are particularly worth emphasising. The first is that the question of combining the Greek with the Roman remained an issue throughout the first centuries AD: indeed, each Imperial succession could be said to have rendered the representation of the emperor's body ever more complex. Second, the history of the Roman portrait seems to have been a history of conceptualising the head separately from the body – whether in the first century BC, or indeed the third century AD. At least in the late first/early second centuries, moreover, such reckoning applies to images of women as well as to images of men. This explains how an image like the Copenhagen matron could come to pass [**fig. 40**]: if the 'Pseudo-Athlete' from Delos could aspire to being Roman in head and Greek in body, why couldn't a respectable female *matrona* do the same?

The body in pieces

I began this chapter by diagnosing an essential problem in the legacy of the Greek body. Greek artists endowed posterity with an ideal model of the unclothed body, and Hellenistic rulers were among the first to adopt such nude bodies for their own self-images. In appropriating the Classical body, the subsequent challenge has lain in reconciling the general with the particular: how to square the ideals of the past with the realities of the present?

As I hope to have shown, this is a question about 'antiquity' and 'modernity' in the widest possible sense. Coming to terms with portrait nudity means owning up to the familiarity and attractiveness of the Classical body on the one hand, and its alterity – even faint ridiculousness – on the other.

By comparing the statues of Canova, Greenough, and Gori with a number of more distant Roman examples, we can see how the challenge of representing the portrait body defies any straightforward chronological delineation between 'ancients' and 'moderns'. Already in Rome, as indeed even earlier in Greece, we find nudity conventionalised as a visual formula – a prestigious costume that could be donned (and taken off) so as to convey something about the person portrayed.

But there are also differences between Roman engagements with the Greek body and those of later western portraitists. The essential challenge of squaring Classical ideals with present reality might have been much the same for Romans as it has been for us. And yet the different ways in which different epochs have responded to that challenge reveal what is distinctive about each 'modern' mindset on the one hand, and about each view of 'antiquity' on the other. The ideal that Greek nudity embodies was evidently different for Roman viewers than it is for us: think back to the Roman artistic background of veristic portraiture, or to ongoing Roman cultural associations between nudity and divinity. Don't Augustan images negotiate a rather different sort of 'antiquity' and 'modernity' from the more recent portraits of Napoleon, Washington, and Mussolini?

What makes this process so intricately complicated is that each successive portrait not only influences the next, but also *changes* the ways in which viewers make sense of earlier images. When Canova was looking for an ancient model for his Napoleon [fig. 1], for example, one inspiration was the Julio-Claudian portrait recently taken from Rome to the Musée Napoléon [fig. 48]. With each appropriation and re-appropriation, distinctions between 'ancient' and 'modern' become ever more blurred and confused.

I want to end this chapter, though, by returning to the issue of Roman heads and bodies. As we have said, one critical difference between modern nineteenth- and twentieth-century portraits and those from ancient Rome lies in the Roman treatment of the head separately from the body. Modern critics have not been kind to the likes of the Copenhagen matron [fig. 40], 'Pseudo-Athlete' [fig. 47], or Trebonianus Gallus [fig. 54]. Indeed, such

images have been taken to exemplify the shallow aspirations of Roman art at large: following the rhetoric of Winckelmann, Roman sculpture is deemed not only 'derivative' (i.e. parasitic on the Greek), but also in bad taste. The complaint is rather similar to that regarding Greenough's Washington, with its young athletic body but creased middle-aged face [**fig. 42**]. Was the 'Pseudo-Athlete' from Delos not evidence of a 'confusion of cultures' – a monstrous mixing of Greek bodies and Roman heads? Periodically there comes the suggestion that some higher-minded aesthete or ruler – someone like Augustus – 'put right' this 'confusion'. Fundamental to Zanker's argument about the 'power of images' in Augustan Rome is the emperor's supposed 'ironing out' of Greek–Roman bastardisation: Augustus, or so the story runs, had the aesthetic sensibility and connoisseurial know-how to deploy (*viz.* reinstate) earlier Greek models . . .

But there is no evidence that Roman viewers found 'hybrid-bodies' 'confused', 'incongruous', or 'monstrous' in the way that modern critics have done. Nor, as we have seen, can we dismiss the trait as some 'mongrelisation' of art (Greek with Roman, or Roman patrician with Roman plebeian), or indeed as something eradicated by Augustus. This is a phenomenon that stretches the length and breadth of the Roman world: the Copenhagen matron [**fig. 40**] was erected some two centuries later than the 'Pseudo-Athlete', and the Trebonianus Gallus [**fig. 54**] some two centuries later still.

This idiosyncrasy can be detected at all manner of different times, and all over the Roman Empire. Take a fresh look at the Augustus from Prima Porta [**fig. 50**], for example, and observe how the prominent neckline of the cuirass demarcates the head from the body: the statue goes out of its way to emphasise the fault lines between Augustus' costume and his facial portrait. We find something similar in contemporary images from Roman Egypt, not least the mummy cases used to entomb the dead. Consider, for instance, **fig. 55**, in which an ornamental golden collar sets off the polychrome painting of the head from the symmetrically arranged scenes of the body, rendered in gold leaf below. A Greek inscription ('farewell, Artemidorus') occupies the boundary between the two, with Artemidorus' golden feet poking out again at the lower edge of the case: the feet re-estab-

lish a vertical (top-to-bottom) rather than horizontal (left-to-right) axis of viewing, even though they are hardly 'believable' in the same way as the face. For modern viewers this all seems rather strange (no wonder that museums so often display such facial portraits in isolation from the mummi-fied bodies, championing them as prototypical 'western' paintings). To my mind, though, first-century viewers would have taken all this in their stride: in a world where multiple cultures of the body had to co-exist – where many visual conventions were brought together within the overarching frame of the Roman Empire – viewers learnt to navigate *between* different rationales of representation.

How, then, should we explain this Roman proclivity to fragment the body? Richard Brilliant has termed the phrase 'assemblage aesthetic' to diagnose the phenomenon, comparing Roman images of the body to the sorts of comedy 'cut-out boards' once so popular in seaside resorts: the objective was to insert one's head within a pre-established body type and then to strike a facial pose – *Cheese*! Comparison is sometimes made to the Roman habit of carving prefabricated heroic bodies with an individual's particular portrait on sarcophagi (Great Uncle Max's portrait atop the bulky body of a Greek Achilles!), or else to the practice of re-cutting facial features on Imperial monuments. Following the posthumous condemnation of an 'evil' emperor, heads (*capita*) were frequently re-fashioned in the image of the new command, whereas bodies were nearly always left as they were. This was an idea of assemblage upon which megalomaniac emperors could quite literally capitalise. According to Suetonius, the Emperor Caligula instructed portraits of his own head to be placed on the most famous Greek sculptures of the gods (*Life of Caligula*, 22.2).

While the idea of an 'assemblage aesthetic' is useful, it doesn't quite capture the stylistic discrepancies that such compilation might involve. This was not a question of appending some recognisably 'real' head on some

Opposite page: Fig. 55 (cf. **pl. 10**): Portrait and mummy case of Artemidorus, from Hawara in Egypt, early second century AD. CT scans indicate that Artemidorus was around 20 when he died, which tallies with the painted facial portrait. Observe too how the gold wreath around the head echoes the Egyptian stylisation of the body below. But how do these different styles fit together?

recognisably 'unreal' body: as we have seen, faces were at least as conventionalised in the stylistic languages that they employed. Roman viewers, rather, seem to have had much less difficulty than modern critics in combining *different* conventions within a single image. Better, perhaps, they were much more sensitive to the complementary ways in which disparate styles – rendered in disparate parts of the body – could respectively communicate.

This brings us back to some of the themes of the second chapter, and above all to the burden of the Renaissance. Given our privileging of (what we think of as) the naturalistic – images reflecting empirical 'reality' – it's little wonder that the 'incongruousness' of the Roman nude should have so offended the likes of Sir Kenneth Clark. But Roman viewers seem to have looked to the body rather differently: they could read it as much as a corpus of semiotic signs as a mirage of verisimilitude. Instead of simply mirroring the sight of a 'real' figure, the Roman portrait could simultaneously work in more *symbolic* ways, as a series of amalgamated parts that together added up to more than the whole. Viewers, in other words, might switch between different 'scopic regimes'. It was for this reason that heads and bodies could communicate at once collectively and separately, each in their own stylistically, culturally, and ideologically informed ways: the Greek language of nudity was just one convention within a vibrant and varied visual Esperanto.

We can go still further. Where modern audiences view the nudity of the historical portrait naturalistically – laughing to see what Mussolini had between his legs – Roman portraits might be said to have understood it in rather more abstract terms: the unclothed body served as a sort of code to be deciphered, much like the code of the head (despite the conspicuous stylistic differences). Yes, Roman sculpted bodies resembled *real* bodies in their claims to verisimilitude, just as Roman verism was bound up with a republican rhetoric of the real and down-to-earth. But Roman portraits also operated on a different level, as cryptograms in multiple parts, each section separately interpretable. When it comes to a body like that of Artemidorus [**fig. 55**], moreover, the body could be understood both in

pieces and as a naturalistic whole: for all its stylisation, did the series of Egyptian schematic diagrams not also imitate a supposed real shroud that covered the material body beneath?

What's most distinctive about the Roman art of the body, then, is its uneasy oscillation between figurative and non-figurative modes. Representations prove at once realistic *and* rather more abstract, in a way thoroughly unfamiliar (even unsettling) to modern eyes: aesthetic reprobation follows. This brings us to the subject of our last chapter. For, as we shall see, it was the conceptual gymnastics of the Christian Incarnation – the question of how (if at all) to represent the body of God-made-man – that brought these issues of materiality and imagination to a thundering, theological climax . . .

CHAPTER V

ON GODS MADE MEN MADE IMAGES

Fig. 56 shows a body that really is in pieces. A marble statue of Mercury lies shattered on the floor, its fragmented head staring out at us. The perfectly framed figure of Christ on the cross explains the reason why: the Judaeo-Christian body has triumphed over the effigies of pagan antiquity.

The fresco adorns the ceiling of the Sala di Constantino – one of the so-called 'Raphael Rooms' in the Vatican in Rome. It was painted in the mid-1580s by a Sicilian artist named Tommaso Laureti and intended as the literal high-point of a room celebrating the Emperor Constantine. Constantine had converted to Christianity after a similar vision of the cross (depicted below), taking the Roman Empire with him: some three centuries after Jesus of Nazareth's death in AD c. 33, Christianity was finally legalised, and subsequently promoted, following the so-called 'Edict of Milan' in AD 313. While the walls of the Sala di Constantino deal with Christianity's early rise to legitimacy, its ceiling demonstrates what this new religion meant for the beliefs and images of old. The Christian God smashes ancient art to smithereens. Where Greeks and Romans venerated empty images of the gods in human form, Christianity recognises a God who really *did* become man, and who died for our sins on the cross.

This final chapter explores the intersection between Classical and Christian images of the body, and the different theological assumptions that they incorporate. Just as ancient concepts of the embodied gods were folded into Christian rationalisations of the Incarnation, I argue, so too was Christian art fashioned out of (and indeed against) ancient traditions

Fig. 56 (cf. **pl. 11**): Tommaso Laureti, *Triumph of Christianity*, c. 1585. The ultimate meeting of antiquity and modernity, centred around issues of religion. But do ancients or moderns win out? Christianity paradoxically scorns and sanctions pagan idolatry: it both has its statues, and smashes them.

of figuring the gods in bodily form. Better, perhaps, the story of Christianity is a story of reconciling the theology of the Incarnation with Graeco-Roman ideas and images of the divine.

The religious reception of the ancient art of the body is profoundly complex, as Laureti's fresco nicely demonstrates. Despite its familiar title, this painting is no straightforward image of the *The Triumph of Christianity*. Granted, the crucified Christ demolishes the pagan idol. But in another sense Christ's (dis-)figured form also displaces it. On the one hand, the twisted carcass of the dying (or dead) Christ heralds a religion beyond the body. On the other, Jesus appears the ultimate anthropomorphic deity: God Incarnate, no less. Jesus' bare and battered body – perfect but positively putrid, beautiful but brutally blemished, sublime but irremediably spoiled – recalls *both* the Apollonian form of the pagan gods *and* the broken statue lying on the floor.

If *The Triumph of Christianity* gives Christ an ambiguous sort of body, it also endows the visual depiction of that body with an ambiguous sort of iconic presence. Laureti's painting deliberately blurs the boundaries: are we looking at a *represented* statue of Christ on the cross, or the real body of Christ *present* before us? The (painted image of the) image of the crucifix hovers between different 'ontological' levels of representation: it leaves us with conflicting ideas about what Christ – no less than his figured form – really *is*. Set up on its pedestal, Christ's embodied effigy is inscribed with the same totemic immediacy as the ancient statue it destroys: the crucifix out-idols even the pagan idolatry that it annihilates. For anyone viewing Laureti's fresco in the late sixteenth century, these phenomenological paradoxes must have been all the more apparent. Could the Vatican, with the largest modern-day collection of Classical sculpture, really claim to have *abandoned* the ancient?

Laureti seems to have appreciated the point only too well: that the reception of Greek and Roman art involved an entangled process of cultural-cum-theological negotiation. Within that process, Laureti's ceiling comes at a particularly critical moment. Painted at the height of the Counter-Reformation (see below, pp.197–8), the fresco stands at a crossroads between ancient and modern theologies of seeing.

As the present chapter sets out to explain, we are still living in the aftermath. The process of forging Christian art and religion out of ancient models has directed the grand trajectory of western visual culture, right up to and including the present day. The issues with which Laureti engaged do not just concern the commensurability or incommensurability between man and God – the question of whether or not the divine can be understood in human terms. Nor are they of restricted relevance to Christians (or those of any other creed). These are debates that go to the core of the western artistic tradition, forged out of our modern inheritance of the Christian inheritance of the ancient Greek and Roman.

Imaging and imagining the gods

Debates about what the divine looks like – and the legitimacy of visually figuring it – remain rife in the twenty-first century. The stereotypical western image of God, tendered from childhood, is of a bearded old man in the sky: think, for example, of the Creation of Man in the Sistine Chapel ceiling (Michelangelo in fact lifted this 'God' from the Victories of the Arch of Titus in Rome). But when contemporary art strays into religion, censorious headlines follow. In March 2007, for instance, a life-size statue of *My Sweet Jesus* courted controversy not just for showing the crucified Christ without a loincloth, but also because of its medium: how dare Cosimo Cavallaro mould a life-size and naked Christ from 90 kilograms of chocolate! No less contested was a Swedish collection of photographs that transplanted the lesbian, gay, and transgender community into set-piece Biblical scenes (*Ecce Homo*, touring Europe between 1998 and 2004): surely the real Jesus and John the Baptist never shared *that* sort of love [**fig. 57**]?

Artists don't have to portray Jesus with half-erect (uncircumcised) penis to cause a stir. Some Christians were no less outraged at a life-cast erected on Trafalgar Square's empty fourth plinth in 1999 (Mark Wallinger's installation, again entitled *Ecce Homo*). For many, the sight was too kitschy for comfort: certain groups were outraged at Wallinger's decision, on the eve of the millennium, to show this 'Man of Sorrows' so vulnerable and

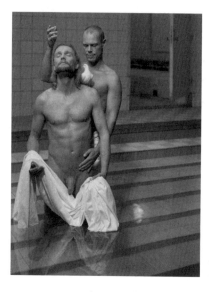

Fig. 57: Elisabeth Ohlson Wallin, *Ecce Homo*, 1998. Behold the man – or behold the homo? This photograph delights in suggesting a same-sex *frisson* between Jesus and John the Baptist. But it also flags the essential challenge of visually embodying the divine: making (images of) mortals of gods *always* risks compromising divine immortality [cf. **fig. 66**].

uncertain, standing perilously at the edge of his pedestal. Visualising (the Son of) God always risks sacrilege: it involves decisions about who He was (and is) – Aryan muscle-man, full-bodied Adonis, militant revolutionary, bearded hippie, long-haired effeminate . . .

Such controversies are by no means peculiar to Christian imagery. If anything, recent artistic encounters with Islam have proven still more contentious. Take the ongoing furore over a set of Danish cartoons of the Prophet Muhammad, first published in September 2005. It was not just the cartoons' content that caused offence. According to some groups, the problem lay in the figurative portrayal of Muhammad in the first place: death threats followed – and continue some five years later (the publishers consequently eschew illustration).

Although debates about the propriety of images were not unknown in antiquity (cf. e.g. pp.90–2 on the Knidian Aphrodite), and despite variations over time and space, ancient polytheism was predicated on a very different set of assumptions. Greek and Roman gods took on mortal shape, and they could be materialised through visual imagery. The divine world was an *embodied* world: gods were figured in, and experienced through, the body. As ancient etymologists knew only too well, moreover, the same Greek

word (*thea*) could denote both a 'sight' and a 'goddess': the Greek word
for beholding, gazing, and contemplating (*theōria*) could claim derivation
from either root.

Two related hypotheses are at work here, concerning first the logic of
anthropomorphism (immortal bodies as human bodies), and second the
rationale of the image (sculpted bodies of gods as sculpted bodies of men).
Just as the gods might be mediated through human form, so too might
their human form be mediated through material means: images did not
simply *re-present* the divine, then, they could also render deities literally
present before a viewer's eyes. Greek and Roman art, in short, made a
nonsense of twentieth-century semiotic jargon, predicated on 'rationalist'
Christian theology: visual 'signifiers' did not 'signify' the divine 'signified';
the divine 'signified' *was* in some sense the 'signifier', and so too was the
'signifier' the 'signified'.

This two-tiered rhetoric stretches back to the earliest Greek discussions
of gods and their images. One poignant moment in the sixth book of the
Iliad has a group of Trojan women lay a supplicatory robe before a statue,
only for Pallas Athena to tilt her head in denial: the goddess – or rather
this statue? – would not oblige (*Iliad*, 6.297–311). When later, in the
second century AD, the likes of Aelius Aristides and Artemidorus came to
analyse the interpretations of dreams, the gods appear not only in human
form, but also in the familiar iconographic guises of their images. Within
Artemidorus' hallucinatory realm, statues of the gods were synonymous
with the gods themselves: 'it makes no difference whether one sees the
goddess as she lives in our imagination or her statue', writes Artemidorus
about an Artemis apparition, 'since whether the gods appear in the flesh
or as statues fashioned out of wood, they have the same significance'
(*Interpretation of Dreams*, 2.35).

As Artemidorus makes clear, the assumed equivalence between image
and deity is the figurative extension of an assumed equivalence between
divine and human bodies. Cultic rites had long been founded upon this
two-tiered ambiguity. Anthropomorphic statues of the gods were treated
as the gods themselves – and washed, dressed, or fed accordingly: through

the statue of the deity, pilgrims could literally come face to face – or rather 'eye to eye' (*kat' omma*) – with the divinity. The same rationale explains the language in which Pausanias talks about (images of the) gods in his *Description of Greece*, written in the early second century AD. Pausanias frequently labels the supernal powers that he encounters in shrines and temples not as 'statues' or 'sculptures' at all, but rather as the deities themselves (cf. p.97 on the Elder Pliny): images could evidently collapse strict ontological hierarchies, whether between mortals and immortals, or indeed between images and referents. As to what might happen if divine images were not treated with the respect they deserved, just think back to Aphrodite's legendary assailant at Knidos (pp.98–9): abusing a stone-statue of a god could prove as disastrous as disrespecting it/him/her in the flesh.

Greek commentators seem quickly to have recognised the theological assumptions at work here. Writing in the fifth century BC, Herodotus pondered why it should be that the Persians needed no temples, altars, or statues, explaining the cultural difference in religious terms: the Persians 'do not believe that the gods share the same nature with men, as we Greeks believe' (*Histories*, 1.131.1). By no means everyone approved. We know of a late sixth-century Greek philosopher named Xenophanes (from Colophon in Lydia) who vociferously opposed such anthropomorphic conventions. For Xenophanes, there was 'one god, greatest among gods and men, in no way like mortals either in body or thought [*oute demas thnētoisi oute noēma*]'. Neglecting this truth, opines Xenophanes, each mortal race has fashioned the gods in its own image, thereby incorporating all that is 'shameful and blameworthy' in humanity. The Ethiopians have gods that are black and snub-nosed. Thracian gods are attributed with blue eyes and red hair. Were horses able to conceive of the divine, wouldn't they depict them with four legs, hooves and hairy tails? 'If oxen or horses or lions had hands – if they could draw and make things like men do – wouldn't each draw and mould the bodies [*sōmata*] of their gods in the manner of their own individual species?'

Xenophanes' doubts were seized upon by later Christian writers – in

this case Clement of Alexandria (*Miscellanies*, 5.109.3): as we shall see, early Church Fathers actively sought Archaic Greek precedent for their own radical view of the Judaeo-Christian God, and the [im]propriety of His image (pp.172–3). But although fourth-century BC Greek philosophers like Plato argued for strict censorship – the gods must not be attributed with anything deemed improper in the ideal republic – Xenophanes and co. occupied a tiny intellectual fringe. Everyday cultic practice carried on regardless, and it revolved around anthropomorphic images of the gods.

This does not mean that Xenophanes' criticisms are wholly irrelevant, however. Such comments capture a long-standing tension in ancient religious and artistic thinking. This is where ancient polytheism gets mind-bogglingly complex and contradictory, at least when approached from the (theo)logical perspectives of the modern rationalising mind. Yes, the gods might take on human form. Yes, those human forms might be sculpted into statues. But right from the beginnings of Greek anthropomorphic art, there was also a niggling reservation: weren't divinities also somehow *other* than us mortals?

Such doubts informed ideas and practices of both imagining and imaging the gods. While the divine was in one sense understandable in human terms – as men and women like us, and consequently able to be experienced through manmade sculptures – they were simultaneously understood as beyond human understanding. The conception of the divine as commensurable with mortals, in other words, went hand in hand with the idea of their incommensurability. The 'many gods' of ancient polytheism meant that, in contrast to the Judaeo-Christian tradition, no single 'god' constituted an absolute standard of divine omnipotence, omniscience, and transcendence: no sooner was one deity clothed, washed, or fed, than another demanded our attention. As its Latin etymology made clear, ancient 'religion' was a never-ending 'bind', inextricably trussed to the cult of the statue. Just as the gods might at once take on human bodily form and exceed that anthropomorphic frame, so too could images of the gods both reveal their godhead and withhold that revelation. The Greek and Roman gods were

forged out of a conceptual catch-22. And so too was the art of (re-)presenting them.

As Verity Platt has wonderfully argued, this theological paradox informs the entire history of ancient visual culture. Different times and places responded to the challenge of visualising the sacred in different ways, and different gods were attributed with different sorts of human bodies (or indeed none at all). But the essential problem persisted regardless of chronological and geographical variation. Artists consequently experimented with a full spectrum of corporeal appearances. In an effort to capture divine essence through physical means, variables of size, material, and iconic form were all exploited: sculptors fashioned sixth-century kouroi that sometimes towered above human dimensions, for example, or else aniconic images that rendered the divine by taking on *non*-figurative guise (like the 'semi'-iconic herm – a fashioned head attached to a flat, rectangular torso-pillar, complete with sculpted genitals). For all their dissociation from 'Oriental' zoomorphism – unlike Egyptians, Greeks prided themselves on worshipping gods, not animals – there were also plenty of bestial-looking 'theriomorphic' Greek and Roman deities [cf. **fig. 39**]. By the same token, primitive-looking *acheiropoiēta* 'not made by hands' were displayed alongside more figurative modes, denying human agency altogether (note, however, that the term is in fact Byzantine: as always, our attempts to make sense of Graeco-Roman religion are entangled with earlier Judaeo-Christian attempts before us).

To demonstrate the ancient plurality of (ways of figuring) gods, one need only think of the assemblage of Athenas on the late fifth-century Athenian Acropolis. Here were several of the city's most important images of the goddess: among them were the wooden Athena Polias, the towering bronze Athena Promachos, and the 'chryselephantine' Athena Parthenos decked out in gold and ivory (all long since lost). Just as Athena took on a variety of epithets, she also appeared on the Acropolis in a variety of forms – an *acheiropoiēton* displayed in the Erechtheum, an open-air bronze statue fashioned by Pheidias (allegedly from the spoils of the battle of Marathon), and a colossal statue erected in the Parthenon. Each successive

Athena looked notably different from the last. So which form best embodied the goddess? And which statue best embodied that form? Because Athena comprised all of these images – and infinitely more besides – every sculpture simultaneously manifested and obfuscated her godhead.

On the individual as well as collective scale, each statue played out this enterprise of divine divulgation-cum-disavowal. The colossal Athena Parthenos provides a miniature case study [**fig. 58**]. Most critics have taken Pheidias' enormous statue (probably measuring around 12 metres or 40 feet) as the ultimate fifth-century manifestation of the divine Athena. Certainly, the administration at Olympia deemed the image sufficiently successful as to commission Pheidias to make a Zeus of their own, forged from the same gold and ivory, and to similarly gigantic proportions [**fig. 61**]. But if the size and medium of the Athena Parthenos, together with its rather backward-looking stylistic appearance, all helped to disclose the divinity, the same formal elements likewise testified to the goddess' *in*commensurability. Scale, materials, iconic form: Pheidias exploited all these variables to negotiate the simultaneous likeness and difference between Athena's immortal body and our own, no less than between *that* body and *this* embodied image.

Did the Athena Parthenos' material extravagance make for a more perfect embodiment of the divine? Despite the money and labour expended on Pheidias' sculpture, the city's Panathenaia – the most important civic festival – revolved not around this state-of-the-art statue, but rather the Athena Polias next door: each year, a newly woven *peplos* robe was dedicated to the Athena Polias, held in the adjacent Erechtheum. That was a much humbler statue, made of wood, and on a considerably smaller scale: legend had it that the image fell from the sky, explaining its old-fashioned appearance. But these elements led Athenians to hallow the statue all the more. According to Pausanias in the second century AD, such primitive-looking wooden *xoana* might *look* rather strange, unnatural, and absurd [*atopōtera . . . es tēn opsin*], but they were nevertheless distinguished by a special 'sort of godliness [*ti . . . entheon*]' – one that is not found in other images (Pausanias, 2.4.5). Although writing some 150 years later, Porphyry expresses a similar point, attributing it to Aeschylus in the early fifth century BC: the

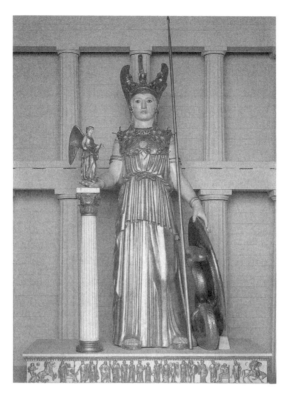

Fig. 58 (cf. **pl. 12**): Reconstruction of Pheidias' colossal chryselephantine ('gold and ivory') statue of Athena Parthenos in the Athenian Parthenon, c. 440 BC. Our knowledge of this lost statue descends from both later copies and Pausanias' second-century AD description (1.24.5–7): the 'virgin' goddess dons the *peplos* worn by everyday citizen-wives – albeit fashioned in heavy gold.

statues of old (*ta archaia*), Aeschylus is said to have noted, were judged divine despite their simple craftsmanship, while the new ones (*ta kaina*), for all their wondrous workmanship, give less of a divine impression (Porphyry, *On Abstinence*, 2.18).

Needless to say, these texts are considerably later that the Athena Parthenos in date, and Porphyry is writing 700 years later than Aeschylus. But a related mode of thinking seems already to have informed cultic practice in the fifth century BC. Consider once again the Athenian Panathenaia. Not only did the climax of the city's climactic festival bypass the Athena Parthenos, but the fact seems to have been flaunted on the east section of

the Parthenon frieze [**fig. 59**]. *Directly* above the external entrance to the Parthenon's *cella* was sculpted the dedication of the *peplos* to Athena Polias – the apogee of the Panathenaic procession, as well as the frieze running round the temple. At the moment when viewers prepared themselves to encounter Athena Parthenos, the scenes over the doorway recalled a different (image of the) goddess.

For those who actually entered the Parthenon and confronted Pheidias' Athena, this sense of deferred epiphany must have been all the more apparent. The size and location of the statue subjected the Athena Parthenos to a fragmented sort of viewing: the closer one got to the statue, the less one actually saw of it; indeed, to envisage the whole statue, viewers were better off standing *outside* the temple, peering in from beyond the *cella* doors. Such playing with 'inside' and 'outside' extended to the statue's sculptural reliefs. The belligerent Giants rendered on one side of Athena's shield, the Amazons on the other, the Centaurs on her sandals: just when viewers thought they had reached Athena's inner sanctum, the framed Athena Parthenos within the temple referred viewers back to the framing sculpted

Fig. 59: Detail from the east frieze of the Parthenon in Athens, 430s BC. The Ionic frieze running around the Parthenon guides viewers to this central scene above the colonnaded entrance. A youth takes a *peplos*-robe from a priest on the left; on the right a larger-than-life Athena poignantly turns her attention away from the action (notice how her pose prefigures the seated Athena Parthenos inside [**fig. 58**]). The Athena Polias who will receive this ceremonial *peplos* was in fact housed in a different temple: even before we enter the Parthenon, the grand procession that encircles it encapsulates a moment of godly revelation-cum-anticlimax.

metopes without. All this on an 'Athena' that did double service as a glorified ATM: as well as capturing the deity's resplendent majesty, the precious gold folds of the goddess' drapery could be removed in times of civic crisis (amounting to 40 talents, i.e. some 1,040 kilograms – a god-sent cash stash for when the going got tough: Thucydides, 2.13.5; Plutarch, *Life of Pericles*, 31). Size, it seems, isn't everything. And money can't buy you a goddess. For all the dazzling presence of the image, Pheidias' resplendent Athena simultaneously monumentalises a sort of divine absence: the statue both did and didn't embody the Athena Parthenos, and the Athena Parthenos both did and didn't embody the goddess.

These themes came to be explored in contemporary texts, from concentrated philosophical critiques to the dramas of the Athenian stage (what did it mean for human actors to take on the character of the gods, for example?) But images also offered their own pictorial sort of commentary. Take **fig. 60**, a fragment of a fourth-century Apulian krater. We see a Doric temple, with two mirroring images of Apollo: inside is a colossal statue of the god (with bow and sacrificial plate); outside stands another Apollo,

Fig. 60 (cf. **pl. 13**): Fragment of an Apulian red-figure krater in Amsterdam's Allard Pierson Museum, c. 380 BC. Image and reality are brought together – but which 'Apollo' is which? The satyr to the left of the original pot suggests that the riddle was once enjoyed during an alcohol-soaked Greek drinking-party, or *symposium*. Wine, presumably, brought an epiphanic clarity of its own . . .

this time holding a lyre, his name inscribed above. The paradoxes of anthropomorphism are here plain to see: we're looking at the (giant) 'image' of the god standing before his imagined (albeit human-scaled) 'reality'. In some ways the two Apollos are strikingly similar: both are shown naked, with slender body, each rendered from the same angle. In other ways, the two are markedly different: quite apart from their attributes, note how the artist emphasises a variation in style and surface, so that the fluidity of the 'real' Apollo's pose and turn of the head contrasts with the archaising rigidity of the statue. Viewers are faced with a mind-bending game of 'spot the difference' – a divine, Apollonian mirage. At the same time, the two-dimensional picture makes a conspicuous problem of our criteria for judgement. As itself a manufactured fabrication, can the 'Real-Apollo' embody the deity any more believably than the 'Image-Apollo' next to it? The fictions of figurative facture are brought to a dizzying head: the ambivalence of Apollo's embodied statue captures the ambivalence of Apollo's own anthropomorphic body.

God Incarnate

This analysis could be extended in various ways. But my overarching point remains: that the human body constituted the definitive vehicle for conceptualising what the gods were on the one hand, and for visually manifesting them on the other. The ambiguities of divine anthropomorphism were bound up with the ambiguities of divine images. Statues of the gods were as multistable as the deities that they embodied: in the same way that the gods were both assimilated to human bodies and different from them, images both materialised and impeded that divine bodily form.

Come the second century AD, writers expressly rationalised (and defended) this understanding of the gods and their statues. When the Greek orator Dio Chrysostom delivered a speech before the Temple of Zeus at Olympia in AD 97, he explicitly associated the logic of anthropomorphism with the logic of visual representation. Contemplating the relative value of art and poetry as vehicles for expressing the divine, Dio imagines how

Pheidias might justify the logic of his anthropomorphic statue [**fig. 61**]. Human bodies best render the non-figurable forms of the gods, we are told, and sculpted representations best figure those human bodies (*Discourses*, 12.59–61):

> Now, no sculptor or painter will ever be able to depict reason and intelligence as such, for we lack the capacity to perceive such things visually and we remain uninformed about them. And because we humans have no idea how to express those abstractions, but know they exist, we fall back upon the human form, and attribute to God a human body as a vessel of his intelligence and rationality. We do so because we have no model and we long for one. We seek to portray in a visible and perceptible way what cannot be depicted or seen. And we make use of a symbolic function, which is preferable to the practice of those barbarians who are said to depict the gods as animals (a trivial and ridiculous decision!).

The Stoic thinking behind all this needn't concern us: suffice it to say that this is a rather anachronistic-sounding 'Pheidias'. What matters, rather, is Dio's association between human appearance and the mediating vessel: to have any hope of understanding the divine, mankind requires a human vehicle; to bestow the divine with the reverence it demands, moreover, material images are needed. 'Nobody would argue that it would be better for mankind not to display a statue or likeness of the gods', Dio continues, 'and nobody would claim that we should look only to the heavens.' A further analogy seals the argument. 'Just as when infants are removed from their father or mother and long for their parents they often dream of stretching out their hands to them in their absence, so too does mankind stretch out its hands to the gods'. Images of the gods are required for the same reason that we need anthropomorphic forms for imaging them.

This cultic-cum-cultural background is crucial for understanding the early history of Christianity. For Judaeo-Christian debates about both the body of Christ, and the legitimacy of visually representing it, might be

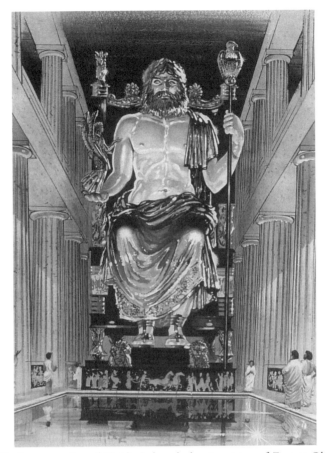

Fig. 61: Reconstruction of Pheidias' chryselephantine statue of Zeus at Olympia, c. 435 BC. The first-century BC Greek geographer Strabo wrote that 'if Zeus were to stand up straight, he would un-roof the temple' (*Geography*, 8.3.30). The assumptions are revealingly contradictory: on the one hand, Strabo says that this (statue of the) god *might* stand up; on the other, he suggests that 'Zeus' cannot be contained – even in an image and temple as colossal as these.

deemed the culmination of ancient ambiguities about the anthropomorphism of the divine on the one hand, and the nature of its material manifestation on the other. If Christ was truly God, how could he (He?) have been really mortal, dying on the cross only to be resurrected on the third day? Likewise, if Christ really was mortal – subject to all our flaws and weaknesses, not least mortality itself – how could He (he?) be truly God?

Such arguments divided early Christian thinkers, and to a large extent still do. Some groups, like the 'Arians', privileged Christ's humanity, while other factions (most famously the 'Gnostics') argued that Christ was really a spiritual being with only the semblance of mortal form. It's no surprise that, when a council of bishops met for the first 'official' time in Nicaea in AD 325, the Incarnation was the leading item on their inaugural agenda. Despite their best ecumenical efforts, the issue wouldn't go away. For how one understood the Incarnation defined how one understood artistic figurations of the divine figuration (and vice versa). Among Christians, as among earlier Greeks and Romans, the Christological question of Christ's body was inextricable from the ontology of the material image.

What made these questions all the trickier was the Christian inheritance of Old Testament strictures about image-making. The Judaic God was emphatically not embodied – He was form-*less*. 'Thou shalt not make unto thee any graven image', reads the Second Commandment (Exodus, 20.4–6: note, though, that the Hebrew word *pesel* proscribes cut, carved, or hewn images specifically, as though the particular objection was to three-dimensional statuary). For Jews, the truest image of the 'hidden God' is Holy Scripture (Isaiah, 45:15): Yahweh calls Israel to 'hearken', not to 'see'. The Torah – the closest Judaism comes to a cult object, housed in the synagogue's 'Holy Ark'– materialises the thinking: although it might be crowned and 'dressed' in a sash, the Torah is a text for reading, not an image for worship or genuflection.

But Judaic attitudes were never quite that simple. For all God's visual obscurity, the Old Testament frequently hints at a more perceptible mode of divine epiphany: a burning bush, lightning and thunder, a pillar of fire. Still more intriguing was Ezekiel's epiphanic vision of 'a figure like that of a man' on 'what looked like a throne of sapphire' (Ezekiel, 1:26). Despite defining itself *against* the idolatry of the 'heathens', Judaism had long meandered around the margins of iconophilia. Indeed, the promise of the Incarnation might be deemed the greatest iconophilic promise of all.

So what happens when you cross Graeco-Roman anthropomorphic imagery with the antagonistic (but equally contradictory) Judaic rhetoric

of the divine? No wonder that Christianity should have ended up with so conflicting a set of ideas. Take Jesus' Passion on the cross. On the one hand, Christ's death provided the prototypical example of Christian bodily renunciation: the emptying of God's Incarnate body empties mankind of its sins, annulling the sinfulness of our bodies in turn. On the other hand, the Resurrection is itself dependent on Christ's corporeal suffering and death: Christ's rising from the dead (quite literally) revives the body even after emptying it. The story of 'Doubting Thomas' materialises the materialist point (John, 20:24–9): if the apostles were sceptical, they should insert their finger into Christ's pierced palms, thrust their hands into the lacerated side – let them *feel* that it was all true. Despite John the Evangelist's reticence to divulge whether or not Thomas accepted the invitation, Caravaggio's graphic depiction of the episode in c. 1602 emphasises Christ's tangibility [**fig. 62**]: Thomas demanded not just to see, but to touch; Caravaggio's viewers cannot touch, but they can now see – or at least see the touching.

Fig. 62 (cf. **pl. 14**): Michelangelo Merisi da Caravaggio, *The Incredulity of Saint Thomas*, 1601–2. 'Thomas, because thou hast seen Me, thou hast believed: blessed are they that have not seen, and yet have believed' (John, 20:29). Painted at the height of the Counter-Reformation, Caravaggio's *chiaroscuro* ('light-and-shadow') painting relates questions of Christ's tangibility to questions about his visual figurability. Observe how Jesus' body is spot-lit, whereas his head is obscured by shadow: Christ's literal holeyness – his wounds as much as his obscured face – makes him wholly holy . . .

The paradoxes of Christ's body also held true for the 'body' of his Church. Among Christ's early followers, denouncing the body became a bodily fetish in its own right. The Christian veneration of relics, increasingly important from the fourth and fifth centuries onwards, reflects the paradox. The more saints and martyrs relinquished the body – whether adopting a life of extreme asceticism, or sacrificing their lives to 'witness' the faith – the more venerable their material bodies became. When Saint Simeon Stylites died in AD 459 – having spent 30 years atop a column in the Syrian desert, 'the fleshy body of his feet having burst open from his standing, while his whole mind was kindled for the Lord' – everyone seems to have wanted their pound of flesh: 600 soldiers were employed to safeguard the removal of Simeon's corpse for veneration in Antioch. Even in its most vehement denials of corporeality, Christianity is a religion premised upon the body.

It's what this paradox has meant for visually figuring Christ, though, that I want to focus upon here. The double-bind of the Incarnation left early Christians in a corresponding double-bind about the image: did the visual realm materialise or occlude Christ's sacred body? For spiritually minded second- and third-century Christian writers like Justin Martyr, Clement of Alexandria, and Origen, images were an abomination that grounded Christians in the profane world of the mortal. Looking to Old Testament proscriptions against the visual, and combining these with the idealist philosophy of Plato, Clement of Alexandria could write that images – or more specifically *statues* (*agalmata*) – 'drag religion to the earth'. According to Clement, God exists *beyond* our bodies (*Exhortation to the Greeks*, 4.45):

But statues are motionless, inert, senseless; they are bound, nailed, fastened; they are melted, they are filed, they are sawn, polished and carved! Sculptors dishonour the dumb earth when they pervert her proper nature – they induce men to worship the earth through their craftsmanship [*technēn*]! Those who make these 'gods' don't worship divinities or demons at all! By my reckoning, they worship mere earth and art: *for that's all statues are!* Here's the truth of the matter: the statue is a corpse – a wooden corpse! It's a corpse that's been re-

shaped by the craftsman's hand! For us, God's image [lit. 'statue': *to agalma*] is not a thing made of wood that can be sensed by our senses [*ouk hylēs aisthētēs aisthēton*]; it's something that can be known only to the mind [*noēton*]! Yes, God is perceived not by senses but by mind! And He is the one true God!

As material entities – hacked, chiselled, drilled – images can never embody God's immaterial truth. And yet, for all Clement's tirade, his argument also lets slip a contradictory rhetoric. Clement, one might say, doth protest too much: while attempting to expose the emptiness of images, he endows them with a sort of *inherent* power. Images nurture demons, and they risk spiritual and bodily depravity. Clement even cites the story of the man who fell in love with the Knidian Aphrodite (cf. pp.98–9): dangerous things, these *agalmata*.

Other Church Fathers saw things differently. One such writer was Irenaeus, Bishop of Lyon, and vociferous opponent of the Gnostics. For Irenaeus, Christianity was best understood in Aristotelian rather than in Platonic terms: the Incarnation made the body more than a mere transitory vessel to transcend. It would be John of Damascus, writing in the early eighth century, who most decisively championed the point. Responding to the 'Iconoclasts' (see pp.188–91 below), John of Damascus justified images in the following terms (*Apology*, 1.8):

> When He who is bodiless and without form, immeasurable in the boundlessness of His own nature, existing in the form of God, empties himself and takes the form of a servant in substance and in stature and is found in a body of flesh, then you may draw His image and show it to anyone willing to gaze upon it.

Like Clement of Alexandria before him, John of Damascus founded his view on the legitimacy of the image on a Christological understanding of Jesus' body. But where others had emphasised Christ's godly incommensurability, forbidding His visual portrayal, John champions Christ's human

body: he consequently defends Christ's visual embodiment through images. If the Incarnation made God man, it also made Christ's body 'circumscribable' (*perigraptos*): the divine could be written and drawn inside the material image, and thereby contained within it.

Wholly holey holy Lord – or God of power and might?

A second- or third-century graffito from the Palatine Hill in Rome shows how strange these debates must have appeared to non-Christian eyes [**fig. 63**]. 'Alexamenos worships god' exclaims the scribbled text below. Next to the writing we see Alexamenos himself, standing before a man (or

Fig. 63: Tracing of a graffito from the Palatine Hill in Rome, first to third centuries AD. *Alexamenos sebete theon* – 'Alexamenos worships god'. The Christian crucifixion was an obvious target for Roman irreverence: so shocking was the subject that the Christians shirked its visual depiction for some five hundred years.

is it a donkey?) stretched out on a cross: how ridiculous to deem a cruci-
fied 'god' worthy of worship!

The graffitist seems to have been rather unsure about who or what this
'god' was. Jesus is portrayed as half-man, half-ass: Alexamenos' eastern-
looking deity had a *different* sort of body from those of the established
Graeco-Roman pantheon. As such, the Palatine graffito also diagnoses a
problem encountered by early Christian artists. For all its spiritual guid-
ance, Scripture provided minimal clues about what this 'Word made flesh'
(John, 1:14) and 'Image of the invisible God' (Colossians, 1:15) actually
looked like. If Christ was indeed both man and God, this had somehow to
be conveyed through visual means. How, then, to reconcile Christ's super-
human divinity with his mortal bodiliness? Should Jesus be shown as an
attractive youth (an Apollo?) or a bearded elder (like Zeus?)? Was he tall

Fig. 64: 'Good Shepherd' painting from the Catacomb of Priscilla outside Rome, second
to third century AD. The 'Good Shepherd' was a favourite image within the early
Church, both in funerary contexts (as in this catacomb), and in ritual settings (over the
baptismal font in a third-century Christian building at Dura-Europos, for example).

or short, thin or fat, muscular or weedy – an 'Oriental' Other from Judaea or a recognisable Greek or Roman?

Early artists seem to have struck upon a variety of (non-)solutions. One favoured response, particularly popular in the third century, was to privilege a symbolic sort of body: whether sculpted on sarcophagi, or painted in burial catacombs, depictions of the 'Good Shepherd' show a dressed youth bearing a lamb around his shoulders [**fig. 64**]. But was this Jesus himself, or was it just a reminder of a Biblical analogy ('Christ is *like* a good shepherd who tends his flock': John, 10:11). Indeed, was Jesus the shepherd? Or was he rather the lamb, sacrificed for our sins (cf. John, 1:29, 36)? This sort of bodily form gave Christ a material presence while resorting to allegory: it suggested a significance beyond what could actually be seen, dependent in part upon a viewer's recollection of Holy Scripture.

The figure of the 'Good Shepherd' worked like numerous other early Christian images, functioning in the manner of the parables in which Jesus was said to speak. The chi-rho 'christogram' (abbreviating the first two letters of his Greek name), the schematic symbol of the fish (referring to the Greek word *ichthus*, an acronym for a theological credo about Jesus' identity), the alpha–omega (Christ as the beginning and the end – fashioned from the opening and closing letters of the Greek alphabet): all of these were material signs whose meaning transcended their material form. So too with the stylised outline of the cross. Revealingly, Christ's crucifixion was judged too grisly for full narrative depiction, and remained so until around the sixth century. But a simplified *symbol* of the cross was different: this schema could evoke the whole story of Christ's Passion without in fact figuring God at all.

Something similar might be said for the Old Testament scenes that became popular during this time, especially in Christian funerary contexts. Whether dealing with Susannah and the Elders, Jonah and the Whale, or Daniel with the lions [cf. **fig. 65**], these Judaic stories could be understood to *pre*-figure the true revelations of Christianity. In choosing such visual schemata, the persecution of Christians must have been one consideration: it was evidently important that pagan viewers could see a sleeping Endymion

in the reclining Jonah, for example, or else Hermes Kriophoros ('Hermes the Ram-bearer') in the 'Good Shepherd' [**fig. 64**]. But oppression alone cannot explain early Christian art's oscillation between figurality and non-figurality. Already at work are a much larger set of ideas about the materiality vs. non-materiality of divine truth.

With Christianity's sudden rise to legitimacy in the fourth century, the question of how to visualise God Incarnate took on a whole new urgency. Could Graeco-Roman iconographies be used to convey the Christian message? The simultaneous potential and awkwardness of traditional Classical figurations is nicely demonstrated by a sarcophagus from the second quarter of the fourth century [**fig. 65**]. The reliefs bring together a variety of stories from both the Old and New testaments, sandwiched between a central medallion with portraits of the deceased. Proceeding from left to right, the upper frieze appears to depict the story of Adam and Eve on one side of the medallion, and three of Jesus' miracles on the other (Jesus turning water into wine, multiplying the loaves, and bringing back Lazarus from the dead – an appropriate theme for a sarcophagus). In the lower section we see the three Magi visiting the Holy Family, Jesus healing a blind boy, Daniel in the lion's den, and three scenes from the life of Saint Peter (his denial of Christ, his arrest, and his miraculous creation of a spring).

Most remarkable about this sarcophagus, though, is its brave attempt to explain the Trinity at the upper left-hand corner. God the Father, God the Son and God the Holy Spirit are each shown as a collective triumvirate of bearded and clothed male figures, with God the Father sitting in the middle like a seated Zeus or Jupiter [cf. **fig. 61**]. This presentation of the Trinity gives the so-called 'Dogmatic sarcophagus' its name. In accordance with the First Council of Nicaea (cf. p.170), the sarcophagus visualises the dogma of consubstantiation, whereby God and Christ are understood as both one and the same.

But here comes the rub. If God is one with Christ, and Christ is one with mankind, how to convey the divinity of the divine? Our fourth-century sculptor finds himself wrestling with the same dilemmas as Greek and Roman artists before him, albeit in a markedly different conceptual context. By

Fig. 65: 'Dogmatic sarcophagus', AD c. 325–350. A number of the sarcophagus' most recognisably 'Christian' schemata were in fact lifted from earlier pagan contexts: the Mary and child at the bottom left, for example, might have reminded fourth-century viewers of Eirene ('Peace') cradling Ploutos ('Wealth'), or else of the Egyptian Isis nursing

her baby Horus. Sarcophagi (literally 'flesh-eaters') like this were designed both to display and conceal the body of the deceased: holes were often bored into the sarcophagus base – an outlet for the putrid fluids of the decomposing flesh.

playing with the different scales of his figures, he hits upon a favourite Classical solution [cf. **figs. 58–61**]. Just as the seated God the Father is shown as the *largest* of the tripartite Trinity (what would happen were God to stand up?), the bodies of Adam and Eve are rendered in a considerably *smaller* size than their three-bodied divine Creator: Adam lies prostrate at God's feet, while the miniscule Eve is created from his rib (receiving a reassuring pat on the head). The theology of all this must have bewildered many onlookers. Notice, for example, how Adam and Eve are shown in full size in the following scene, comparable in scale to the Trinity: a clothed deity now appears between them, guiding the pair by the hand. A number of questions follow, none of them receiving any 'dogmatic' answer. Are these human bodies now commensurable with the Trinity? Is it God the Son or God the Father depicted between Adam and Eve? Does the Incarnation lead us to make *no* distinction between mortal and divinity after all?

As if the theological intricacies of representing the Trinity were not tricky enough, the 'Dogmatic sarcophagus' also reckons with the comparative sacredness of other sorts of (semi-)divine bodies: the lower section shows Saint Peter, the prophet Daniel, and the Virgin Mary (among others). Not only must the monarchic principle of a monotheistic God be squared with the theology of the Trinity – a three-formed God at once having a body and not having a body – the *mother* of God (that is, the mother of the Son of God?) had somehow to be accommodated within this visual scheme. How, then, to show some bodies as more sacred than others? Are all of these figures wholly holy? Or are some, as it were, wholly more holey in their holiness? As Caravaggio knew all too well, Christianity had overturned everything: Jesus' mortal holeyness in fact made him more immortally holy [**fig. 62**]!

Resourceful to the last, our sculptor struck upon a series of cunning compositional solutions. Note, for instance, how the arrangement of the Holy Trinity at the upper left is repeated in the schema of the tripartite Holy Family directly below, with the seated Father now transformed into the Virgin Mary (what would now happen if *she* stood up?). No less ingenious is the right-hand side of the sarcophagus, where the exploits of Saint Peter

below chime with the miracles of Jesus above (not least in the iconographic echo at the right-hand corner). These sorts of spatial analogies solicit conceptual parallels within a multifarious theology of the body – God, Christ, Mary, the Saints, the prophets. The images posit questions. But it's left to viewers to extricate an interpretative explanation.

Ultimately, however, this whole unabashedly visual discourse is used to frame our view of the real human remains within the 'flesh-eating' sarcophagus. We find the deceased man and/or woman depicted at the sarcophagus' centre, circumscribed within a circular medallion. The portraits have been left provocatively incomplete, leaving us uncertain as to how the figured bodies might compare with those that surround them (a modern Adam and Eve – or a latter-day Mary and Joseph?). At this point, theological abstraction gets personal. Questions about *God's* body take on a figurative relevance for thinking through the *material* bodies within the tomb, buried in the sure and certain hope of resurrection. Occupying the boundary between the living and the dead – standing *between* this world and the next – the ambiguous materiality of the seeable/unseeable cadaver(s) plays out the intricacies of the Christian Incarnation represented. As we stare *at* the sarcophagus but not *through* it, we find the deceased bodies both present and absent, visible and invisible, there and not there. Death, it seems, is the ultimate figuration of Christianity's Christological paradox.

Figuring [out] the empty body

The issues with which the 'Dogmatic sarcophagus' reckons would occupy countless Christian writers, councils, and synods. And yet what this particular sarcophagus so nicely demonstrates, already in the fourth century, is the difficulty of treating Christian dogma in Graeco-Roman visual terms. In a religion dominated by Scripture, words were needed, not pictures. Their inherent materiality meant that, dogmatically speaking, images only got in the way. This is the Christian invention of theology as we know it – the privileging of *verbal* logic (*logos*) in rationalising the Judaeo-Christian God (*theos*).

But Christianity nevertheless needed images, all the more so in the fourth century. It's hard to conceive of the scale of cultural and religious conversion at this time: imagine, as one scholar (Jaś Elsner) puts it, the United States ordaining that all its citizens should become Hare Krishnas. Then there was the mass construction of basilicas, the largest being constructed in Rome and Byzantium (modern-day Istanbul, refounded as Constantinople in AD 330). With churches being built all over the Empire, an 'official' take on decorative programmes was required – one that brought different communities together.

So what sort of images might best convey the Christian credo? Saint Neilos of Ankyra seems to have offered the following answer, advising Olympiadorus on the decoration of his own church in the early fifth century:

> It should be filled on both sides with pictures from the Old and New Testaments, executed by an excellent painter, so that the illiterate who are unable to read the Holy Scripture may, by gazing at the pictures, become mindful of the manly deeds of those who have genuinely served the true God and may be roused to emulate their deeds.

Images – and, more specifically, paintings – are attributed with a narrative purpose, taking their lead from the Bible. A comparable scheme survives in the Basilica of Santa Maria Maggiore in Rome, dating from the AD 430s. Just as Neilos had proscribed, 42 panelled mosaics were installed in the nave, depicting Old and New Testament stories alike (27 can still be seen *in situ*). As in Saint Neilos' ideal programme of church decoration, Scripture was sacrosanct at Santa Maria Maggiore: images served to teach the Word. The didactic pictures installed in the Christian basilica are therefore notably different in purpose from the temple statues of Athena, Apollo, and Zeus [**figs. 58, 60, 61**]. These mosaics and paintings were not to be seen for their own sake, nor did they provide a direct encounter with the divine. Rather, they were intended to inform, enlighten, and inspire. It was a sentiment enshrined by Pope Gregory the Great some two centuries later. According to Gregory, pictures are the 'poor

man's Bible' (*biblia paupera*): painting does for the illiterate what writing does for those who can read.

When Paulinus of Nola commented on a series of Old Testament paintings displayed in his own late fourth-century basilica, he remarked on precisely this difference. Images should not supply viewers with images of the divine, Paulinus writes. Rather, viewers must try to get at the divine *through* images. The picture becomes a sort of conceptual stepping-stone – in fact, rather as Dio Chrysostom had described some three centuries earlier (pp.167–8). 'Crane your neck a little so that you can take in all these images, tilting back your face', as Paulinus advises (*Poems*, 27.511–15); 'the man who looks at these and acknowledges the truth within these empty figures [*uacuis figuris*], nurtures his faithful and believing mind with an image which for him is *not* empty [*non uacua sibi*]'.

For Paulinus, truth lies not in figurative form, nor in the verisimilitude of appearances, but rather in the subjectivity of the person looking. Paulinus' words are revealing for the way in which they *dis*embody the embodied image – their knowing 'emptying' of the picture's material presence: images become not downloadable manifestations of the divine, so to speak, but occasions for conceptual uploading. Through the individual act of contemplating an image, the viewing subject could move closer to God: if viewed properly – that is to say, in the right *Christian* way – the picture casts off its materiality and 'nurtures the mind of the believer [*fidam pascit mentem*]'.

The quest to make images that are at once 'empty' and 'not empty' would define the art of the following centuries. Our histories of 'late antique' and 'Byzantine' art have been much contested in recent years (the latter term refers not just to the city of Byzantium, but more generally to the arts of the Byzantine Empire between the fourth and fifteenth centuries). Broadly speaking, however, Byzantine art witnesses a widespread shift away from Graeco-Roman naturalism towards more abstract and stylised forms. That such a transition has so often been deemed a 'decline' or 'demise' reflects our own ideological inheritance: when approached through the Vasari-tinted spectacles of the Renaissance, it's no wonder that late antiquity is associated with artistic 'dissolution' rather than (for example) progressive

'forward-thinking' (cf. pp.47–53). To lament some 'collapse' of Classicism would of course be mistaken. But to deny the overarching shift would be equally wrong-headed: there evidently was a change in late antique visual forms, as indeed in modes of viewing them; to my mind, moreover, Christianity goes some way in explaining such conversions in style and subjectivity.

What 'Byzantine art' would look like can already be seen in the mosaic dome of the Orthodox Baptistery in Ravenna, installed in the 450s. The dome is divided into three concentric circles, each one occupying a different sort of figurative mode [**fig. 66**]. At the lowest level are four enthroned crosses alternating with open books of the Gospel; above we find the twelve apostles, their names inscribed. These two outer bands frame the literal and metaphorical centre-piece: a depiction of Christ's baptism. The Graeco-Roman debts are clear to see. To the left stands a rather hunky-looking John the Baptist (his pose taken from an ancient schema – Odysseus handing a wine-cup to the one-eyed Cyclops); to the right, half-submerged in water, is an embodied personification of the river Jordan (in accordance with ancient traditions of figuring river-gods: note, though, how the name is also inscribed to avoid any pictorial confusion). Most interesting of all is the naked Jesus standing in the middle. Thanks to the semi-transparent water that surrounds him, the body of Christ is at once visible and obscured: if the schema of the legs is almost Polyclitan in its Classicism [cf. **fig. 2**], the blue of the river occludes any full revelation.

The figure of Jesus takes its place within a larger set of ambiguities about embodied and disembodied form. Viewers of this Baptistery are faced with a series of questions about the materiality of the divine: look again at the personification of Jordan, for example, there for pictorial clarity, but not as a real being (rather like the juxtaposed inscription?); observe too the dove above Jesus' head, figuring the Holy Spirit, described by the Gospels as an epiphany '*like* a dove' (Mark, 1:10; Matthew, 3:16; Luke, 3:21). The visible vs. the invisible, the figurable vs. the non-figurable, the present vs. the absent: these issues hover magisterially over the Baptistery, informing every baptism carried out below – each one refiguring the prototypical baptism of Christ depicted above.

Fig. 66 (cf. **pl. 15**): Restored dome mosaic from the Orthodox Baptistery in Ravenna, AD c. 458. Might this image have been any less controversial in the fifth century than modern-day depictions of the subject [**fig. 57**]? We know that a similar depiction of Christ's baptism was installed in the Baptistery of the Arians during the sixth century.

By at once embodying and disembodying the divine, our Ravenna mosaic exemplifies some typically Byzantine traits. 'For the Byzantines,' writes Henry Maguire, 'it was the image . . . that made the unseen world real, and the unseen world that gave real presence to the image.' The Orthodox Baptistery proves no exception. As is common in Byzantine images, certain iconographic short-hands – the haloes over Jesus' and John the Baptist's heads, for example – signal some sort of corporeal remove. But perhaps most

striking of all is the medium of the flat mosaic. Gone are the sculpted statues of the Greek and Roman temple [figs. 58, 60, 61], or even the architectural reliefs that framed them [fig. 59]. In their stead is a golden, two-dimensional mosaic, stretched over the three-dimensional architecture of the basilica (or in this case baptistery): the Church has become a sort of three-dimensional 'body' in its own material right (cf. I Cor., 12:12–14).

To call this a difference between the 'tactile' and 'optical', as Riegl and others proposed some hundred years ago, might be to put things too starkly. But the change from sculptural illusion to flat surface does have important consequences. Despite the figurative form, the divine is conceived not plastically, but as an artificial construct within a higher pictorial plane. The sacred is embodied, but not reduced to the dimensions of *our* corporeal realm. This presumably explains the choice of precious materials, above all the fragmented *tesserae* of gold and coloured glass. If working in two rather than three dimensions was one way of making the sacred both present and absent, mosaics go still further in fragmenting their (re)presentation. The illusionism of the figurative whole is made up of wholly un-illusionistic and non-figurative parts. Each individual *tessera* drives home the mannered manufacture of the divine: God both is and isn't of the viewer's world.

Icons and idols

It's worth remembering that Greek and Roman (images of the) gods didn't simply vanish during 'late antiquity'. Nowhere were they more conspicuous than in Constantinople. From the Hippodrome to the Baths of Zeuxippus, Graeco-Roman statues crowded the city; indeed, many monuments remained *in situ* until the Crusaders sacked Constantinople in 1204. Some Christian dissidents duly despaired. 'Constantinople was adorned with the nudity of almost every other city', wrote Saint Jerome (*Chronicles*, on the year AD 330; cf. Eusebius, *Life of Constantine*, 3.54): one need only think of the fifth-century Palace of Lausus, where the original Knidian Aphrodite [fig. 34] was displayed alongside other celebrated pagan statues (including

Pheidias' Olympian Zeus [**fig. 61**]). But not everyone disapproved, either in the fourth century, or in the centuries that followed. When, in his seventeenth *Homily,* the patriarch Photios inaugurated an apse mosaic of the Virgin Mary at St Sophia in AD 867, he publicly invoked a Graeco-Roman artistic tradition: surely not even Apelles, Parrhasius, or Zeuxis could have managed so wondrous a feat?

Byzantine image-making was always entangled within its Graeco-Roman heritage. What made Byzantine art even more theologically complex, though, was the continuation of a notably 'pagan' tradition of conceptualising the presentational-cum-representational status of the image. Alongside Paulinus' rhetoric of the 'empty figure' developed the Christian understanding of the 'icon'. The word is Greek, referring to any sort of 'likeness' or *eikon* (interestingly, the etymology also encompasses ideas of 'seeming' and 'appearance' – both reality *and* illusion). But within the Byzantine world, such terminology came complete with a loaded set of assumptions, whereby the painted picture embodied a *real* sort of presence: the icon is less a 'particular technique of painting', as Hans Belting writes, than a 'pictorial concept that lends itself to veneration'.

Icons became an ever more conspicuous feature of private and public Christian devotion, especially from the late sixth century onwards. Paraded in processions, venerated, and not infrequently attributed with miraculous powers, these objects were understood to manifest the actual divine subjects that they visualised. To look at an icon – to kneel before it, bestow it with kisses, whisper a prayer into its ear – was to enact the action before the present subject represented. Although two-dimensional, and although nearly always focussing on the head and upper body, icons very much aligned with Graeco-Roman traditions of figuring the gods. It therefore made sense that so many icons resorted to the naturalistic styles of Greece and Rome. A sixth-century icon of Christ from St Catherine's monastery at Sinai provides a telling example [**fig. 67**]. Not only is Christ rendered to a life-size scale (84 x 45.5 cm), his face and hands give the impression of real flesh: a varied palette of whites, pinks, and rouges evokes Christ's radiant frontal gaze; the effects of light and shade are carefully delineated (observe, for example,

Fig. 67 (cf. **pl. 16**): Painted icon of Christ from St Catherine's Monastery in Sinai (wax encaustic on wood), probably mid-sixth century AD. For all the icon's 'Byzantine' innovations, there is still a Graeco-Roman iconographic debt. What better schema for imagining the all-powerful Christ Pantocrator, for example, than that of Pheidias' Olympian Zeus [**fig. 61**]? And does the hand gesture betoken a divine blessing, or an imperial oratorical address [cf. **figs. 50, 54**].

the neck and hands); and the perfect symmetry of the golden halo, set within a receding architectural niche, is undercut by the conspicuously asymmetrical crown of dark hair (notably thicker to the right than to the left). The viewer's encounter with the image is made (to seem like) an encounter with Christ himself. For all the differences between a two-dimensional icon like this and a statue like the Athena Parthenos [**fig. 58**], both are premised on the same ontological ambiguity: the incarnated image of an incarnate deity merges into the divinity itself.

Censure quickly followed. By the eighth century, icons found themselves at the heart of a theological argument that threatened to split the Christian communion in two. Were icons like **fig. 67** not simply idols in disguise?

Motivated in part by Islamic strictures against figurative representations of the sacred – in the wake of Muhammad's death in AD 632, Muslims had conquered huge chunks of the Byzantine Empire – Iconoclasts ('icon-destroyers') set out to whitewash images, even to remove figurative mosaics: Judaeo-Christianity had to be rescued from the clutches of paganism. Only in AD 843, with a meeting of bishops at Constantinople, would the 'Iconoclastic Controversy' be settled decisively in the icon's favour. The synod upheld the early ruling of the Second Council of Nicaea in AD 787: icons should be adored with the same adoration as both 'the figure of the honoured and life-giving cross' and 'the holy books of the gospels'. Subsequent theologians elucidated the rationale, explaining how a venerated image could serve as a material by-pass for its venerable subject: 'religious worship is not directed to images in themselves, considered as mere things, but under their distinctive aspect as images leading us on to God Incarnate', wrote Saint Thomas Aquinas in the thirteenth century (*Summary of Theology*, II.II.q.81.3, 3). 'The movement toward the image does not terminate in it as image, but tends toward that whose image it is.'

The 'Khludov Psalter', completed soon after the triumph of Orthodoxy in AD 843, uses pictures to explain such pro-pictorial thinking. Take **fig. 68**, which surrounds the text of Psalm 69 with a fascinating pair of images. Just as the Old Testament verbally predicts, we see Christ on the cross, given gall to eat and vinegar to drink (Psalms, 69:21; cf. Matthew, 27:34, 48): the Christian truth fulfils the Judaic prophecy, just as the image materialises the text. This Old-cum-New-Testament subject is made to prefigure a second and wholly more contemporary scene below, in which two Iconoclasts suspend an icon of Christ over a chalice of lime white-wash. The visual ensemble stakes a claim about both Christ and the legit-imacy of His icon. To dishonour Christ's *image*, it seems, is to dishonour Christ himself – to re-enact his crucifixion, no less. Dressed in the same garb (and note the visual parallel between the tormentors' circular shields and the Iconoclasts' circular icon), the Iconoclasts hold the image of Christ on a pole that resembles the stick on which Christ is offered the vinegar-soaked sponge; similarly, the bucket of whitewash beneath the

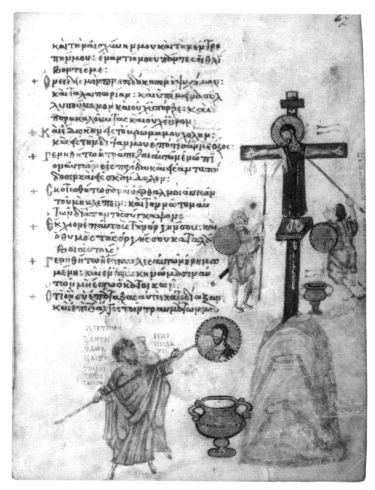

Fig. 68: Folio 67r of the Chludov Psalter, c. AD 850. A series of visual parallels links those tormenting Christ's icon (below) with those tormenting Christ himself (above). An inscription beside the two Iconoclasts alludes to the verbal language of the Psalm, telling how water was mixed not with vinegar (as during the crucifixion) but with lime: the Old Testament is thereby made to prophesy both Christ's mortal suffering and the more recent heresies of Iconoclasm.

Iconoclasts echoes the chalice of vinegar at Christ's feet. A further visual pun underscores the equivalence: the circular medallion surrounding Christ's icon recalls the circular halo quite literally circumscribing Christ's godhead on the cross. Images are themselves exploited to celebrate the

legitimacy of images. Woe betide the Christian who sees things otherwise!

Case studies could be multiplied. But my overarching argument would remain the same: namely, that Graeco-Roman images helped determine not only *what* Christian images looked like, but also *how* they were understood. Indeed, the problematic Christian status of the image – the perpetual paradox of the 'empty figure' – can *only* be understood in relation to the Graeco-Roman artistic-cum-religious inheritance.

The argument needs stressing because we so regularly assume otherwise. It is often thought, for example, that the ancient art of the body lay dormant through the *longue durée* of the Middle Ages, whether in Byzantine traditions of the east, or the Mediaeval art of the Holy Roman Empire in the west. Scholars not infrequently imply that ancient materials become relevant again only with the emergence of the 'Renaissance' out of the so-called 'Dark Ages'. In art historical circles, it's all too common to construct a narrative of 'ancient and moderns' that revolves around some metaphorical light switch: pioneers like Pisano and Giotto are accordingly heroised as having rediscovered Classical models – and thereby rescuing Europe from the Gothic gloom. The rhetoric, as we have seen, ultimately derives from Giorigo Vasari and his 1550 *Lives of the Most Excellent Painters, Sculptors, and Architects* (pp.48–9).

The story told in this chapter is somewhat more complex: that the conventions of Byzantine and Mediaeval art themselves arose in reaction to Graeco-Roman figurative traditions. So what, then, of the 'Rinascimento'? How should the self-conscious 'rebirth' of Classical image-making be fitted within our theological-cum-artistic account?

To my mind the Quattrocento is best understood as the reverse swinging of an artistic and theological pendulum. Yes, the Renaissance brought about a dramatic change in visual language. And yes, this was founded upon a conspicuous revival of ancient forms. But because art still remained first and foremost a matter of religion, it was inevitable that these visual shifts should also plunge the world into theological crisis. With Renaissance artists looking to ever more ancient models, the divine became ever more corporeal

and believable: God became increasingly embodied and present, and decreasingly spiritual and removed. In one sense, Christianity became more 'ancient' in the fifteenth century than it had ever been before.

Nowhere is this clearer than in Renaissance depictions of the crucifixion. As we noted earlier (pp.156–71), Christ's passion had long served as a paradigm for Christian bodily rejection. Despite the Scriptural detail that Christ was naked on the cross (his clothes removed by the Roman soldiers and divided by lot: cf. John, 19:23–4, fulfilling Psalms, 22:18), Byzantine and Mediaeval representations nearly always showed Christ either in a long tunic or else in a loin cloth [fig. 68]. Alternatively, the body of Christ was banished altogether: as the Byzantine Iconoclasts had advocated in the late eighth century, it was better to rely on the schematic symbol of the cross alone. This iconographic detail evidently worried Christian theologians. In the late sixth century, Gregory of Tours even records how, after a painting of a 'naked Christ upon the cross' was installed in the cathedral at Narbonne, Jesus appeared to the bishop in a dream: his body, Christ demanded, must be covered up – and covered up immediately. The crucifixion had to turn people away from the pagan cults of the body and its image, not arouse or titillate . . .

Contrast that thinking with a newly rediscovered wooden crucifix, attributed to the teenage Michelangelo in 1492 [fig. 69]. In keeping with western Mediaeval practice, we see the crucifixion not as a flat image, but as a three-dimensional statue, just under life-size: it originally hung over the high altar in the Church of Santa Maria del Santo Spirito in Florence. But the corporeal suffering of Christ is here glorified, not covered up. Rather than repudiate the body, this particular 'Passion' offers the most marvellously majestic manifestation of Christ's *naked* humanity. Just as the divine has become more and more embodied, images of the divine have become more and more real: the sacred is sensory, sensuous, even sexually arousing.

It's easy to see where this particular vision of Christ has come from. Michelangelo looked to an ancient tradition of the body to vindicate Christ's nudity and quasi-*contrapposto*: stretched out on his literal cross, 'Vitruvian man' [fig. 6] has morphed into *Christian* Man. Michelangelo's contemporaries, concludes James Hall, couldn't be sure whether the artist 'was

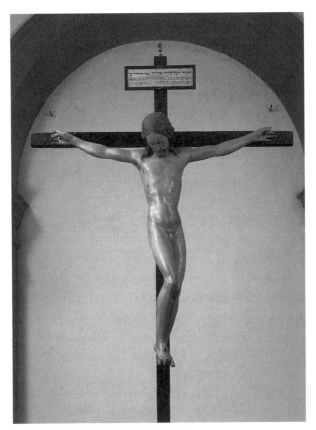

Fig. 69: Michelangelo, painted wooden crucifix, c. 1.39 metres (around 4½ feet), crafted c. 1492. In 2008, the Italian government purchased another (smaller) wooden sculpture of the same subject, associating that statue too with Michelangelo. Neither attribution is wholly certain. But such sexualised images of Christ's crucified body tally with Michelangelo's later work – his many drawings of Jesus on the cross, for example, and his *Pietà* of 1499.

Christianising pagan culture, or paganising Christianity'. This is the Renaissance at its height, where art and religion celebrate the corporeal in one accord: God's flesh is to be experienced *in* the flesh.

Michelangelo's 'icon' privileges verisimilitude above all else. Legend has it that the artist was granted access to the corpses of the convent hospital, as anatomical studies for Christ's tortured body. Everything about the crucifix is intended to convince of Jesus' presence and bodily reality, lording it over

the Eucharistic 'body and blood' celebrated below: the plastic rendering, the polychrome colouring, the spear wound at Christ's side (complete with painted blood for heightened drama and effect). Even the sign attached to the cross, inscribed in Hebrew, Greek, and Latin, helps play out the drama as staged in the script of John's Gospel (John, 19:19).

As such, the Santo Spirito crucifix presents the antitype to Paulinus' 'empty figure'. If Christian art had always been torn between adhering to and rejecting the Classical body – between God's figurality and non-figurality – Michelangelo tips the scales firmly in antiquity's favour. The magnificent beauty of divine *disegno* is to be admired even (and indeed especially) at its most repugnant moment. *Praise be to God!*

It's no coincidence that, within a few decades of Michelangelo's crucifix, the western world would be mired in the greatest theological and intellectual controversy ever known. Modern Christianity could no longer put up with the 'antiquity' of the Roman Catholic Church: a theological purging was required, and with it a purging of 'Christian' imagery. For the likes of Andreas Bodenstein von Karlstadt in the Saxon town of Wittenberg, the spiritual truth of the Incarnation had been compromised. Karlstadt consequently took it upon himself to put things right, explaining his actions in a 1522 tract *On the Removal of Images*:

> Certainly you must say that one learns from pictures nothing but the life and the suffering of the flesh and that they do not lead further than the flesh. More they cannot do. For example, from the image of the crucified Christ you learn only about the suffering of Christ in the flesh, how his head hung down, and the like . . . Since, then, images are deaf and dumb, can neither see nor hear, neither learn nor teach, and point to nothing other than pure and simple flesh which is of no use, it follows conclusively that they are of no use. But the Word of God is spiritual and alone is useful to the faithful.

Karlstadt's argument is an old one: compare Clement of Alexandria's abrogation in the second century (pp.172–3), or the words of the Judaic Psalms

(whereby idolaters are as empty as the idols that they make – 'they have mouths, but do not speak; eyes, but do not see': Psalms, 115:4–5). In the case of the Protestant Reformation, however, a whole new visual economy would emerge. Different theologians would take different positions – Martin Luther, Ulrich Zwingli, Philip Melanchthon, and John Calvin each pontificating on why, how, and where images might be allowed (or indeed why, how, and where they might not). And yet – and this point is crucial – the Reformation was fought over the *materiality* of Christian devotion: what kind of body did Christ have, and how should it (indeed *could* it) be visually portrayed?

Beyond the body?

As well as determining almost every other aspect of modern theological, cultural, and intellectual history, the Reformation prepared the way for 'art' as we know it. Banished from the Church, images would be removed to the secular cloisters of the museum, especially in the eighteenth century. During the same period of the 'Enlightenment', philosophers developed a new discipline of aesthetics to rationalise art in non-religious terms: from this line of enquiry emerged 'art history' as practised today, together with our modern museographic mind (and all its critical vocabulary).

I want to end this chapter, though, by relating these developments back to the ancient art of the body. If the Reformation laid the ground for 'Art' in its familiar, autonomous, post-Enlightenment sense, this process can *only* be explained by looking back to the visual-cum-theological legacy of the Graeco-Roman world. Modern secular notions of the image descend from the theological upheavals of the Reformation, which themselves descend from the ancient legacy of embodying and figuring the divine.

The extent to which the Reformation reformed concepts of the image is quite unparalleled within the earlier history of Christianity. 'Christendom will not be known by sight', preached Martin Luther, 'but by faith, and faith has to do with things not seen'; 'Christ's kingdom is a hearing kingdom, not a seeing Kingdom.' What this meant in visual terms is nicely

Fig. 70: Marcus Gheeraerts the Elder, *Allegory of Iconoclasm*, after 1566. The paradox here is that the 'image-breakers' prove the 'image-makers': an image is used to decry the idolatry of imagery [contrast **fig. 68**]. The picture consequently embodies a modern, post-Reformation condition: what might an art *beyond* the body look like?

demonstrated in an engraving by Marcus Gheeraerts the Elder, made in the late 1560s [**fig. 70**]. The artist shows the idolatries of the Roman Catholic Church fleshing out the rotting skull of a tonsured monk, the hair formed out of snakes and barren trees: Catholic sacraments are performed in the corresponding part of the head (confession in the ears, Eucharist in the mouth, matrimony and holy orders in the eyes); each ritual is interspersed with other scenes of materialist devotion (the sale of indulgences, bell-ringing, pilgrimage, etc.). The worst abomination of all, though, is reserved for the nasal crux: a woman is shown kneeling before an image of the crucified Christ. All other Catholic heresies derive from this one, crucial profanation. By grounding itself in the flesh, Roman Catholicism fails to secure the redemptive grace proffered by faith: the Catholic body withers, rots, and festers – just like the idols that Roman Catholics have created.

In striving for a spiritual truth beyond the body, Reformation theologians inaugurated a markedly different mode of conceptualising the world around us. Every materialist devotional ritual had to be questioned: was even the supposed transubstantiation of the Eucharist (bread and wine becoming the real body and blood of Christ) an empirical truth, or some more logical figure of speech? The display of images was also carefully policed, even banned altogether (at least within the Church): God existed on a higher plane.

This was not just a Protestant development. In 1563 the Council of Trent imposed some similar restrictions on the display of Roman Catholic imagery, abolishing all 'lasciviousness' – and thereby initiating the so-called 'Counter-Reformation'. Although the Roman Catholic Church would permit (and still does permit) the 'respectful veneration' of images, it ordained that 'figures shall not be painted or adorned with a beauty exciting to lust': 'there shall be nothing seen that is disorderly, or that is unbecomingly or confusedly arranged, nothing that is profane, nothing indecorous'. Michelangelo's crucifix [**fig. 69**], created less than a century beforehand, could not have been sanctioned at this time. Indeed, even his 1530s fresco of the Last Judgement in the Sistine Chapel came under increasing criticism for its Classicism – the nudity of the figures (subsequently painted

over), the beautiful body of Christ, the figure of Charon ferrying the dead. As testified so clearly in Laureti's fresco [**fig. 56**], the Catholic Counter-Reformation would define itself *against* the idolatrous – despite the lingering intimations to the contrary. Something profound had changed. And it had changed profoundly.

How do these developments relate to the 'art of the body', or indeed to 'antiquity and its legacy'? By situating the Reformation at the crossroads between the Graeco-Roman world and our own, I end this book with a two-fold conclusion. First, that the Reformation (and all it brought about) was a theological reaction against the ancient art of the body: protests about the Christian image reached boiling point at precisely the Renaissance moment when ancient traditions were 'reborn'. My second conclusion follows on from the first: namely that, both religiously and visually, the legacy of the Reformation remains our visual condition in the twenty-first century. Whatever our theological conviction (or lack thereof), the Reformation determined the image-making of the modern western world: not only the subsequent trajectory of western art, but the phenomenon (and phenomenology) of 'art' in the first place. Our whole western history of art totters around the problematic inheritance of the ancient Greek and Roman.

This is a grand thesis for a humble book such as this. Too grand, perhaps. But the thesis is not in fact my own. It was Georg Wilhelm Friedrich Hegel who first articulated the argument in a series of lectures delivered in the 1820s. For Hegel, the history of art was a history of artistic epiphany – of trying to express the super-sensory in sensory form. It was a history, moreover, inextricable from the artistic legacies of ancient Greece and Rome.

It's worth summarising the essentials of Hegel's argument, or at least his theory of a three-tiered art history, centred around what he called the 'Symbolic', 'Classical', and 'Romantic' phases. In the first, 'Symbolic' stage (associated with the oriental East), argues Hegel, the relationship between divinity and artistic form was wholly arbitrary: the image served as a symbol rather than as an embodiment of the god. The art of the second, 'Classical' age of Greece (and to a lesser extent Rome) reversed this situation, reconciling signifier with signified: artists set out to present the divine in full,

material splendour. But the more perfectly ancient sculptors attempted to render the gods' humanity, the more wholly they were diverted from the *non*-material. 'The contradiction between spirituality and sensuous existence', as Hegel puts it, 'drags Classical art itself to its ruin.'

From this ruin arose Christianity, together with a third, 'Romantic' phase of art. Just as the Christian Incarnation had transformed God into man, Romantic art openly theorised the relationship between material form and spiritual abstraction: where Classical art had concerned itself with the perfection of outward form, Christian viewers had to look to a subjective 'beauty of inwardness' (*Schönheit der Innigkeit*). At first, various concessions were made within the Classical tradition: whereas Greek art had tried to materialise the gods through sculpture, Christian Romantic art became two-dimensional, preferring paintings and mosaics. With the Reformation, however, even this had to change: thanks to Martin Luther, Christianity came to prioritise the spiritual and abstract over the material and tangible. There could subsequently be no turning back: 'transferred into our ideas instead of maintaining its earlier necessity in reality, art, considered in its highest vocation, is and remains for us a thing of the past.' 'No matter how excellent we find the statues of the Greek gods, no matter how we see God the Father, Christ, and Mary so estimably and perfectly portrayed: it is no help. We bow the knee no longer.'

According to Hegel, the Reformation constituted the paradigm shift between ancients and moderns. Although lecturing in Berlin in the 1820s, Hegel could predict what this would mean for the art of the later nineteenth and twentieth centuries: after the Reformation had exposed the emptiness of all material form, a more reflective sort of image-making would emerge, premised on the perceived dichotomy between form and content. What would follow, writes Hegel, would be the 'dissolution' (*Auflösung*) of art altogether: reified, ratified, and refuted, the image would serve a contemplative rather than religious purpose. 'Art invites us to intellectual consideration, and that not for the purpose of creating art again, but for knowing philosophically what art is.'

Impressionism, Expressionism, Dadaism, Futurism, Surrealism, Cubism:

each and every modernist movement might be said to have played out Hegel's prophecy, experimenting with ever less figurative and ever more conceptual modes. Not only is painting duly privileged over sculpture, but painting has itself given way to other forms of 'installation' and 'performance' art (what Douglas Crimp heralded as the 'end of painting' in 1981). By the turn of the millennium, the pinnacle of (post)modern artistic achievement could be judged a pickled shark, an unmade bed, or a white room with lights flickering on and off. What matters in each case is not what you see, but what you *think* about what you see. Any more figurative mode of painting seems belated or outmodish, and sculpture thereby doubly so: just ask Damian Hirst, Tracey Emin, Martin Creed – or any other Turner Prize-winner . . .

Not everything in Hegel's account will convince. Modern-day sceptics are rightly suspicious of a *Geistesgeschichte* ('History of Spirit') that culminates all too conveniently in the Protestant enclaves of 1820s Prussia. I for one would also protest against Hegel's championing of Protestant iconoclasm – his very assumptions about what 'art' is (or must be). Nor am I convinced by the straightforwardly linear march of Hegel's narrative – as with so much of the *Aesthetics*, Hegel's first and foremost debt is to Winckelmann. Many other assumptions are equally objectionable: Hegel is unashamedly nationalist, staunchly teleological, and not infrequently racist. But in a sense this all testifies to Hegel's own place within the cultural history that he chronicles. It needn't overly distract.

By writing a grand narrative of art, and placing religion at its heart, Hegel attempted something unpopular with many historians of philosophy, art, and culture today. 'Big picture' accounts like Hegel's are inherently risky because they can always be fragmented into smaller (and smaller) pieces. Then there is the taboo of religion: in an age of avowed, even militant secularism, it's unsurprising that we play down the theologies underpinning how we see. Indeed, Hegel himself predicted as much.

But what the *Lectures on Aesthetics* so magisterially convey is the centrality of Graeco-Roman art in directing the *entire* course of western art, no less than of western theology. Hegel's history of the art of the body is the ultimate

account of 'ancients and moderns'. On the one hand, Hegel analyses (?post-)Christianity's attempts to deal with the artistic and theological inheritance of the Classical past. On the other, Hegel explains the post-Reformation/post-Enlightenment liberation of 'art for art's sake' – its subsequent freedom to go its own, autonomous, secular way.

Hegel therefore makes for an appropriate ending to the present project. He understood that everything we see and think about 'art' derives from the delicate negotiation of each successive present from each successive past: only by thinking about the modern alongside the ancient can we conceptualise either – or indeed both. Contemporary western image-making is *still* premised upon the Greek and Roman art of the body; the modern discipline of 'art history', moreover, is *still* bound up with our ancient inheritance. This little book has sought to embody that grand overarching principle.

FURTHER READING

The following bibliographical suggestions are intended primarily as references for citations and quotations. But my aim has also been to guide readers who are interested in finding out more. I've privileged two criteria in particular: first, I've tried to list English-language publications in preference to those in other languages; second, I've tended to list the most recent discussions where possible. References to 'primary' Greek and Latin texts are given in individual chapters and are not repeated here: most texts can be found in the Loeb Classical Library published by Harvard University Press ('Loebs' contain facing English translations, although all translations in this book are my own).

Preface

The three volumes of Michel Foucault's history of sexuality were published in French in 1976 (vol. 1) and 1984 (vols 2 and 3). For a translation, see M. Foucault, *The History of Sexuality* (3 vols, trans. R. Hurley: London and New York, 1986): the second and third volumes (on 'the use of pleasure' and 'the care of the self') are explicitly concerned with Graeco-Roman antiquity.

On the Greek and Roman body, there is a useful assembled bibliography in T. Fögen and M. Lee (eds), *Bodies and Boundaries in Graeco-Roman Antiquity* (Berlin and New York, 2009), pp.11–14. Still useful too is the overview in A. Richlin, 'Towards a history of body history', in M.

Golden and P. Toohey (eds), *Inventing Ancient Culture: Historicism, Periodization, and the Ancient World* (London, 1997), pp.16–35. Readers of German will find an accessible introductory history in T. L. Thommen, *Antike Körpergeschichte* (Zurich, 2007). For a more thematic discussion of the Greek material, centred around the differences between the visual and verbal, see R. Osborne, *The History Written on the Classical Greek Body* (Cambridge, forthcoming).

There are also a number of relevant edited volumes: the most significant is F. Prost and J. Wilgaux (eds), *Penser et représenter le corps dans l'Antiquité* (Rennes, 2006). Other (rather more eclectic) volumes include: D. Montserrat (ed.), *Changing Bodies, Changing Meanings: Studies on the Human Body in Antiquity* (London and New York, 1998): M. Wyke (ed.), *Gender and the Body in the Ancient Mediterranean* (Oxford, 1998); J. Porter (ed.), *Constructions of the Classical Body* (Ann Arbor, 1999); D. Cairns (ed.), *Body Language in the Greek and Roman Worlds* (Swansea, 2005); L. Cleland, M. Harlow and L. Llewellyn-Jones (eds), *The Clothed Body in the Ancient World* (Oxford, 2005); A. Hopkins and M. Wyke (eds), *Roman Bodies: Antiquity to the Eighteenth Century* (London, 2005).

Specifically on the art of the ancient body, two books are crucial, the first concerned with Greek material, the second with Roman: A. Stewart, *Art, Desire and the Body in Ancient Greece* (Cambridge, 1997); C. H. Hallett, *The Roman Nude: Heroic Portrait Statuary 200 BC–AD 300* (Oxford, 2005). Those seeking a glossier 'coffee-table' introduction might try I. Jenkins and V. Turner, *The Greek Body* (London, 2009). One somewhat reactionary discussion of both the ancient material and its legacy is K. Clark, *The Nude: A Study of Ideal Art* (2nd edition: London, 1960): this book will have frequent recourse to Clark's classic overview.

There are many English-language textbook introductions to Greek and Roman art more generally. Among the most popular guides to the Greek material are: A. Stewart, *Greek Sculpture* (2 vols: New Haven, 1990); N. Spivey, *Understanding Greek Sculpture: Ancient Meanings, Modern Readings* (London, 1996 – a new edition is forthcoming); idem, *Greek Art* (London, 1997); R. Osborne, *Archaic and Classical Greek Art* (Oxford, 1998); recom-

mended too are John Boardman's various handbooks on Greek sculpture and vase-painting in the Thames and Hudson World of Art series (especially for the copious pictures). For the Roman material, there is a basic chronological guide in N. H. Ramage and A. Ramage, *Roman Art: Romulus to Constantine* (5th edition: London, 2008); a thematic introduction in E. D'Ambra, *Art and Identity in the Roman World* (Cambridge, 1998); and a much weightier handbook in D. Kleiner, *Roman Sculpture* (New Haven, 1993). Two other books might also be useful: first, M. Beard and J. Henderson, *Classical Art: From Greece to Rome* (Oxford, 2001), which offers a racy guide to issues of reception; and second, N. Spivey and M. J. Squire, *Panorama of the Classical World* (2nd edition: London, 2008), a one-volume 'portable museum'. Although these volumes go largely uncited in the bibliographic suggestions below, they provide basic introductions to many of the case studies discussed.

For readers interested in wider questions of art historical theory and method, there's a useful thematic guide in R. S. Nelson and R. Shiff (eds), *Critical Terms for Art History* (2nd edition: Chicago, 2003). For a history of art theory, one cannot do better than M. Barasch, *Theories of Art* (2nd edition, 3 vols: New York and London, 2000). More succinct and visually minded is M. Hatt and C. Klonk, *Art History: A Critical Introduction to its Methods* (Manchester, 2006). Specifically on the German art historical tradition, at least between the 1820s and 1920s, one cannot beat M. Podro, *The Critical Historians of Art* (New Haven, 1982).

For my own thoughts on the state of Classical art history, see M. J. Squire, 'Introduction: The art of art history in Graeco-Roman antiquity', *Arethusa* 43.2 (2010): 133–63. Compare also J. Tanner, *The Invention of Art History in Ancient Greece: Religion, Society and Artistic Rationalisation* (Cambridge, 2006), pp.1–19, and A. A. Donohue, 'Introduction', in A. A. Donohue and M. D. Fullerton (eds), *Ancient Art and its Historiography* (Cambridge, 2003), pp.1–12. One of the most provocative critiques of 'art history' as a discipline is still D. Preziosi, *Rethinking Art History: Meditations on a Coy Science* (New Haven, 1989).

The two quotations on p.xiv are taken from the editor's introduction

to J. Boardman (ed.), *The Oxford History of Classical Art* (Oxford, 1993), p.2; and J. Whitley, *The Archaeology of Ancient Greece* (Cambridge, 2001), p.xxiii. Needless to say, this author sees things rather differently!

Chapter I

On the afterlife of the Classical, two volumes are particularly useful: first, F. Haskell and N. Penny (eds), *Taste and the Antique: The Lure of Classical Sculpture, 1500–1900* (New Haven, 1981), structured around individual works; second, M. Greenhalgh, *The Classical Tradition in Art* (London, 1978), which is chronologically arranged. Numerous other books are also relevant: e.g. R. Rowland, *The Classical Tradition in Western Art* (Cambridge, 1963); C. C. Vermeule, *European Art and the Classical Past* (Cambridge, MA, 1964); J.-P. Cuzin, J.-R. Garborit and A. Pasquier (eds), *D'après l'antique* (Paris, 2000); V. Coltman (ed.), *Making Sense of Greek Art* (Chicago, 2010).

On Canova's statue of Napoleon, see the bibliography cited in Chapter Four below, along more generally with M. E. Micheli, '*Iudicium et ordo*: Antonio Canova and antiquity', in J. Fejfer, T. Fischer-Hansen and A. Rathje (eds), *The Rediscovery of Antiquity: The Role of the Artist* (Copenhagen, 2003), pp.277–97, esp. pp.288–90. On the meaning of the term 'Classical', see especially S. Settis, *The Future of the Classical* (Cambridge, 2006); cf. G. Luck, '*Scriptor classicus*', *Comparative Literature* 10 (1958): 150–8, and R. Wellek, 'The term and concept of classicism in literary history', in E. R. Wasserman (ed.), *Aspects of the Eighteenth Century* (Baltimore and London, 1965), pp.105–28. On Neoclassicism more generally: D. Irwin, *Neoclassicism* (London, 1997); V. Coltman, *Fabricating the Antique: Neoclassicism in Britain, 1760–1800* (Chicago, 2006), esp. pp.1–16; eadem, *Classical Sculpture and the Culture of Collecting in Britain Since 1760* (Oxford, 2009). The quote on pp.6–7 comes from M. Camille, *Master of Death: The Lifeless Art of Pierre, Illustrator* (New Haven, 1996), p.7.

On Polyclitus and his *Canon*: the surviving literary sources are collected in J. J. Pollitt, *The Art of Ancient Greece: Sources and Documents* (Cambridge, 1990), pp.75–9. The best one-volume guide is W. G. Moon (ed.), *Polykleitos,*

the Doryphoros, and Tradition (Madison, WI, 1995). Cf. A. Stewart, 'The canon of Polyclitus: A question of evidence', *Journal of Hellenic Studies* 98 (1978): 122–31; A. H. Borbein, 'Polykleitos', in O. Palagia and J. J. Pollitt (eds), *Personal Styles in Greek Sculpture* (New Haven, 1999), pp.66–90; J. Tanner, *The Invention of Art History in Ancient Greece: Religion, Society and Artistic Rationalisation* (Cambridge, 2006), pp.117–21 (review of bibliography), pp.161–70 (relation to contemporary medical writing). For analysis of the Oxford metrological relief [**fig. 3**], see E. Fernie, 'The Greek metrological relief in Oxford', *Antiquaries Journal* 61 (1981): 255–63.

On antiquity and the Renaissance: the best guidebook is P. Bober and R. Rubinstein (eds), *Renaissance Artists and Antique Sculpture: A Handbook of Sources* (2nd edition: Turnhout, 2010); the most important thematic discussion is L. Barkan, *Unearthing the Past: Archaeology and Aesthetics in the Making of Renaissance Culture* (New Haven, 1999). Cf. S. Howard, *Antiquity Restored: Essays on the Afterlife of the Antique* (Vienna, 1990); A. Schnapp, *The Discovery of the Past: The Origins of Archaeology* (trans. I. Kinnes and G. Varndell: New York, 1996), esp. pp.121–77; A. Payne, A. Kuttner and R. Smick (eds), *Antiquity and its Interpreters* (Cambridge, 2000). On Michelangelo specifically, see S. Howard, 'Michelangelo and Greek Sculpture', in J. Fejfer, T. Fischer-Hansen and A. Rathje (eds), *The Rediscovery of Antiquity: The Role of the Artist* (Copenhagen, 2003), pp.37–62.

On Vitruvius: the most accessible translation is by I. D. Rowland: *Vitruvius, Ten Books on Architecture* (Cambridge, 1999), which discusses this passage on pp.188–9; for more detailed commentary, see P. Gros (ed.), *Vitruve, De l'architecture: Livre 3* (Paris, 1990), pp.55–60. On the cultural remove between Vitruvius' text and subsequent Renaissance responses to it, there's an excellent discussion in I. K. McEwan, *Vitruvius: Writing the Body of Architecture* (Cambridge, MA, 2003), pp.155–83.

Hogarth's essay is reproduced in J. Burke (ed.), *William Hogarth: The Analysis of Beauty* (Oxford, 1955): I quote from pp.56 (chapter 7) and 104–5 (chapter 11); there are also some additional notes about **fig. 8** on pp.xi–xii. On the general eighteenth-century cultural and artistic backdrop, see M. Craske, *Art in Europe, 1700–1830* (Oxford, 1997).

On the Classical body and modern muscle-building, the key article is M. Wyke, 'Herculean muscle! The classicizing rhetoric of bodybuilding', *Arion* 4.3 (1996): 51–79 (reprinted in J. Porter (ed.), *Constructions of the Classical Body* (Ann Arbor, 1999), pp.355–79); also relevant is E. Alvarez, *Muscle Boys: Gay Gym Culture* (London, 2008). The Lloyd-Jones quotation is cited by J. Walters, *Magical Revival: Occultism and the Culture of Regeneration in Britain, c. 1880–1929* (unpublished PhD thesis, University of Stirling, 2007), p.136: I greatly learnt from Walters' discussion of Sandow on pp.150–65. The underlying nineteenth-century ideology of the Classical nude is well discussed in the catalogue accompanying the exhibition at London's Tate: A. Smith (ed.), *Exposed: The Victorian Nude* (London, 2001), esp. pp.86–127.

On Nietzsche and German responses to the Classical body in the nineteenth and twentieth centuries, the most important discussion is in German: L. Schneider, 'Der Körper als Kunst: "Griechische" Körperinszenierungen von Winckelmann bis zum 20. Jahrhundert', in G. Lohse and M. Schierbaum (eds), *Antike als Inszenierung* (Berlin, 2009), pp.71–128. Compare more generally E. M. Butler, *The Tyranny of Greece over Germany* (Cambridge, 1935); L. Marchand, *Down from Olympus: Archaeology and Philhellenism in Germany, 1750–1970* (Princeton, 1997); A. Taha, *Nietzsche, Prophet of Nazism: The Cult of the Superman. Unveiling the Nazi Secret Doctrine* (Bloomington, 2005). I translate the passage of Nietzsche from G. Colli and M. Montinari (eds), *Nietzsche: Werke. Kritische Gesamtausgabe*, volume 7.3 (Berlin and New York, 1974), pp.412–13: the notes appear under August–September 1885 (fr. 41.4). There's also an important discussion in S. D. Goldhill, *Who Needs Greek? Contests in the Cultural History of Hellenism* (Cambridge, 2002), pp.294–9.

On the Fascist art of the body, see the essays in both J. A. Mangan (ed.), *Shaping the Superman: Fascist Body as Political Icon – Aryan Fascism* (London, 1999) and J. A. Mangan (ed.), *Superman Supreme: Fascist Body as Political Icon – Global Fascism* (London, 2000): especially important are the essays by G. McFee and A. Tomlinson ('Riefenstahl's *Olympia*: Ideology and aesthetics in the shaping of the Aryan athletic body':

pp.86–106 of the 1999 volume), and G. Gori ('Model of masculinity: Mussolini, the "New Italian" of the Fascist era': pp.27–61 of the 2000 volume; Gori cites the Ferreti quotation on p.39). The best photographic guide is D. Ades (ed.), *Art and Power under the Dictators* (London, 1995), together with G. Mott et al., *Foro Italico* (New York, 2003) on Rome's Stadio dei Marmi. On the disciplinary ideologies of art history under the Nazis, see E. Michaud, *The Cult of Art in Nazi Germany* (trans. J. Lloyd: Stanford, CA, 2004), and J. Elsner, 'Myth and chronicle: A response to the values of art', *Arethusa* 43.2 (2010): 289–307, esp. pp.294–301.

The 1936 Berlin Olympics: Riefenstahl's 1937 album of stunning photographic stills has been reprinted (*Olympia*: London, 1994): the *Discobolos* images feature on pp.26–7. The best discussion of the underlying ideology is by B. Hannah Schaub, *Riefenstahls Olympia: Körperideale – ethische Verantwortung oder Freiheit des Künstlers?* (Cologne, 2003), esp. pp.35–57. Cf. A. Krüger and W. J. Murray (eds), *The Nazi Olympics: Sport, Politics and Appeasement in the 1930s* (Champaign, IL, 2003); D. C. Large, *Nazi Games: The Olympics of 1936* (New York and London, 2007) esp. pp.295–315.

I take my quotations of Hitler from 'Hitlers Rede zur Eröffnung der "Großen Deutschen Kunstausstellung"', in P. K. Schuster (ed.), *Nationalsozialismus und 'Entartete Kunst'* (Munich, 1987), pp.250–2, and A. Hitler, *Mein Kampf* (trans. J. Murphy: London, 1939), p.221. For the famous quote on 'culture after Auschwitz', see T. Adorno, *Negative Dialectics* (trans. G. B. Ashton: New York, 1966), p.367.

The translations and quotations of Picasso and Marinetti are taken from N. Spivey and M. J. Squire, *Panorama of the Classical World* (2nd edition: London, 2008), pp.326, 328, 330. For a magisterial chronological and thematic guide, see C. Harrison and P. Wood (eds), *Art in Theory, 1900–2000: An Anthology of Changing Ideas* (2nd edition: Malden, MA, 2003), which contains 371 of the most important texts (and an excellent introduction on pp.1–14); also useful are the more visual guides of R. Brettell, *Modern Art 1851–1929: Capitalism and Representation* (Oxford, 1999) and D. Hopkins, *After Modern Art: 1945–2000* (Oxford, 2000). Umberto Eco's quote comes from U. Eco, *Reflections on the Name*

of the Rose (trans. W. Weaver, 2nd edition: Reading, 1994), p.67. For a wider discussion of the postmodern stakes, see J. F. Lyotard, *The Postmodern Condition* (Manchester, 1984).

Chapter II

There are three especially important recent discussions of the 'Greek Revolution'. First, from the perspective of Pioneer vase-painting, is R. Neer, *Style and Politics in Athenian Vase-Painting* (Cambridge, 2002), pp.27–86, esp. pp.28–32 (p.31 is quoted on pp.54, 65). Second is J. Tanner, *The Invention of Art History in Ancient Greece: Religion, Society and Artistic Rationalisation* (Cambridge, 2006), pp.31–96, a more sociologically oriented read. Third, and most succinct, is J. Elsner, 'Reflections on the Greek revolution in art: From changes in viewing to the transformation of subjectivity', in S. Goldhill and R. Osborne (eds), *Rethinking Revolutions Through Ancient Greece*, pp.68–95 (p.85 of which is quoted on p.54). All of these cite extensive bibliography. R. Neer's *The Emergence of the Classical Style in Greek Sculpture* (Chicago, 2010) was published while this book was in final proofs – but also comes highly recommended.

For earlier scholarship, one might consult C. H. Hallett, 'The origins of the Classical style in sculpture', *Journal of Hellenic Studies* 106 (1986): 71–84. The 'democratic' spinning of this artistic 'revolution' is most conspicuous in the museum catalogue accompanying the exhibition mentioned on pp.62–3: D. Buitron-Oliver (ed.), *The Greek Miracle: Classical Sculpture from the Dawn of Democracy, the Fifth Century BC* (Washington, DC, 1992). On the importance of bronze-casting, somewhat downplayed in this chapter, compare C. Mattusch, *Greek Bronze Statuary from the Beginnings through the Fifth Century BC* (Ithaca, NY, 1988); eadem, *Classical Bronzes: The Art and Craft of Greek and Roman Statuary* (Ithaca, NY, 1996); cf. R. Neer, *The Emergence of the Classical Style in Greek Sculpture*, pp.70–103.

For Gombrich's discussion of the 'Great Awakening', see E. Gombrich, *The Story of Art*, pp.49–64 (London, 1950). All quotations come from this

first edition (pp.1, 33, 51, 52, 55, 61, 67–8, 160), although the most recent full edition was published in 2003, two years after Gombrich's death. For the 'Greek Revolution', compare E. Gombrich, *Art and Illusion: A Study in the Psychology of Pictorial Representation* (5th edition: London, 1977), pp. 99–125 (I quote p.110 on p.45). The quotation on p.47 comes from C. Greenberg, 'Towards a newer Laocoön', *Parisian Review* 7 (1940): 296–310 (p.307). On kouroi and their evolution, see especially G. Richter, *Kouroi: Archaic Greek Youths. A Study of the Development of the Kouros Type in Greek Sculpture* (3rd edition: New York, 1970), esp. pp.1–6 (I quote pp.4 and 5). Cf. B. S. Ridgway, *The Archaic Style of Greek Sculpture* (Princeton, 1977); A. Stewart, 'When is a kouros not an Apollo? The Tenea "Apollo" revisited', in M. del Chiaro (ed.), *Corinthiaca: Studies in Honour of Darrell A. Amyx* (Columbia, 1986), pp. 54–70; T. Hölscher, *Aus der Frühzeit der Griechen: Räume – Körper – Mythen* (Stuttgart and Leibniz, 1998), esp. pp.30–56. On the Egyptian proportions, see E. Guralnick, 'Proportions of kouroi', *American Journal of Archaeology* 82 (1978): 461–72; cf. W. Davis, *The Canonical Tradition in Ancient Egyptian Art* (Cambridge, 1989), and R. S. Bianchi, 'Der archaische griechische Kouros und der ägyptische kanonische Bildnistypus der schreitenden männlichen Figur', in H. Beck, P. Bol and M. Bückling (eds), *Ägypten–Griechenland–Rom: Abwehr und Berührung* (Tübingen, 2005), pp.65–73.

The 'evolution' of the kouros: fig. 19 is taken from A. Stewart, *Greek Sculpture: An Exploration* (New Haven, 1990), vol. 2, p.42; for a similar diagram, see e.g. J. Boardman, *Greek Sculpture: The Archaic Period: A Handbook* (London, 1978), p.78. The passage on the 'Critian Boy' quoted on p.54 also comes from Stewart's *Greek Sculpture* (vol. 1, pp.133–4): dissent by no means betokens disapproval.

On Geometric images of the body, see e.g. J. Carter, 'The beginning of narrative art in the Greek Geometric period', *Annual of the British School at Athens* 67 (1972): 25–58, and A. Snodgrass, *An Archaeology of Greece* (Berkeley, 1987), pp.132–69. For a more general guide to the historical background, see e.g. R. Osborne, *Greece in the Making: 1200–479 BC* (2nd edition: London, 2009), esp. pp.124–30.

A selection from Vasari's *Lives* is available in G. Vasari, *The Lives of the Artists* (trans. C. Bondanella and P. Bondanella, 2nd edition: Oxford, 1998): I quote from pp.5–6. Particularly influential on my thinking have been S. Alpers, 'Ekphrasis and aesthetic attitudes in Vasari's *Lives*', *Journal of the Warburg Institute* 23 (1960): 190–215, and P. L. Rubin, *Giorgio Vasari: Art and History* (Cambridge, 1995). On Pliny the Elder's *Natural History* and its reception, see S. Carey, *Pliny's Catalogue of Culture: Art and Empire in the Natural History* (Oxford, 2003), esp. pp.1–16; for a more detailed bibliographic guide, see M. J. Squire, 'Pliny's *Historia Naturalis*', in G. Pooke and D. Newall (eds), *Art History: The Fifty Key Texts* (London, forthcoming).

The first edition of Winckelmann's *Geschichte* is now available in a new accessible translation: *Johann Joachim Winckelmann: History of the Art of Antiquity* (trans. H. F. Mallgrave: Los Angeles, 2006). The historical scheme is most succinctly laid out in part 1, chapter 4, section 3 (pp.227–44): I quote from pp.231, 234, 244, 317; the citations from the *Reflections* come from the 1765 translation of Henry Fusseli: *Reflections on the Painting and Sculpture of the Greeks* (London, 1765; reprinted Menston, 1975), pp.2, 3, 23, 34, 35, 46 (adapted). A selection of Winckelmann's other works is collected and translated in D. Irwin (ed.), *Winckelmann: Writings on Art* (London, 1972). The best discussion is E. Pommier, *Winckelmann, inventeur de l'histoire de l'art* (Paris, 2003); cf. A. Potts, *Flesh and the Ideal: Winckelmann and the Origins of Art History* (New Haven, 1994). For my own views (and an up-to-date bibliography), see M. J. Squire, *Image and Text in Graeco-Roman Antiquity* (Cambridge, 2009), pp.43–9.

On the ideology of naturalism, the crucial contribution came in the postcolonial challenge of R. Layton, 'Naturalism and cultural relativity in art', in P. J. Ucko (ed.), *Form in Indigenous Art: Schematisations in the Art of Aboriginal Australia and Prehistoric Europe* (Canberra, 1977), pp.3–43; cf. N. Bryson, *Vision and Painting: The Logic of the Gaze* (London, 1983), pp.1–35; idem, *Tradition and Desire: From David to Delacroix* (Cambridge, 1984), pp.7–18; W. J. T. Mitchell, *Iconology: Image, Text, Ideology* (Chicago, 1986), pp.75–94. For Loewy's view, see E. Loewy, *The Rendering of Nature*

in Early Greek Art (trans. F. Forthergill: London, 1907); there's a stimulating recent discussion in L. Rose, *The Survival of Images: Art Historians, Psychoanalysts and the Ancients* (Detroit, MI, 2001), esp. pp.64–73. On fifth-century Greek attitudes towards anatomy, see S. Kuriyama, *The Expressiveness of the Body and the Divergence of Greek and Chinese Medicine* (New York, 1999), pp.111–51 (who cites the Alberti and Leonardo passages on pp.115–16 and 292); cf. R. Osborne, *The History Written on the Classical Greek Body* (Cambridge, forthcoming), especially the second chapter on 'the appearance of the Greek body'. The quotations on pp.58–9 come from D. Kurtz, *The Berlin Painter* (Oxford, 1983), pp.19, 33, 34. For some much more 'Renaissance'-centred approaches to the artistry of fifth-century anatomy, one might consult G. P. R. Metraux, *Sculptors and Physicians in Fifth-Century Greece: A Preliminary Study* (Montreal, 1995), esp. pp.vii–xiv, 32–68; G. V. Leftwich, 'Polykleitos and Hippokratic medicine', in W. G. Moon (ed.), *Polykleitos, the Doryphoros, and Tradition* (Madison, WI, 1995), pp.38–51. On these issues in relation to the Riace Bronzes, see N. Spivey, *How Art Made the World* (London, 2005), pp.75–81, along with the photographic tour of P. Moreno, *I bronzi di Riace: Il maestro di Olimpia e i sette a Tebe* (Milan, 1998).

On ancient stories of artistic illusion, one might try A. Schnapp, 'Are statues animated? The psychology of statues in ancient Greece', in C. Renfrew and E. B. W. Zubrow (eds), *The Ancient Mind: Elements of Cognitive Archaeology* (Cambridge, 1994), pp.40–4; cf. N. Spivey (1995), 'Bionic statues', in A. Powell (ed.), *The Greek World* (London and New York, 1995), pp.442–59; M. J. Squire, 'Making Myron's cow moo? Ecphrastic epigram and the poetics of simulation', *American Journal of Philology* 131 (2010): 589–634 (which also discusses the passage from Xenophon's *Memorabilia*). For fifth-century views of *mimesis* (a word not in fact used in conjunction with the visual until the fourth century), see G. Else, '"Imitation" in the fifth century', *Classical Philology* 53 (1958): 73–90. Among the best introductions to Plato specifically is R. C. Lodge, *Plato's Theory of Art* (London, 1953); compare too S. Halliwell, *The Aesthetics of Mimesis: Ancient Texts and Modern Problems* (Princeton, 2002).

The most important work on Archaic and Classical Greek theories of simulation is by Jean-Paul Vernant: Vernant's work is most accessible to Anglophone students in *Mortals and Immortals: Collected Essays* (ed. F. Zeitlin: Princeton, 1991). Compare too D. T. Steiner, *Images in Mind: Statues in Archaic and Classical Greek Literature and Thought* (Princeton, 2001), pp.3–78; and on the larger western aesthetic reception of ancient ideas, see K. Gross, *The Dream of the Moving Statue* (Ithaca, NY, 1992).

Finally, on 'seeing-in' and 'seeing-as': R. Wollheim, *Art and its Objects* (2nd edition: Cambridge, 1980), pp.205–26; idem, 'On pictorial representation', *Journal of Aesthetics and Art Criticism* 56 (1998): 217–26. For an introductory guide to Gestalt psychology and 'seeing double', compare more generally A. M. Barry, *Visual Intelligence: Perception, Image and Manipulation in Visual Communication* (Albany, NY, 1997), pp.15–68, esp. pp.42–4.

Chapter III

Some of the key feminist art historical interventions from the last forty years are collected in A. Jones (ed.), *The Feminism and Visual Culture Reader* (London and New York, 2003). John Berger's 1972 chapter on the 'female nude' is reprinted in his *Ways of Seeing* (London, 1973), pp. 45–64 – quotations from pp.45, 46, 47, 51, 52, 54. Clark's distinction between the 'naked' and the 'nude' comes in *The Nude: A Study of Ideal Art* (2nd edition: London, 1960), pp.1–25 – I quote from pp.1, 3. For Mulvey's essay, see L. Mulvey, 'Visual pleasure and narrative cinema', *Screen* 16.3: 6–18 (my quotation on p.78 comes from p.11): it is reproduced in her *Visual and Other Pleasures* (2nd edition: New York, 2009), pp.14–39 (my quotation on p.113 comes from p.13 of that volume).

Other important feminist contributions include: N. Broude and M. Garrard (eds), *Feminism and Art History: Questioning the Litany* (New York, 1982); S. Kappeler *The Pornography of Representation* (Cambridge, 1986); G. Pollock, 'Feministry', in R. Parker and G. Pollock (eds), *Framing Feminism: Art and the Women's Movement 1970–85* (London, 1987),

pp.238–43; T. Laqueur, *Making Sex: Body and Gender from the Greeks to Freud* (Cambridge, MA, 1990); L. Nead, *The Female Nude: Art, Obscenity and Sexuality* (London, 1992); L. Hunt (ed.), *The Invention of Pornography: Obscenity and the Origins of Modernity, 1500–1800* (New York, 1993). I take the term 'womanufacture' from A. Sharrock, 'Womanufacture', *Journal of Roman Studies* 81 (1991): 36–49.

Specifically on these issues in relation to Graeco-Roman art and its legacy, see above all the contributions in A. Koloski-Ostrow and C. Lyons (eds), *Naked Truths: Women, Sexuality and Gender in Classical Art and Archaeology* (London, 1997). Useful too are A. Richlin (ed.), *Pornography and Representation in Greece and Rome* (Cambridge, 1992); P. DuBois, *Sowing the Body: Psychoanalysis and Ancient Representations of Women* (Chicago, 1988); L. Dean-Jones, *Women's Bodies in Classical Greek Science* (Oxford, 1994); H. King, *Hippocrates' Women: Reading the Female Body in Ancient Greece* (London and New York, 1998). For some more visually oriented thoughts on Venus as the 'incarnation of sexual love par excellence' from the Renaissance to the present day (p.xiii), see the essays in C. Arscott and K. Scott (eds), *Manifestations of Venus: Art and Sexuality* (Manchester, 2000).

For the 'Slasher Mary' episode, see D. Freedberg, *The Power of Images: Studies in the History and Theory of Response* (Chicago, 1989), pp.409–12. Those interested in the Guerrilla Girls' manifesto might try *The Guerrilla Girls' Bedside Companion to the History of Western Art* (New York, 1998).

On the reception of a number of ancient 'Venuses' since the Renaissance, see F. Haskell and N. Penny, *Taste and the Antique: The Lure of Classical Sculpture, 1500–1900* (New Haven, 1981), pp.316–33, nos 83–91. For Victorian attitudes to (female) nudity, see A. Smith, *The Victorian Nude: Sexuality, Morality and Art* (Manchester, 1996), which discusses Alma-Tadema's painting on pp.202–9. My reading of the Dürer portrait has learnt from S. Alpers, 'Art history and its exclusions: The example of Dutch art', in N. Broude and M. D. Garrard (eds), *Feminism and Art History: Question the Litany*, pp.182–99, esp. pp.185–7, and H. D. Russell, *Eva/Ave: Woman in Renaissance and Baroque Prints* (Washington, DC,

1990), pp.21–3. For Panofsky's classic essay on Renaissance perspective, see E. Panofsky, *Perspective as Symbolic Form* (trans. C. S. Wood: New York, 1991).

For ancient myths of 'male gazing', there are some thought-provoking first observations in A. Stewart, 'Rape?', in E. Reeder (ed.), *Pandora: Women in Classical Greece* (Baltimore, 1995), pp.65–79. On Zeuxis' painting of 'Helen', the sources are collected in J. J. Pollitt, *The Art of Ancient Greece: Sources and Documents* (Cambridge, 1990), pp.149–51: E. C. Mansfield, *Too Beautiful to Picture: Zeuxis, Myth and Mimesis* (Minneapolis, MN, 2007), pp.19–38 provides one recent guide. For an accessible introduction to body dysmorphia disorder (BDD), see S. Grogan, *Body Image: Understanding Body Dissatisfaction in Men, Women and Children* (2nd edition: London, 2008).

On the Venus de Milo and her legacy: A. Arenas, 'Broken: The Venus de Milo', *Arion* 9.1 (2001): 35–45; S. Hales, 'How the Venus de Milo lost her arms', in D. Ogden (ed.), *The Hellenistic World: New Perspectives* (London, 2002), pp.253–74; G. Curtis, *Disarmed: The Story of the Venus de Milo* (New York, 2003); cf. also J.-P. Cuzin, J.-R. Garborit and A. Pasquier (eds), *D'après l'antique* (Paris, 2000), pp.432–76.

On the Pygmalion myth: the key discussion is J. Elsner's essay on 'viewing and creativity: Ovid's Pygmalion as viewer', reprinted and updated in idem, *Roman Eyes: Visuality and Subjectivity in Art and Text* (Princeton, 2007), pp.113–31. For related Graeco-Roman stories of *agalmatophilia*, and their afterlives, see K. Gross, *The Dream of the Moving Statue* (Ithaca, NY, 1992); M. Bettini, *The Portrait of the Lover* (trans. L. Gibbs: Berkeley, 1999); G. Heresy, *Falling in Love with Statues: Artificial Humans from Pygmalion to the Present* (Chicago, 2009).

There's an enormous bibliography on the Aphrodite of Knidos, but remarkably little on the statue's cultic stakes. For an overtly feminist discussion, see N. Salomon, 'Making a world of difference: Gender, asymmetry and the Greek nude', in A. Koloski-Ostrow and C. L. Lyons (eds), *Naked Truths*, pp.197–219 (quotation on p.96 from p.204). The literary sources are collected in J. J. Pollitt, *The Art of Ancient Greece*, pp.84–9.

On Praxiteles' original statue, see A. Corso, 'The Cnidian Aphrodite', in I. Jenkins and G. Waywell (eds), *Sculptors and Sculptures of the Dodecanese* (London, 1997), pp.91–8; idem, *The Art of Praxiteles: Volume 2, The Mature Years* (Rome, 2007), pp.9–186; A. Pasquier and J.-L. Martinez (eds), *Praxitèle* (Paris, 2007), pp.130–201. There's an excellent shorter introduction in N. Spivey, *Understanding Greek Sculpture: Ancient Meanings, Modern Readings* (London, 1996), pp.173–86. For two (duly pessimistic) reviews of what we know about Knidian architectural setting, see B. S. Ridgway, *Second Chance: Greek Revisited Sculptural Studies* (Madison, WI, 2004), pp.713–25, and S. Montel, 'The architectural setting of the Knidian Aphrodite', in A. C. Smith and S. Pickup (eds), *Brill's Companion to Aphrodite* (Leiden, 2010), pp.251–68: these respond to the earlier (and rather fanciful) conclusions of Iris Love.

On the relationship between the Knidian Aphrodite and later copies and variants, see C. M. Havelock, *The Aphrodite of Knidos and her Successors: A Historical Review of the Female Nude in Greek Art* (Ann Arbor, MI, 1995). For the relationship with earlier korai, see R. Osborne, 'Looking on – Greek style: Does the sculpted girl speak to women too?', in I. Morris (ed.), *Classical Greece: Ancient Histories, Modern Archaeologies* (Cambridge, 1994), pp.81–96.

The text of Pseudo-Lucian's *Erotes* is most easily consulted in the eighth volume of William Heinemann's Loeb edition of Lucian (Cambridge, MA, 1967), pp.147–235. Cf. M. Foucault, *The History of Sexuality: Volume 3, The Care of the Self* (trans. R. Hurley, 2nd edition: London and New York, 1986), pp.211–27; D. Halperin, 'Historicizing the sexual body: Sexual preferences and erotic identities in the Pseudo-Lucian *Erotes*', in J. Goldstein (ed.), *Foucault and the Writing of History* (Oxford, 1994), pp.19–34; S. Goldhill, *Foucault's Virginity: Ancient Erotic Fiction and the History of Sexuality* (Cambridge, 1995), pp.102–11. Lacan's story of the sardine-tin comes in his discussion of 'The line and light': see his *The Four Fundamental Concepts of Psychoanalysis* (trans. A. Sheridan, ed. J.-A. Miller: New York, 1978), p.95.

On the Aphrodite of Knidos epigrams: the texts are collected in W. Paton's Loeb edition of *The Greek Anthology* (Cambridge, MA, 1918),

vol. 5, pp.252–9. My own view is very much indebted to V. Platt, 'Evasive epiphanies in ekphrastic epigram', *Ramus* 31: 33–50; cf. eadem, *Facing the Gods: Epiphany and Representation in Graeco-Roman Culture* (Cambridge, forthcoming), chapter 4. For the stories about Phryne, see C. M. Havelock, *The Aphrodite of Knidos and her Successors*, pp.42–9.

On the Actaeon myth, the best general guide is J. Heath, *Actaeon, The Unmannerly Intruder: The Myth and its Meaning in Classical Literature* (New York, 1992). The history of the myth is discussed in C. Schlam, 'Diana and Actaeon: Metamorphoses of a myth', *Classical Antiquity* 3.1 (1984): 82–110, and L. R. Lacy, 'Aktaion and a lost "Bath of Artemis"', *Journal of Hellenic Studies* 110 (1990): 26–42. For Callimachus' fifth *Hymn*, there is (in addition to the Loeb) a thorough edition with English translation in A. W. Bulloch (ed.), *Callimachus: The Fifth Hymn* (Cambridge, 1985): Bulloch discusses earlier parallels for vv.101–2 on pp.212–13. On Pompeian depictions of the myth, see E. W. Leach, 'Metamorphoses of the Actaeon myth in Campanian painting', *Mitteilungen des Deutschen Archäologischen Instituts [Römische Abteilung]* 88 (1981): 307–27 (the painting reproduced here is number 9 in Leach's catalogue); compare too J. Hodske, *Mythologische Bildthemen in den Häusern Pompejis* (Stuttgart, 2007), pp.193–5. More generally on the way in which Pompeian paintings of such myths collapse our categories of secular and sacred, see V. Platt, 'Viewing, desiring, believing: Confronting the divine in a Pompeian House', *Art History* 25.1 (2002): 87–112, discussing Actaeon and Artemis imagery on pp.97–101.

For some provocative, gender-bending comments on Greek seeing as power (in the context of Xenophon, *Memorabilia* 3.10), see S. Goldhill, 'The seductions of the gaze: Socrates and his girlfriends', in P. Cartledge, P. Millett and S. von Reden (eds), *Kosmos: Essays in Order, Conflict and Community in Classical Athens* (Cambridge, 1998), pp.105–24. On (dressed) Greek female portraits, see now S. Dillon, *The Female Portrait Statue in the Greek World* (Cambridge, 2010). Although applying it to images of *men* (not women), I take the term 'homospectatorial' from D. Fuss, 'Fashion and the homospectatorial look', *Critical Inquiry* 18.4 (1992): 713–37.

On the 'Slipper-Slapper' group and its context, see M. Beard and J. Henderson, *Classical Art from Greece to Rome* (Oxford, 2001), pp.139–41 (I cite their picture caption from p.139 on p.114); cf. C. M. Havelock, *The Aphrodite of Knidos and her Successors*, pp.55–8; G. Zanker, *Modes of Viewing in Hellenistic Poetry and Art* (Madison, WI, 2004) pp.151–2.

Chapter IV

Crucial to this chapter is C. H. Hallett, *The Roman Nude: Heroic Portrait Statuary 200 BC–AD 300* (Oxford, 2005): my quotation on p.128 is taken from p.61. Fundamental too is L. Bonfante, 'Nudity as a costume in Classical art', *American Journal of Archaeology* 93.4 (1989): 543–70. Clark's dismissal of these 'errors in taste' (pp.132–3) comes from *The Nude: A Study of Ideal Art* (2nd edition: London, 1960), p.44. Finally, there's a stimulating review of bibliography in T. Stevenson, 'The "problem" with nude honorific statuary and portraits in Late Republican and Augustan Rome', *Greece and Rome* 45 (1998): 45–69.

On the Greek background to 'heroic nudity', see A. Stewart, *Art, Desire and the Body in Ancient Greece* (Cambridge, 1997), esp. pp.24–42; R. Osborne, 'Sculpted men of Athens: Masculinity and power in the field of vision', in L. Foxhall and J. Salmon (eds), *Thinking Men: Masculinity and its Self-Representation in the Classical Tradition* (London and New York, 1998), pp.23–42; idem, 'Men without clothes: Heroic nakedness and Greek Art', in M. Wyke (ed.), *Gender and the Body in the Ancient Mediterranean* (Oxford, 1998), pp.80–104; C. H. Hallett, op. cit, pp.5–60; J. Hurwit, 'The problem with Dexileos: Heroic and other nudities in Greek Art', *American Journal of Archaeology* 111.1 (2009): 35–60.

My quotations about Canova's Napoleon are all taken from D. O'Brien, 'Antonio Canova's *Napoleon as Mars the Peacemaker* and the limits of imperial portraiture', *French History* 18.4 (2004): 354–78 (adapting O'Brien's translations). Cf. H. Honour, 'Canova's Napoleon', *Apollo* 98 (September 1973): 180–4; C. Johns, *Antonio Canova and the Politics of Patronage in Revolutionary and Napoleonic Europe* (Berkeley, 1998); V. Huet, 'Napoleon I:

A new Augustus?', in C. Edwards (ed.), *Roman Presences: Receptions of Rome in European Culture, 1789–1945* (Cambridge, 1999), pp.53–69; J. Bryan, 'How Canova and Wellington honoured Napoleon', *Apollo* 162 (October 2005): 38–43.

For an introduction to 'imagining' George Washington, see J. Smith, *The Presidents We Imagine: Two Centuries of White House Fiction on the Page, on the Stage, Onscreen and Online* (Madison, WI, 2009), pp.14–44. My description of Mussolini and the *Genius of Fascism* comes from the memoirs of B. Knox, *Essays Ancient and Modern* (Baltimore, 1989), pp.226–9; cf. C. H. Hallett, op. cit., p.272 (with fig. 147), and G. Gori, 'Model of masculinity: Mussolini, the "New Italian" of the Fascist era', in J. A. Mangan (ed.), *Superman Supreme: Fascist Body as Political Icon – Global Fascism* (London, 2000), pp.27–61.

For Greek portraits: the best general guide is S. Dillon, *Ancient Greek Portrait Sculpture: Contexts, Subjects, and Styles* (Cambridge, 2006); on the developing Greek self-consciousness ('rationalisation') of portraiture, see also J. Tanner, *The Invention of Art History in Ancient Greece: Religion, Society and Artistic Rationalisation* (Cambridge, 2006), pp.97–140. On Hellenistic developments, see A. Stewart, *Faces of Power: Alexander's Image and Hellenistic Politics* (Berkeley, 1993), along with R. R. R. Smith, *Hellenistic Royal Portraits* (Oxford, 1988). On images of Socrates and other Greek philosophers, see P. Zanker, *The Mask of Socrates: The Image of the Intellectual in Antiquity* (Berkeley, 1995); J. Henderson, 'Seeing through Socrates: Portrait of the philosopher in sculpture culture', *Art History* 19 (1996): 327–52.

On Roman portraits generally, see now the very detailed discussion in J. Feyfer, *Roman Portraits in Context* (Berlin, 2008). For some shorter introductions, compare: S. Nodelmann, 'How to read a Roman Portrait', in E. D'Ambra (ed.), *Roman Art in Context* (Englewood Cliffs, NJ, 1993), pp.10–26; A. Gregory, '"Powerful images": Responses to portraits and the political uses of images in Rome', *Journal of Roman Archaeology* 7 (1994): 80–99; P. Stewart, *Roman Art: Greece and Rome, New Surveys in the Classics*, no. 34 (Oxford, 2004), pp. 5–28; idem, *The Social History of Roman Art* (Cambridge, 2008), pp.77–107.

On the Roman toga, see C. Vout, 'The myth of the toga: Understanding the history of Roman dress', *Greece and Rome* 43.2 (1996): 204–20; G. Davis, 'What made the Roman toga *virilis?*', in L. Cleland, M. Harlow and L. Llewellyn-Jones (eds), *The Clothed Body in the Ancient World* (Oxford, 2005), pp.121–30. For a fascinating insight into the deliberate visual blurring between the Greek *pallium* and the Roman toga in the first century BC, compare A. Wallace-Hadrill, *Rome's Cultural Revolution* (Cambridge, 2008), pp.38–70.

The best discussion of 'verism' and Roman Republican portraits is in German: L. Giuliani, *Bildnis und Botschaft: Hermeneutische Untersuchungen zur Bildniskunst der römischen Republik* (Frankfurt, 1986); compare also the excellent analysis in J. Tanner, 'Portraits, power and patronage in the late Roman Republic', *Journal of Roman Studies* 90 (2000): 18–50. Other discussions include: R. R. R. Smith, 'Greeks, foreigners and Roman Republican portraits', *Journal of Roman Studies* 71 (1981): 24–38; D. Kleiner, *Roman Sculpture* (New Haven, 1992), pp. 31–47; H. Flower, *Ancestor Masks and Aristocratic Power in Roman Culture* (Oxford, 1997). On Cromwellian portraiture and republicanism, see L. L. Knoppers, *Constructing Cromwell: Ceremony, Portrait and Print, 1645–1661* (Cambridge, 2000).

More generally on Greek art turned Roman, see J. J. Pollitt, 'The impact of Greek art on Rome', *Transactions of the American Philological Association* 108 (1978): 155–74; E. Gruen, *Culture and National Identity in Republican Rome* (London, 1993), pp. 84–182; A. Kuttner, 'Roman art during the Republic', in H. I. Flower (ed.), *The Cambridge Companion to the Roman Republic* (Cambridge, 2004), pp. 294–321; M. Marvin, *The Language of the Muses: The Dialogue Between Greek and Roman Sculpture* (Los Angeles, 2008).

On Augustan portraits, the most important discussions have been in German. P. Zanker's key contribution is available as *The Power of Images in the Age of Augustus* (trans. A. Schapiro: Ann Arbor, MI, 1988) – I quote from p.4; note too A. Wallace-Hadrill's stimulating review – 'Rome's cultural revolution', *Journal of Roman Studies* 79 (1989): 157–64; for an English

guide to Augustan art more generally, see K. Galinsky, *Augustan Culture: An Interpretive Introduction* (Princeton, 1996), esp. pp.3–9, 141–224. The best discussion of the Prima Porta Augustus is I. K. McEwan, *Vitruvius: Writing the Body of Architecture* (Cambridge, MA, 2003), esp. pp.250–75. Cf. J. Elsner, *Art and the Roman Viewer: The Transformation of Art from the Pagan World to Christanity* (Cambridge, 1995), pp.159–72; J. Pollini, 'The Augustus from Prima Porta and the transformation of the Polykleitan heroic ideal: The rhetoric of art', in W. Moon (ed.), *Polykleitos, the Doryphoros, and Tradition* (Madison, WI, 1995), pp.262–82. On ancient cuirassed statues at large, see C. Vermeule, 'Hellenistic and Roman cuirassed statues', *Berytus* 13 (1959): 1–82. My talk of 'cosmos and *imperium*' derives from P. Hardie, *Virgil's* Aeneid: *Cosmos and Imperium* (Oxford, 1986), esp. pp.336–76. For 'dialectical' or 'multistable' images, see W. J. T. Mitchell, *Picture Theory: Essays on Verbal and Visual Representation* (Chicago, 1994), pp.35–82, esp. 45–57.

On the Imperial aftermath of the Augustan portrait, see H. Jucker, 'Iulisch-claudische Kaiser- und Prinzenporträts als "Palimpseste"', *Jahrbuch des Deutschen Archäologischen Instituts* 96 (1981): 236–316. Cf. M. Anderson and L. Nista, *Roman Portraits in Context: Imperial and Private Likenesses from the Museo Nazionale Romano* (Rome, 1988); E. Varner, *From Caligula to Constantine: Tyranny and Transformation in Roman Portraiture* (Atlanta, GA, 2001). For the Misenum Vespasian, see P. Miniero (ed.), *The Sacellum of the Augustales at Miseno* (Naples, 2000), esp. pp.29–45.

On the naked Copenhagen matron, see E. D'Ambra, 'The calculus of Venus: Nude portraits of Roman patrons', in N. Kampen (ed.), *Sexuality in Ancient Art* (Cambridge, 1996), pp.219–32 – with references to the (German) work of H. Wrede in particular; cf. eadem, 'Nudity and adornment in female portrait sculpture of the second century AD', in D. E. Kleiner and S. B. Matheson (eds), *I Claudia II* (Austin, 2000), pp.101–14; S. Hales, 'Men are Mars, women are Venus: Dressing up and down', in L. Cleland, L. Llewellyn-Jones and M. Harlow (eds), *The Clothed Body in the Ancient World* (Oxbow, 2005), pp.131–42.

The 'appendage aesthetic' is discussed by R. Brilliant, *Gesture and Rank*

in Roman Art: The Uses of Gesture to Denote Status in Roman Sculpture and Coinage (New Haven, 1963), pp.10, 26–31; cf. idem, *Roman Art from the Republic to Constantine* (London, 1974), esp. pp.166–87. Cf. P. Stewart, *Statues in Roman Society: Representation and Response* (Oxford, 2003), pp.46–78; C. H. Hallett, op. cit., pp.271–307. My thinking at the end of the chapter is indebted especially to the Germanophone work of Tonio Hölscher (available in English as *The Language of Images in Roman Art: Art as a Semantic System in the Roman World* (trans. A. Snodgrass and A. M. Künzl-Snodgrass: Cambridge, 2004)) – albeit as much in reaction as in agreement; cf. J. Elsner, 'Classicism in Roman art', in J. Porter (ed.), *Classical Pasts: The Classical Traditions of Greece and Rome*, pp.270–96 (Princeton, 2006).

Chapter V

The issues discussed in this chapter have occupied me for some time: I have explored some of them (albeit in a rather different context) in M. J. Squire, *Image and Text in Graeco-Roman Antiquity* (Cambridge, 2009), pp.1–193. Two books are particularly recommended: H. Belting, *Likeness and Presence: A History of the Image Before the Era of Art* (trans. E. Jephcott: Chicago, 1994) – I quote p.29 on p.187; and A. Besançon, *The Forbidden Image: An Intellectual History of Iconoclasm* (trans. J. M. Todd: Chicago, 2000). The arguments laid out in this chapter might be contrasted with those of e.g. T. Pékary, *Imago res mortua est: Untersuchungen zur Ablehnung der bildenden Künste in der Antike* (Stuttgart, 2002): to my mind, Pékary is too (anachronistically) iconoclastic in reconstructing ancient Greek and Roman attitudes to the visual and divine.

On Laureti's ceiling painting – set above a monochrome fresco by Giulio Romano that depicted another scene of a sculptor destroying statues – see e.g. L. Freedman, *The Revival of the Olympian Gods in Renaissance Art* (Cambridge, 2003), p.238; M. Bull, *The Mirror of the Gods: How Renaissance Artists Rediscovered the Pagan Gods* (Oxford, 2005), pp.385–7.

Bibliography on the visuality of Greek and Roman religion is (finally!)

booming. The most important contributions are those of Jaś Elsner and Verity Platt: revised versions of two of Elsner's most influential articles ('Image and ritual: Reflections on the religious appropriations of Classical art'; 'Between mimesis and divine power: Visuality in the Greek and Roman world') are reproduced in his *Roman Eyes: Vision and Subjectivity in Art and Text* (Princeton, 2007), pp.1–48; the second chapter of Platt's *Facing the Gods: Epiphany and Representation in Graeco-Roman Art, Literature and Religion* (Cambridge, forthcoming) has been particularly influential on my thinking in this chapter. Two excellent earlier places to start are R. Gordon, 'The real and the imaginary: Production and religion in the Graeco-Roman world', *Art History* 2.1 (1979): 5–34; and J.-P. Vernant's work on 'the body of the divine' – translated in *Mortals and Immortals: Collected Essays* (ed. F. Zeitlin: Princeton, 1991), esp. pp.27–49. Other relevant discussions include: B. Gladigow, 'Präsenz der Bilder – Präsenz der Götter: Kultbilder und Bilder der Götter in der griechischen Religion', *Visible Religion* 4–5 (1985–6): 114–33; H. S. Versnel, 'What did ancient man see when he saw a god? Some reflections on Graeco-Roman epiphany', in D. van der Plas (ed.), *Effigies Dei: Essays on the History of Religions* (Leiden, 1987), pp. 42–55; A. A. Donohue, 'The Greek images of the gods: Considerations on terminology and methodology', *Hephaistos* 15 (1997): 31–45; D. T. Steiner, *Images in Mind: Statues in Archaic and Classical Greek Literature and Thought* (Princeton, 2001), esp. pp.79–134; M. Gaifman, 'Statue, cult and reproduction', *Art History* 29.2 (2006): 258–79; J. Tanner, *The Invention of Art History in Ancient Greece: Religion, Society and Artistic Rationalisation* (Cambridge, 2006), esp. pp.40–55; J. Mylonopoulos (ed.), *Divine Images and Human Imaginations in Ancient Greece and Rome* (Leiden, 2010); V. Platt and G. Petridou (eds), *Epiphany: Envisioning the Divine in the Ancient World* (Leiden, forthcoming).

On *theōria* and its contested etymology, see A. W. Nightingale, *Spectacles of Truth in Classical Greek Philosophy: Theoria in its Cultural Context* (Cambridge, 2004), esp. pp.40–71. For Xenophanes' views, see G. S. Kirk, J. E. Raven and M. Schofield (eds), *The Presocratic Philosophers* (2nd edition: Cambridge, 1983), pp.168–72.

For more on the Parthenon and Athena Parthenos, see R. Osborne, 'The viewing and obscuring of the Parthenon frieze', *Journal of Hellenic Studies* 107 (1986): 98–105; K. Lapatin, *Chryselephantine Statuary in the Ancient Mediterranean World* (Oxford, 2001), pp. 63–79; G. Nick, *Die Athena Parthenos: Studien zum griechischen Kultbild und seiner Rezeption* (Mainz, 2002); C. Marconi, 'The Parthenon frieze: Degrees of visibility', *Res: Anthropology and Aesthetics* 55–6 (2009): 156–73. The classic discussion of the comparative cults of Athena Parthenos and Athena Polias is C. J. Herrington, *Athena Parthenos and Athena Polias: A Study in the Religion of Periclean Athens* (Manchester, 1955).

For Dio Chrysostom and his intellectual background, see H. D. Betz, 'God, concept and cultic image: The argument in Dio Chrysostom's *Oratio* 12, *Olympikos*', *Illinois Classical Studies* 29 (2004): 131–42; compare too V. Platt, 'Virtual visions: Phantasia and the perception of the divine in Philostratus' *Life of Apollonius of Tyana*', in E. L. Bowie and J. Elsner (eds), *Philostratus* (Cambridge, 2009), pp.131–54, esp. pp.149–54 (on Philostratus, *Life of Apollonius of Tyana*, 6.19).

There's a raunchy introduction to the Christian body in S. Goldhill, *Love, Sex and Tragedy: How the Ancient World Shapes our Lives* (London, 2004), pp.104–27 (who cites the quoted extract from Simeon Stylites' biography on p.104). The fundamental study is P. Brown, *The Body and Society: Men, Women and Sexual Renunciation in Early Christianity* (New York, 1988); my thinking has also been sharpened by C. W. Bynum, *The Resurrection of the Body in Western Christianity, 200–1336* (New York, 1995).

In terms of Christian attitudes to images, the best single-volume guide is P. C. Finney, *The Invisible God: The Earliest Christians on Art* (Oxford and New York, 1994); also important are M. Barasch, *Icon: Studies in the History of an Idea* (New York, 1992) and J. Pelikan, *Imago Dei: The Byzantine Apologia for Icons* (Princeton, 1990). Clement of Alexandria's *Exhortation to the Greeks* is available in the Loeb edition by G. W. Butterworth (Cambridge, MA, 1919): the relevant discussion is translated on pp.101–43 (the passage quoted comes from p.116). For a more detailed analysis of the cultural and theological stakes, see M. Pujiula, *Körper und*

christliche Lebensweise: Clemens von Alexandreia und sein Paidagogos (Berlin, 2006); L. S. Nasrallah, *Christian Resposnses to Roman Art and Architecture: The Second-Century Church amid the Spaces of Emprire* (Cambridge, 2010), esp. pp. 249–95. John of Damascus' writings are available in D. Anderson's translation – *St John of Damascus:* On the Divine Images. *Three Apologies Against Those Who Attack the Divine Images* (Crestwood, NY, 1980) – I quote from p.18. My thinking about the 'Doubting Thomas' episode is indebted to G. W. Most, *Doubting Thomas* (Cambridge, MA, 2005).

On early Christian iconography specifically, the key text remains A. Grabar, *Christian Iconography: A Study of its Origins* (New York, 1968). Cf. T. Matthews, *The Clash of Gods: A Reinterpretation of Early Christian Art* (Princeton, 1993); J. Lowden, *Early Christian and Byzantine Art* (London, 1997), esp. pp.4–100 (with excellent colour pictures); J. Engemann, *Deutung und Bedeutung frühchristlicher Bildwerke* (Darmstadt, 1997); J. Elsner, *Imperial Rome and Christian Triumph* (Oxford, 1998), esp. pp.199–259. The 'Dogmatic sarcophagus' has received remarkably little attention: for a brief discussion in relation to another (more famous) Vatican sarcophagus, see E. S. Malbon, *The Iconography of the Sarcophagus of Junius Bassus* (Princeton, 1990), pp.89–90.

Neilos' comments on church decoration are discussed in H. Thümmel, 'Neilos von Ankyra über die Bilder', *Byzantinische Zeitschrift* 71 (1978): 10–21; P. van Dael, 'Aniconic decoration in early Christian and medieval churches', *The Heythrop Journal* 36.4 (1995): 382–96; J. Lowden, 'The beginnings of Biblical illustration', in J. Williams (ed.), *Imaging the Early Mediaeval Bible* (University Park, PA, 1999), pp.9–59, esp. pp.56–7. Gregory the Great's sobriquet comes in his thirteenth letter to Serenus: for a translation of the passage, see pp.139–40 of C. M. Chazelle, 'Pictures, books and the illiterate: Pope Gregory I's letters to Serenus of Marseilles', *Word & Image* 6 (1990): 138–53. For Paulinus' somewhat earlier comments and their significance, see J. Elsner, *Art and the Roman Viewer: The Transformation of Art from the Pagan World to Christianity* (Cambridge, 1994), esp. pp.88–124, 249–87.

There are many introductory books on Byzantine art, but remarkably few that do justice to the religious stakes: the most popular is R. Cormack, *Byzantine Art* (Oxford, 2000), which contains a detailed bibliographic essay on pp.231–7; compare too R. Cormack and M. Vassilaki (eds), *Byzantium 330–1453* (London, 2008). Much more attuned to this chapter's theological concerns is the magisterial analysis of H. Maguire, *The Icons of their Bodies: Saints and their Images in Byzantium* (Princeton, 1996) – I quote from p.3 on p.186. Two other recent books are also recommended: first, G. Peers, *Subtle Bodies: Representing Angels in Byzantium* (Berkeley, 2001); second, P. C. Miller, *The Corporeal Imagination: Signifying the Holy in Late Ancient Christianity* (Philadelphia, 2009), reconstructing a 'material turn' between the fourth and seventh centuries. On Byzantine art's Greek debts specifically, compare also E. Kitzinger, 'The Hellenistic heritage of Byzantine art', *Dumbarton Oaks Papers* 17 (1963): 97–115; I have not seen M. Hatzaki, *Beauty and the Male Body in Byzantium: Perceptions and Representations in Art and Text* (London, 2009).

On Graeco-Roman images in Constantinople, see C. Mango, 'Antique statuary and the Byzantine beholder', *Dumbarton Oaks Papers* 17 (1963): 55–75; C. Mango et al., 'The Palace of Lausus at Constantinople and its collection of ancient statues', *Journal of the History of Collections* 4 (1992): 89–98; L. James, '"Pray not fall into temptation and be on your guard": Pagan statues in Christian Constantinople', *Gesta* 35 (1996): 12–20; S. Bassett, *The Urban Image of Late Antique Constantinople* (Cambridge, 2004). On Photios' speech of AD 867, the key discussion is R. Nelson, 'To say and to see: Ekphrasis and vision in Byzantium', in idem (ed.), *Visuality Before and Beyond the Renaissance: Seeing as Others Saw* (Cambridge, 2000), pp.143–68.

On the Byzantine icon: the most important discussion in English is R. Cormack, *Writing in Gold: Byzantine Society and its Icons* (London, 1985); compare too the essays in A. Eastmond and L. James (eds), *Icon and Word: The Power of Images in Byzantium* (Aldershot, 2003). For the Byzantine Iconoclastic controversy, there is a useful sourcebook in L. Brubake and J. Haldon (eds), *Byzantium in the Iconoclast Era, c.680–850*

(Aldershot, 2003). Cf. A. Grabar, *L'Iconoclasme byzantin: Le dossier archéologique* (2nd edition: Paris, 1984); K. Corrigan, *Visual Polemics in the Ninth-century Byzantine Psalters* (Cambridge, 1992), esp. pp.27–42; C. Barber, *Figure and Likeness: On the Limits of Representation in Byzantine Iconoclasm* (Princeton, 2002). For St Thomas Aquinas' later defence, see A. Besançon, *The Forbidden Image*, pp.148–64.

On the crucifixion in Christian art, there's still much to be learnt from K. Clark, *The Nude: A Study of Ideal Art* (2nd edition: London, 1960), pp.214–63: Clark mentions the Gregory of Tours story (p.192) on p.223. My ideas have been informed by two books in particular: L. Steinberg, *The Sexuality of Christ in Renaissance Art and in Modern Oblivion* (2nd edition: Chicago, 1984); and E. Scarry, *The Body in Pain: The Making and Unmaking of the World* (2nd edition: Oxford, 1988), esp. pp.181–277.

On the Reformation and art, my own views (including references to the quoted Martin Luther passages) can be found in M. J. Squire, *Image and Text in Graeco-Roman Antiquity*, esp. pp.17–41. Particularly important is J. Koerner, *The Reformation of the Image* (London, 2004); compare the earlier analyses of S. Michalski, *The Reformation and the Visual Arts: The Protestant Image Question in Western and Eastern Europe* (Cambridge, 1993), and J. Cottin, *Le regard et la parole: Une théologie protestante de l'image* (Geneva, 1994). The Karlstadt text is translated in B. D. Mangrum and G. Scavizzi (eds), *Karlstadt, Emser, and Eck on Sacred Images. A Reformation Debate: Three Treatises in Translation* (2nd edition: Toronto, 1998), pp.21–43 (the quoted passage comes from p.27). The quotation about Michelangelo comes from J. Hall, *Michelangelo and the Reinvention of the Human Body* (New York, 2005), p.xix. For the modern-day Roman Catholic theology of the image, there's a useful overview in S. J. Schloeder, *Architecture in Communion: Implementing the Second Vatican Council Through Liturgy and Architecture* (San Francisco, 1998), pp.145–67.

On the 'modern system of the arts' and their supposed eighteenth-century derivation, the key discussion is P. O. Kristeller, most easily accessible in his *Renaissance Thought and the Arts* (Princeton, 1990), pp.163–227; there are various responses to this essay in V. Platt and M. J. Squire (eds),

The Art of Art History in Graeco-Roman Antiquity (= *Arethusa* 43.2, 2010). The best English translation of Hegel's lectures on aesthetics (themselves reconstructed from posthumous lecture notes) is by T. M. Knox: *Lectures on Fine Arts* (2 vols: Oxford, 1985). The 'three stages' of art are discussed on pp.299–611 of Knox's first volume, and my quotations are taken from pp.11, 103, 485, 531. For further bibliography and critique, see M. J. Squire, *Image and Text in Graeco-Roman Antiquity*, pp.58–71: the most important modern exponent of the thesis is arguably A. Danto, *Philosophical Disenfranchisement of Art* (New York, 1986), esp. pp.81–115.

Finally, the article mentioned on p.200 is D. Crimp, 'The end of painting', *October* 16 (1981): 69–86.

PICTURE CREDITS

Acquiring pictures for academic books is a difficult, expensive, and thankless chore: had it not been for the aid of two institutions – the Fotoarchiv of the Institut für Klassische Archäologie und Museum für Klassische Abgüsse at the Ludwig-Maximilians-Universität in Munich (LMU), and the Deutsches Archäologisches Institut in Rome (DAI) – the author would long ago have abandoned the task. Particular thanks to Daria Lanzuolo at the DAI for her help, as well as to those museums and individuals that provided their images free of charge (as indicated below); most importantly of all, the author and publishers are grateful to the Alexander von Humboldt-Stiftung for their generous grant towards costs. In the event of any error or oversight, copyright-holders are requested to inform the publishers: due accreditation will be sought for any future edition.

Frontispiece: Photograph by John Borthwick, © Lonely Planet
1. © Scala / Art Resource, New York
2. DAI: Rom 1966: 1831
3. © Ashmolean Museum, University of Oxford (without charge)
4. Author
5. Author
6. Author
7. © Albertina, Vienna
8. Author

9. © Wellcome Images, London (without charge)
10. Author
11. © Leni Riefenstahl Produktion, Berlin
12. Author
13. Author
14. After N. Spivey and M. J. Squire, *Panorama of the Classical World* (2nd edition: London, 2008), p.329, fig. 509
15. © Art Institute of Chicago (without charge)
16. Author
17. © Metropolitan Museum of Art / Art Resource, New York
18. Drawing by Candace Smith: after A. Stewart, *Greek Sculpture: An Exploration* (New Haven, 1990), vol. 2, p.55, fig. 55
19. Drawing by Candace Smith: after A. Stewart, *Greek Sculpture: An Exploration* (New Haven, 1990), vol. 2, p.42, fig. 42
20. Author
21. DAI: Rom 1966: 0750
22. © Metropolitan Museum of Art / Art Resource, New York
23. © Metropolitan Museum of Art / Art Resource, New York
24. DAI: Rom 1970: 2013
25. After D. Kurtz, *The Berlin Painter* (Oxford, 1983), p.40, figs. 7–8 (by kind permission of the author)
26. LMU
27. © National Gallery, London (without charge)
28. Reproduced by kind permission of the Guerrilla Girls: www.guerrillagirls.com (without charge)
29. LMU
30. Private collection: photograph by kind permission of Christie's, London (without charge)
31. Author
32. LMU
33. Author
34. DAI: Rom 1968: 3650

35. © Museum of Classical Archaeology, University of Cambridge (without charge)
36. Drawing by Sian Francis, after N. Spivey and M. J. Squire, op. cit., p.54, fig. 82
37. Author
38. LMU
39. © Mary Mauzy / Art Resource, New York
40. LMU
41. © Paris, Bibliothèque Nationale
42. © Library of Congress, Washington, DC (Prints and Photographs Division): LC–ppmsc–04904
43. Author
44. DAI: Rom 1966: 1688
45. DAI: Rom 1934: 214
46. DAI: Rom 1937: 378
47. Author
48. LMU
49. DAI: Rom 1965: 1111
50. Author
51. Author
52. DAI: Rom 1933: 136
53. LMU
54. © Metropolitan Museum of Art / Art Resource, New York
55. © Trustees of the British Museum, London (without charge)
56. Author
57. © Elisabeth Ohlson Wallin (by kind permission, without charge)
58. LMU
59. © Trustees of the British Museum, London (without charge)
60. LMU
61. Drawing by Sian Francis, after N. Spivey and M. J. Squire, op. cit., p.83, fig. 126
62. Author

63. Author, after N. Spivey and M. J. Squire, op. cit., p.81, fig. 123
64. © Erich Lessing / Art Resource, New York
65. © Scala / Art Resource, New York
66. © Scala / Art Resource, New York
67. LMU
68. © State Hermitage Museum, St Petersburg
69. © Scala / Art Resource, New York
70. © Trustees of the British Museum, London (without charge)

Colour Plates

Pl. 1. © Albertina, Vienna
Pl. 2. Author
Pl. 3. Author
Pl. 4. LMU
Pl. 5. © National Gallery, London (without charge)
Pl. 6. Private collection: Photograph by kind permission of Christie's, London (without charge)
Pl. 7. © Museum of Classical Archaeology, University of Cambridge (without charge)
Pl. 8. © Mary Mauzy / Art Resource, New York
Pl. 9. Author
Pl. 10. © British Museum, London (without charge)
Pl. 11. Author
Pl. 12. LMU
Pl. 13. LMU
Pl. 14. LMU
Pl. 15. © Scala / Art Resource, New York
Pl. 16. LMU

INDEX

Abercrombie & Fitch 110
acheiropoiēta 162–4
Achilles 126, 131, 142
Actaeon 103–9
'Action Men' 76
Adam 14, 177–81
adlocutio 136–7, 146
'Adonis girdle' 60–1
Adorno, Theodor 25–6
advertising imagery 76, 110
Aelius Aristides 159
Aeschylus 163–4
agalmatophilia 64, 86–8, 97–9
Ajax 93
Albano, Lake 115
Alberti, Leon Battista 58, 77, 82
Albiker, Karl 20
Alexamenos 174–5
Alexander the Great 22, 51, 126,
 133–4
Alison Lapper Pregnant 27–9
Alma-Tadema, Sir Lawrence 72–5
Amasis II 36
Amazons 165
Analysis of Beauty 15–16
anastolē 133
Anchises 98–9, 101, 108, 133
'ancients and moderns' 4–7, 28–31,
 109–10, 147–8, 156–8, 198–201
Anderson, Pamela 112
anorexia nervosa 82
'anthropometric' measuring systems 8–9
anthropomorphism 63, 157–68
 Christianity as anthropomorphic
 religion 167–81

Antinous 15
Aphrodite *see* Venus; Knidian Aphrodite
Apelles 10, 187
Aphrodisias 135
Apollo
 'Apollo's belt' 60–1
 Apollo Belvedere 15, 119
 on fourth-century Apulian krater
 166–7
 Augustus' appropriation of 140
 Christian appropriations of 156, 175
 at Olympia 137
 'Piraeus Apollo' 40
Apsley House, London 1–2, 118
Apuleius 86
Aquinas, Saint Thomas 189
'Archaic smile' 40
Argos 8, 46
Arianism 170
'Aristodikos' kouros 40–1
Aristotle 173
Arringatore 136–8
art, invention of 63, 195, 199–201
Artemidorus 159
Artemidorus mummy case 149–53
Artemis 103–9, 159
art history
 ancient/ modern narratives of 46–62
 and Classics xiii–xiv
 and feminism 71–9
 Hegel's history of art 198–201
 'assemblage aesthetic' 151–2
Athena 80–81, 105–6, 108, 125, 159,
 162–6
Athenaeus 100–1

Athens
 Acropolis 92, 162–6 *see also*
 Parthenon
 Archaic/ Classical art from 33–46
 Athenian democracy 46, 125
 Dipylon cemetery 43
 Erechtheum 162–3
 Panathenaia 164–6
 portraits from 125–6
 vase-painting from 57–60
 1896 Olympic Games 18
Augustus 134–49

Bannenträger 123
Barberini Faun 22
'Barberini Togatus' 130–1, 133
'Barbie' dolls 76
Baroque 51–3
beards 145
beauty pageants 81
Beckmann, Max 25
Beirut 114
Belting, Hans 187
Belvedere torso 15
Berger, John 72–81, 96, 110
Berlin Painter 58–9
Blu-ray DVDs 5
body
 Archaic Greek images of 33–45
 architectural concepts of 11–12
 body-building 16–19
 body dysmorphia disorder (BDD) 82,
 110
 of Christ 154–8, 168–81, 184–95
 Christian attitudes towards 167–74,
 192
 Classical ideals of 1–23
 in contemporary advertising 76, 110
 cuirassed bodies 120, 123, 136–43,
 145
 dead bodies 177–81 *see also* funerary
 monuments
 dissection 59
 divine bodies 154–201 *see also*
 Knidian Aphrodite
 embarrassment about 117–33
 female bodies 69–114
 fragmented bodies 82–4, 147–57
 genitals 84–6
 male bodies 1–24, 110
 as measuring system 8–9

 in modern art 26–7, 199–201
 'multistable' bodies 136–43
 Nazi attitudes towards 19–23
 as personification 7, 140, 184
 Reformation attitudes towards
 194–9
 relics 172
 Renaissance attitudes towards 7–15
 Roman attitudes towards 115–53
 shaved bodies 24, 86
 Victorian attitudes towards 17–18,
 72–4, 84
 see also nudity; sex
'Borghese Hermaphrodite' 70
Botticelli, Sandro 9–10, 27, 75–6, 79
Breker, Arno 20, 21, 47
Britain's Got Talent 18
bronze-casting 63
bulimia 82
Burne-Jones, Edward 82
Byron, Lord George Gordon 120
Byzantine art 162, 183–91

Cacault, François 118
Caesar, Julius 133–4, 142
Caligula 133, 151
Callimachus 105–6
Cameron, David 24
Camille, Michael 6–7
Canon see Polyclitus
Canova, Antonio 2, 4–7, 117–21
Caravaggio, Michelangelo Merisi da 171,
 180
Cassandra 93
Catholicism, Roman 10, 23, 194–8
Cavallaro, Cosimo 157
Cesarino, Cesare 15
Chagall, Marc 25
Christ 154–201
 as an ass 174–5
 baptism of 157, 184–6
 Byzantine images of 184–91
 celebration/ denial of the body
 154–7, 167–74
 chocolate sculpture of 157
 crucifixion of 156–7, 174–6, 189–90,
 192–4
 earliest images of 174–81
 Eucharist as embodiment of 197
 as 'Good Shepherd' 175–6
 homoerotic depictions of 157–8, 192

Renaissance images of 192–5
and the Trinity 177–80
chryselephantine 162–6, 169
Ciamabue, Giovanni 49, 51
Cicero 81–4, 88, 133
cinema 5, 21–2, 77–8, 88
Clark, Sir Kenneth 42, 76, 132, 152
Classicism
as bodily aim 16–19
definitions of 7–15
Hegel on 199
homoerotic undertones of 22, 50
and nationalism 19–23, 123–4
and nudity 115–53
in USA 27–8, 120–3
see also naturalism; Renaissance
Claudius 143–4
Cleisthenes 46
Clement of Alexandria 114, 142, 161,
172–3, 194
Cold War 46–7
Conan Doyle, Sir Arthur 18
Constantine 122, 154, 186
Constantinople (Istanbul) 90, 182, 186,
189
contrapposto 3, 5, 10, 42, 139, 146,
192
Copenhagen matrona 115–17, 147–9
Cos 90–2
Counter-Reformation 156, 171, 197–8
Cranach the Elder, Lucas 72
Creed, Martin 200
Crimp, Douglas 200
'Critian Boy' 41–2, 54–5, 61
Croesus 35
Cromwell, Oliver 129
'Cubism' 24, 199–200
cuirass 120, 123, 136–43, 145
Cupid see Eros
Cycladic art 26

'Dadaism' 24, 199
Dalí, Salvador 27–8
damnatio memoriae 64, 151
Danae 103
Daniel 176–7, 180
David and Goliath 9–11
David, Jacques-Louis 120
death see funerary monuments
Debbio, Enrico del 23
Delos 35, 110–14, 132

democracy 46–7, 62–3, 125
Denon, Baron de 118–19
Diana see Artemis
Dio Chrysostom 167–8, 183
Diodorus Siculus 36–8
Dione 92
Dionysus 103
'Dipylon krater' 43–5
Discobolos see Myron
disegno 13, 15
Disney, Walt 83–4
dissection 59
'Dogmatic sarcophagus' 177–81
Domitian 145
Doryphoros see Polyclitus
dreams 159
Duccio di Buoninsegna 49, 51
Dura-Europos 175
Dürer, Albrecht 14, 77–9, 82
'Dying Gaul' 18

Ecce Homo 157–8
Eco, Umberto 27
Egyptian art 34–40, 45, 149–51, 162
Eirene 178–9
Elgin, Lord 118
Emin, Tracey 200
Enlightenment 62, 68, 195
epigram 100–2
Eros 110–14, 116, 142
Euripides 105
Europa 103
Eurydice 103
Eusebius 186
Eve 10, 177–81
'Expressionism' 24, 199–200

'Farnese Heracles' 15–18
Fascism 18–23, 69, 123 see also Hitler,
Adolf; Mussolini, Benito
'Fauvism' 24
'female nude' 69–114
association with bathing 93–5, 103–9
Berger's analysis of 74–7
development in ancient Greece 92–3
as goddess 96–114
on Parthenon pediments 92
Roman appropriations of 115–17
Victorian attitudes towards 72–4,
95–6
western/ Indian traditions of 84–6

Ferretti, Lando 23
fig-leaf 1, 5, 18
Flavians 117–19, 143–5
Florence 13, 95, 192
Florio, Emilio 123
footwear 142–3
Foucault, Michel xi, 80, 97
Freud, Sigmund 78
funerary monuments
 Artemidorus mummy 149–53
 catacomb paintings 175–6
 Copenhagen *matrona* 115–17
 'Dipylon krater' 43–5
 kouroi/ korai 35, 40–1, 45, 92
 Roman busts 131
 sarcophagi 108, 151, 176, 177–81
'Futurism' 24, 199

'Gabinetto Segreto' 80
Galatea 64, 86–8
Galen 8
gaze
 'homospectatorial gaze' 110
 Lacanian theories of 99–100
 divine gaze 102–9, 113, 187–8
 'male gaze' 74–81, 88, 94, 99, 109
 voyeurism 76–9, 54, 112–13
Gedächtnisbilder 57
Genius of Fascism 123–4
Geometric art 43–5
Germany
 art historical traditions xiii, 49–53
 idealisations of the Classical 18–23
 Renaissance art from 14, 72,
 77–9
Gérôme, Jean-Léon 88
Gheeraerts the Elder, Marcus 195–7
Giacometti, Alberto 26
Giocondo, Giovanni 15
'GI Joe' 110
Giorgio, Francesco di 15
Giorgione (Giorgio Barbarelli da
 Castelfranco) 72
Giotto di Bondone, 49, 51, 191
Gnosticism 170, 173
gods and goddesses
 ancient depictions of 157–67
 as animals 103, 112, 162, 168
 chryselephantine depictions of 162–6,
 169
 divine gaze 102–9, 113, 187–8

humans posing as 4, 115–17, 141–4,
 177–81
 nakedness of 96–109, 142–3, 155–7
 Persian gods 160, 168
 see also Christ
Goebbels, Joseph 22
Goethe, Johann Wolfgang von xiii, 19
'golden shower' 103
Gombrich, Ernst 33–53, 62–3, 66
Gori, Giorgio 123–4
Gothic *see* Mediaeval art
Grande Odalisque 71
Graziosi, Giuseppe 123
Greek art
 Archaic/ Classical 33–68, 92–3
 Hellenistic 51, 53, 125–7, 142, 147
 Winckelmann's analysis of 49–53
 'Greek Revolution' 32–68
Greek Slave 96–7
Greek War of Independence 95
Greenberg, Clement 47
Greenough, Horatio 121–3, 143
Gregory the Great, Pope 182–3
Gregory of Tours 192
'Guerrilla Girls' 69–71
gymnos 100–2

Hadrian 96, 145
hairstyles 35, 40, 115, 126, 130, 136, 139,
 144, 147, 188
Hamilton, Lady Emma 16–17
Hegel, Georg Wilhelm 198–201
Helen 81–2
Hellenistic Greek art 51, 53, 125–7, 142,
 147
Hephaestus 64
Hera 80–1, 103
Heraclea 81
Heracles 15, 18, 58–9, 83, 126
Hermes 135, 177
Herodotus 36, 160
Hirst, Damian 200
Hitler, Adolf 19–22, 24–5, 123
Hogarth, William 15–16
Homer 45, 50, 80, 82, 159
Homeric Hymn to Aphrodite 99, 108
homoeroticism/ homosexuality 18, 20,
 22, 50, 97–9, 110, 157–8
'homospectatorial gaze' 110
Horus 178–9
Houdon, Jean-Antoine 121

iconoclasm 69–71, 188–91, 195–7
icons 187–91
idolatry 154–7, 170–1, 187–91, 195–7
iliac crest 60–2, 67
'Impressionism' 199–200
Incarnation 167–74
Indian art 86
Ingres, Jean Auguste Dominique 71
Io 103
Irenaeus 173
Isis 178–9
Islamic art 158, 188–9

Jefferson, Thomas 120
Jerome, Saint 186
Jesus see Christ
John the Baptist 157–8, 184–6
John of Damascus 173–4
John the Evangelist 171, 175–6, 192, 194
Jonah 176–7
Judaism 170
Jupiter 143–4
Justin Martyr 172

kalokagathia 8, 126
Kappeler, Susan 78–9
Karlstadt, Andreas Bodenstein von 194–5
'Khludov Psalter' 189–91
Klee, Paul 25
Knidian Aphrodite 22, 72, 84, 88–114
 architectural context of 94–6, 106
 as model for Roman matronae 115–17
 in Planudean Anthology 100–2
 Pliny the Elder on 90–2, 95, 97, 98, 108
 Pseudo-Lucian on 97–100, 110
 and 'Slipper-Slapper' group 109–14
 stain between legs 91, 97–9
 as three-dimensional statue 106–7
 water jar 93–4, 105, 112
Kopienkritik 90
korai 38, 92–3, 103, 105
kouroi 33–45
 'Aristodikos' kouros 40–1
 Anavyssos kouros 35
 'Critian Boy' 41–2, 54–5, 61
 Egyptian origins of 35–40
 functions of 35
 influence on twentieth-century art 26
 'New York kouros' 34–5, 37–8, 40,
 43, 54, 62
 'Piraeus Apollo' 40

production of 38
Kresilas 125
Kronos 106
Kuriyama, Shigehisa 58

Lacan, Jacques 99–100
Lakshmi 85–6
Lanzinger, Hubert 123
Laocoön 15, 118
Lapper, Alison 29
Laqueur, Thomas 84–6
Laureti, Tommaso 154–7, 198
Lawes, Sir Charles 18
Lazarus 177
Leda 103, 107
Leonardo da Vinci 13–15, 58
Lloyd-George, David 18
Loewy, Emmanuel 57
Lucian/ Pseudo-Lucian 97–100, 110
'Ludovisi Hermes' 135
Luther, Martin 19, 195–7, 199
Lysippus 9, 17, 126

Macedon 126
Maguire, Henry 185
'male gaze' 74–81, 88, 94, 99, 109
'manorexia' 110
Marathon 162
marble 18, 35, 38, 56, 89
Marcellus 135, 148
Marinetti, Filippo Tommaso 24–5
Mars 4, 117
Mary 10, 177–81, 187, 199
Mediaeval art
 appropriated by Nazis 123
 historiography of 47–8, 49, 51–3, 54,
 57, 191
 representations of the crucifixion 192
Melanchthon, Philip 195
Mengs, Anton Raphael 50
Mercury 154
Mesopotamia 40
metric measuring systems 8–9
Michelangelo Buonarroti 9–11, 49, 52,
 157, 192–4, 197–8
Milan, Edict of 154
mimesis 64–5
Misenum 143
modernism 24–7, 199–200
Moore, Henry 25–6
mosaics 182, 184–7, 189, 199

Moss, Kate 29
MTV 76
Muhammad, Prophet 158, 189
Mulvey, Laura 77–8, 82, 112–13
Musée Napoléon 118–9, 148
Mussolini, Benito 20, 22–3, 26, 123–4
Myron 20–3, 56–7, 61, 63
My Sweet Jesus 157

Napoleon Bonaparte 4–7, 117–21, 123,
 148
Narbonne 192
Narcissus 102–3
naturalism
 ancient anecdotes about 63–4
 in Archaic/ Classical art 32–68
 Byzantine responses to 183–8
 as Classical legacy xiii, 3, 5, 26,
 53–68, 84, 152
 democratic associations of 46–7,
 62–3
 and Egyptian art 39–40
 and female nude 84–6
 in Roman art 148–53
Naukratis 36
Nazism (National Socialism) xiii, 19–26,
 46–7
Neilos, Saint 182–3
Neoclassical 7, 117
neura 58
New York Metropolitan Museum of Art
 69–71
Nicaea 170, 177, 189
Nietzsche, Friedrich 19–20, 24
'Nikandre' 35
Niobe 92
Normand, Ernest 88
nudity
 as artistic choice 117
 of Christ 154–7, 192–4
 Classical traditions of 1, 4–5, 115–53
 divine connotations of 141–3,
 154–7
 female nudity 69–114
 of kouroi 38
 and 'nakedness' 76–7
 'nudity as a costume' 116
 Roman attitudes towards 115–53
 western/ Indian traditions compared
 84–6
Nuremberg 14

Octavian *see* Augustus
Odysseus 184
Olympia
 Olympic Games 18, 21–2
 Temple of Zeus 137
 Pheidias' statue of Zeus 4, 121, 163,
 167–9, 177, 187–8
opera 19
Opera Nazionale Balilla 23
'Orientalising' 35
Origen 172
Orpheus 103
Ovid 86–8, 103–5, 116, 141

Pan 110–15
Pankhurst, Emmeline 69
Paris 80–2, 101
Parrhasius 63–4, 66–7, 187
Parthenon
 as artistic model/ anti-model in
 twentieth century 20, 24–5
 pedimental sculptures 92
 purchased by British Museum 118
 statue of Athena Parthenos 125,
 162–6, 188
 within Gombrich's *Story of Art* 46
Paulinus of Nola 183, 187, 194
Pausanias 160, 163–4
penis 84–6
'Peplos kore' 92–3
Pericles 20, 125, 166
perspective 77
Peter, Saint 177–81
Pheidias
 statue of Athena Parthenos 125,
 162–6, 188
 statue of Zeus at Olympia 4, 121–2,
 163, 167–9, 177
 Winckelmann's discussion of 52
Pherecydes 105
Photios 187
photography 5, 17–18, 65, 88
Phryne 100–1
Picasso, Pablo 24, 26
Pioneers 46, 65, 67
Pisano, Niccolò 191
Pistoletto, Michelangelo 72
Planudean Anthology 100–2
Plato 64–5, 161, 172, 173
Playboy 71
Pliny the Elder

description of Knidian Aphrodite
 90–2, 95, 97, 98, 108
description of Polyclitus' *Doryphoros*
 6, 131
description of Roman artistic tradi-
 tions 131, 138
description of Tyrannicides
 Harmodios and Aristogeiton 125
description of Zeuxis' *Helen* 81–2
description of Zeuxis and Parrhasius
 63–4, 67
as model for Vasari and Winckelmann
 48–50, 65
Pliny the Younger 64
Plutarch 166
Polyclitus 5–15, 26, 42, 46, 55–7, 131,
 139, 146, 184
Pompeii 6, 85–6, 107–9
Pompey the Great 133
pornography 71–2, 78–80, 86
Porphyry 163–4
portraits
 of Augustus 134–47, 149
 Greek portraits 125–7, 142
 modern western portraits 4–7,
 117–24
 Roman portraits 126–47
postmodernism 27–9, 200
Powers, Hiram 95–6
Praxiteles 9, 27, 51 *see also* Knidian
 Aphrodite
Prima Porta Augustus 135–43, 146, 149
Prometheus 64
prostitution 80, 93, 100–1
Protagoras 8–9
prothesis 43
Psalms 189–90, 192, 194–5
'Pseudo-Athlete' from Delos 132–3, 143,
 147–9
pubic hair 41, 84–6
Putin, Vladimir 24
Pygmalion 33, 64, 86–8, 99

Quincy, Quatremère de 120
Quinn, Marc 27–9
Quintilian 56–57

Raphael 26, 52
Ravenna 184–6
Reformation 19, 96, 194–201
relics 172

Renaissance
 art criticism 48–9 *see also* Vasari,
 Giorgio
 attitudes towards antiquity 9–15
 attitudes towards God 15, 191–5, 198
 female nude 71–9
 influence on narratives of Classical art
 history 47–9, 51–62, 183–4,
 191–2
 relationship with the Mediaeval
 191–5
Renaissance and ancient 'naturalism'
 compared 53–62, 152
Reni, Guido 52
'Riace bronzes' 60–2
Richardson, Mary 69–70
Richter, Gisela 40
Riefenstahl, Leni 21–2, 57
Riegl, Alois xiii, 186
Rodin, Auguste 88
Rokeby Venus 69–70, 75–6
Roman art
 'assemblage aesthetic' 147–53
 female nude portraits 115–17
 relationship with Greek 125–47
Rome
 Arch of Titus 157
 Basilica of Santa Maria Maggiore
 182–3
 Catacomb of Priscilla 175–6
 Stadio dei Marmi/ Foro Italico 23
 Vatican, Raphael Rooms 154–6
Ruskin, Sir John 84, 86, 87, 90

Samos 35–6
Sandow, Eugen 16–19
sarcophagi 108, 151, 176, 177–81
Sarkozy, Nicolas 24
Schultze-Naumburg, Paul 20
Scopas 9
'scopophilia' 78, 96
A Sculptor's Model 72–6
sculpture
 development in Archaic/ Classical
 Greece 33–43
 'ontology' of 64, 101–2, 156–7,
 162–7, 188, 199–201
 painted sculpture 93, 135–6
 relationship with painting/ mosaics
 185–6, 170, 188, 192, 199–200
 'seeing as'/ 'seeing in' 67, 100

Semele 103, 105
semiotics 100–2, 159
Seneca the Elder 64
sex
 with statues 64, 86–8, 97–9
 homoeroticism/ homosexuality 18,
 20, 22, 50, 97–9, 110, 157–8
Sinai 187–8
Sistine Chapel 157, 197–8
'Slipper-Slapper' group 109–14
Socrates 52, 64–7, 126
Sommariva, Giovanni Battista 118
'Spear-Bearer' see Polyclitus
sport 16–23
Stadio dei Marmi 23
Strabo 169
Stuck, Franz von 88
Stylites, Saint Simeon 172
Suetonius 151
suffragettes 69–70
Surrealism 24, 27–8, 199–200
Susannah 176
Sutor, Emil 21
symmetria 8–15
symposium 93, 166

Talos 64
Teiresias 105–6, 108
'Terme Ruler' 126–7
Thomas, Saint 171
theōria xii, 159
Thorak, Josef 20, 47
Thucydides 166
Titian (Tiziano Vecellio) 49, 72
Titus 145, 157
Tivoli 96, 106
toga 130–1, 133, 136, 138, 144–5
Torah 170
Trafalgar Square, London 27–9, 157–8
Trebonianus Gallus 146–7
Trent, Council of 197
Triumph of Christianity 154–7, 198
Troy 80, 82, 93, 159
Turner Prize 200

'ugliness' 128–33
USA 120–2

Vasari, Giorgio 9, 48–9, 51, 53, 63, 65,
 183, 191
vase-painting 43–6, 57–60, 62 67, 92–3
Velázquez, Diego Rodríguez 69–70, 75–6

Venice Reconstituted 27
Venus
 as artistic subject 71–9
 The Birth of Venus 9–10, 79
 'Capitoline Venus' 90, 107, 108, 112
 'Esquiline Venus' 72–4
 Rokeby Venus 69–70, 75–6
 'Venus Colonna' 89
 Venus Genetrix 116
 Venus de Milo 27–9, 83–4
 Venus de' Medici 15–16, 73, 90, 95,
 107, 112, 115
 Venus razor 24
 Venus with Drawers 27–8
 see also Knidian Aphrodite
'verism' 130–4, 143–5, 148, 152
Vespasian 143–5
Victorian England 17–18, 72–4, 84
Victory of Samothrace 24
Virgil 116, 131, 133, 141
Vishnu 85
Vitruvius 10–15, 192
Vivant, Dominique 118
Wagner, Richard 19
Wallin, Elisabeth Ohlson 157–8
Wallinger, Mark 157–8
Warburg Institute xiii
Washington, George 120–3
Ways of Seeing 72–81
Wellington, Duke of 2, 118
Whitehead, Alfred North 65
Winckelmann, Johann Joachim xiii, 18,
 49–53, 55, 62
 attitudes towards Roman art 149
 History of the Art of Antiquity 28–9,
 50–3
 homoerotic interests 50
 influence on Hegel 200
Wollheim, Richard 67, 100
World War Two 24–6, 124
Xenophanes 160–1
Xenophon 65–7
X Factor 18
Zeising, Adolf 16
Zeus 4, 64, 80, 103, 121, 163, 167–9,
 175, 177
Zeuxis 63–4, 67, 81–2, 88, 187
Zwingli, Ulrich 195